Modernism in the 1920s
Interpretations of
Modern Art in New York from
Expressionism to Constructivism

Studies in the Fine Arts: Criticism, No. 17

Donald B. Kuspit, Series Editor

Chairman, Department of Art
State University of New York at Stony Brook

Other Titles in This Series

Modernism in the 1920s
Interpretations of
Modern Art in New York from
Expressionism to Constructivism

by
Susan Noyes Platt
Assistant Professor of Art History
Washington State University
Pullman, Washington

UMI RESEARCH PRESS

Ann Arbor, Michigan

Produced and distributed by
UMI Research Press
an imprint of
University Microfilms International
A Xerox Information Resources Company
Ann Arbor, Michigan 48106

Library of Congress Cataloging in Publication Data

Platt, Susan Noyes, 1945-
 Modernism in the 1920s.

 (Studies in fine arts. Criticism ; no. 17)
 "A Revision of the author's dissertation, University
of Texas, 1981"—T.p. verso.
 Bibliography: p.
 Includes index.
 1. Art, Modern—20th century—New York (N.Y.)
2. Art, Modern—20th century. 3. Art criticism—
New York (N.Y.)—History—20th century. I. Title.
II. Series.
N6535.N5P54 1985 701'.1'8097471 85-1070
ISBN 0-8357-1661-9 (alk. paper)

98863

This book is dedicated to
 my friends and family
 with gratitude
for their love and support;

with particular appreciation
 to my brothers
 my daughter
 and Gregg
for their special caring;

and in memory of my parents
 two people
 who lived
with the pioneering spirit
 of the 1920s.

Contents

Acknowledgments

I would like to express my sincere appreciation to the following individuals who have supported and advised me in various ways throughout the creation of this book: Linda D. Henderson, Kenneth Prescott, Richard Brettell, Eleanor Greenhill, Jeffrey Meikel, Judith Zilczer, Garnett McCoy, William Camfield, Sam Hunter, William Agee. I would also like to acknowledge the support of the Rockefeller Foundation during the initial stages of research, and of the Smithsonian Institution, for a crucial period of research in Washington, D.C.

Introduction

Surveys of American art often address the 1920s as a period of decline for modern art and its related theories, collectively known as modernism. A typical interpretation runs as follows:

> [T]he collapse of American modernism in the twenties was more complete, tragic and inevitable than the European *detente.*
> ... Of the major painters only Dove maintained his committment to abstract art. Stieglitz' gallery, 291, had closed, and the artists associated with it had disappeared. When *Camera Work* suspended publication in 1917, its circulation was thirty subscribers....[1]

The implication of this comment is that modernism in the 1920s simply ceased to exist as a concern or an issue. This book challenges that interpretation. It demonstrates that the art and theory of modernism continued to be a major concern between 1920 and 1930 in America. That concern appeared in both the preoccupation with modern structural principles among American artists, and in the ongoing interest in and awareness of recent European avant-garde art and theory.

Studies of the 1920s underestimate the importance of modernism in America for several reasons. First, historians tend to focus narrowly on the history of abstract art as the only legitimate issue of modern art. A consideration of modernism in the 1920s must include Expressionism, Dada, Constructivism and various late Cubist styles, including the Ingresque work of Picasso. Second, the environment of modernism altered significantly in the 1920s, so a continued focus on the activities of the previous decade distorts the actual situation. The discussion of modern art moved from the esoteric concern of an elite group of intellectuals, such as that found at Alfred Stieglitz' 291 Gallery, to a widespread issue discussed almost daily in newspapers and magazines. Unlike the public coverage of modernism from 1910 to 1919, which tended to be derogatory and skeptical, the debate about the issues of modern art in the press of the twenties was, for the most part, informed and intelligent. Third, historians misinterpret modernism in the 1920s because they fail to

acknowledge the interrelatedness of American and European avant-garde development. Modernism in America from 1920 to 1930 can only be fully evaluated by including a consideration of the ongoing influx of European art and theory into New York.

This book offers an examination of modernism in the 1920s that is inclusive, rather than exclusive; it moves beyond the narrow perspective of the history of abstract art to a concept that encompasses the full spectrum of modern art and theory. Rather than trace the changes in the art itself from a contemporary perspective, this study focuses on the critical interpretations of that art by examining the discussions of modern art and theory by the critics, dealers, collectors and artists of the 1920s.

A dominant characteristic of the development of modernism in the 1920s in New York is the simultaneous appearance of different styles and their concomitant theories. Thus by 1920, Impressionism, the avant-garde style of the 1870s, finally found acceptance among even the most academic artists. Almost simultaneously, Cézanne, Cubism, Expressionism, Dada, Surrealism and Constructivism appeared in America and became major issues and influences. For the critics of modernism this overlapping created a challenge. Although they received some art ambivalently (particularly Dada), by the end of the decade they were discussing all the phases of European contemporary art, as well as various types of American modern art with a surprising sophistication.

The interpretation of art during this intense decade was open to anyone who wished to take on the responsibility. Since few reference texts offered authoritative opinions,[2] individual predilections and beliefs became of major importance. No defining institution arbitrated the outstanding accomplishments of modern art, only a myriad of small galleries and groups. The result was an outpouring of opinion and impassioned interpretation that has heretofore been neglected in studies of modernism in America. While individual writers are not usually considered extraordinary thinkers, the collective body of literature on modern art in the 1920s forms an important chapter in the intellectual history of modern art.

In order to include as broad a spectrum of this literature as possible, the methodology used is horizontal rather than vertical; that is, instead of monographic studies of individual critics, I have surveyed a cross section of responses to a particular style. In this way, the interconnections and influences of one group or theory on another emerge more clearly. In addition, the place of each critic or organization with respect to other activities can be located. These interconnections are an important aspect of the history of modernism in the 1920s. From this study of the criticism, a picture emerges that encompasses ideas from avant-garde to ultraconservative and many compromises in between.

Monographic studies of some of the major figures of the 1920s have recently been published. The Société Anonyme, the most important organization to support the avant-garde in that decade, is the subject of a recent publication.[3] Other brief studies treat the more well-known critics: Forbes Watson, Henry McBride and Christian Brinton.[4] An innovative exhibition catalog documents the history of John Quinn, a major collector and catalyst for interest in modern art in the teens and twenties.[5] Other studies look at criticism in America prior to the 1920s[6] and one dissertation examines the sources and writings of the most important critic of the teens, Willard Huntington Wright.[7] The groundbreaking book by Milton Brown, *American Painting From the Armory Show to the Depression*,[8] has been an example for the present study in its examination of the entire art world, rather than simply the art. Brown discusses the collectors, critics and patrons as well as the complex nature of modernism itself in the 1920s.

The widespread debate about modern art in the 1920s ended with the founding of the Museum of Modern Art in November 1929. That institution, with a consciously historical stance, immediately became the central focus for the modern art environment in New York. Its exhibitions and its catalogs, created with the sophisticated perspective of Alfred Barr and other curators, set the definition of modern art. Yet, those same curators' perspectives were formed in the atmosphere of the 1920s, in the exciting, fluid, open period before the definition of modern art was established. Thus, to look at the literature of modernism in the 1920s is to understand the foundation for later interpretations of modern art in America.

Finally, the literature documents that the interest in modernism was itself a pressure, at first subtle and later less subtle, toward the interest in its opposite, American Regionalism. The study of modernism reveals that the rise of Regionalism was, in part, a reaction to the obsession with modern art, particularly European modern art, that began in America with the Armory Show and increased in the 1920s. By the middle of the decade American critics felt that modernism was suffocating American art. The concern for "native" art expressions led to a promotion of American art, first in the context of modernism, then in the context of Regionalism.

The definition of "modern" and "modernism" as used here varies according to the art literature's use of the terms in the 1920s. The terms "modern," "ultramodern," "modernistic," and "extremist" were some of the many terms used to characterize modern art. The term "modernism" itself to mean art has been used since Impressionism first found currency in the late teens and early 1920s. Most writers on modern art of that time accepted Cézanne and his structural concerns as the starting point of modern art;[9] many rejected Dada and Constructivism as too extreme. This broad spectrum of ideas and definitions is the subject of this book.[10]

1

Institutions and Dealers

The Institutional View

In January 1920, at the Metropolitan Museum of Art, an exhibition of "Modern French Art" featured the Impressionist artists Claude Monet and Auguste Renoir.[1] Although the Metropolitan had purchased a painting by the Post-Impressionist Paul Cézanne from the 1913 Armory Show, by 1920 the museum still defined "modern" as Impressionism.[2] In the same year, the Pennsylvania Academy of Fine Arts displayed what the *American Art News* described as "modern and modernistic" art in a show that ranged from Courbet to Picasso and included the "weird de Bracque," "charming examples of Toulouse-Lautrec," and "the delicate art of Marie Laurencin."[3] A local Philadelphia newspaper under the headline "Arch Cubists Recant?" commented:

> What does this ... present display of 'Modernist' art lead to? That it leads nowhere except into the mire is likely to be the conclusion if the ... hint that came from ... Paris that Picasso and Picabia have now forsworn their futurism and are painting portraits in the normal should prove to be true. Why not? There are others of their ilk who have confessed behind the scenes that the game is about up.[4]

Thus, even as rumors of retrenchment among avant-garde artists reached America, the acceptance of modern art after Impressionism by the lay public in America was only beginning. As a result, the retrenchment of Cubism in the early 1920s was taken as a sign of its lack of validity. Such a strange overlapping of the avant-garde and the conservative is characteristic of the 1920s.

In 1921 both the Metropolitan Museum and the Pennsylvania Academy of Fine Arts again held exhibitions of modern art. The Philadelphia exhibition called "Paintings and Drawings Showing the Latest Tendencies in Art," generated an even more hostile reaction in Philadelphia than had the show of the previous year. While the writer and future publisher of *Art Digest*, Peyton Boswell, praised the exhibition in the *American Art News*, another article

carried a medical analysis by a group of Philadelphia doctors who claimed that modern artists were afflicted with defective vision, "ghastly lesions of the mind and body," and other pathological problems.[5]

John Quinn, a well known collector of modern art, instigated a loan exhibition of "Modern French Painting," in the summer of 1921 at the Metropolitan Museum.[6] Quinn not only convinced the conservative museum to hold the exhibition, but advised the curator about the selections and sought display of Picasso's Cubist work as well as Matisse's recent painting. Although these works were not included, the show was significantly more up-to-date than the modern exhibition of the previous year. It included paintings by Cézanne, Van Gogh, Gauguin, Matisse, and works by Picasso up to the Rose Period. While these artists had long been familiar to the artists in America, the show was a significant step forward for the Metropolitan Museum. The bulletin of the museum presented an official interpretation of the artists:

> The search of Van Gogh and Cézanne for the inner significance of objects led to the discovery of modified natural forms capable of expressing and calling forth emotion. This anti-literal purpose has been carried to great lengths by such dynamic artists of the present as Matisse, Picasso and Derain. The attempt is no longer to capture the appearance of natural objects but merely to employ forms, forms not outworn by constant usage, as the means through which an idea is expressed.[7]

Bryson Burroughs, curator of the exhibition, reinforced this analysis with an article quoted in the *American Art News*. Burroughs pointed out that although the show stopped short of Cubism, its aim was to

> appeal mainly to the mind which is curious about the solution of abstract problems and to the senses only by the expressive qualities inherent in the relation of lines and shapes and colors. Their abstractions can also be traced logically to the disapproval of the subject growing since Courbet's time and the distaste for the 'human interest'.[8]

Although the exhibition attracted large crowds,[9] it also generated negative criticism. An anonymous pamphlet quoting the same medical analysis discussed previously in reference to the Philadelphia exhibition of 1920, claimed that modern art was Bolshevist propaganda, the product of human greed on the part of the dealers and the expression of the insane. It further stated that the insanity took two forms: "deterioration of the optic nerve, whereby all values and proportions are transposed," and "an uncontrollable desire to mutilate the human body."[10] Despite the absurdity of the statements, John Quinn wrote a personal rebuttal which appeared in the same article saying that the criticism was the work of Ku Klux Kan degenerates. Support for Quinn's show came from the *Arts*, the major art magazine of the 1920s, which stated that the

Metropolitan Museum should be congratulated on the exhibition...[The pamphlet] is merely the expression of a group of degenerate minds who see in all things they do not understand something twisted and unlicensed![11]

The furor caused by the relatively mild step of showing modern art up to Picasso's Rose Period was a late outburst of vituperation toward modern art, a practice which had started in America with the Armory Show of 1913. The outburst demonstrated that the broader lay public was being reached and that modern art awareness was spreading. By the end of the decade the Museum of Modern Art would institutionalize the same art that was derided by the pamphleteers.

The Metropolitan Museum of Art held no other shows that they termed modern during the decade except a memorial to the realist George Bellows.[12] Other exhibitions of recent, not modern art, included the work of the Impressionist/Realist John Singer Sargent and the academic printmaker Joseph Pennell. Moreover, the Metropolitan did not purchase modern paintings. The Prints and Drawings Department was the most up-to-date as a result of gifts from the collector Albert E. Gallatin that included the American moderns John Marin and Charles Demuth.[13] Other recent American artists in the museum collection by 1931 included George Bellows, Guy Pène du Bois, Rockwell Kent and Kenneth Hayes Miller.[14] This selection reflects that "modern" for the Metropolitan Museum was related to a slightly expressive imagery, rather than use of modern structural principals of composition.

The Brooklyn Museum also displayed modern art in the 1920s. Less prestigious and accessible than the Metropolitan, the Brooklyn Museum was more receptive to a variety of modern expressions. The director of the museum, William H. Fox, showed modern art from Russia, Italy, France and America in a series of exhibitions.[15] In April 1921 Fox showed an important collection of Impressionist and Post-Impressionist paintings.[16] The auction of that collection in February 1922 led the *American Art News* to comment that "there were enough Modernist works to establish a basis of value in this country for the production of the new school."[17]

At the same time that the Brooklyn Museum displayed the Kelekian Collection and the Metropolitan was holding the Quinn-sponsored exhibition, another major exhibition of Post-Impressionism was assembled by art critic Forbes Watson for the French Institute in New York. Watson, who later became an influential editor of the *Arts,* wrote that

Even the confirmed dealers in "old masters" and their subsidized experts are talking "in society" about modern art, and archive hunters make bright observations at smart dinners on our astonishing Cubist New York. This means that the final act of recognition of the art of the nineteenth century is being played.[18]

In the same column, Henry McBride, critic for the *Dial* and the *New York Herald* commented about the exhibitions by saying that the moderns "may fairly be said to have finally arrived at a state of classicism."[19]

Even as New York was going through the last stages of accepting Post-Impressionism in 1920 and 1921, other cities in America were predictably less aware. The *American Art News* carried columns by writers from all over the country that frequently highlighted confrontations with modern art. One report from a writer in Cleveland headlined in New York "Cleveland Jolted by Modernistic Art," suffices as an example. The show had been juried by, among others, George Bellows, hardly the most radical artist in 1921. The only familiar name on the list of artists is Charles Burchfield, who at that time painted Expressionistic landscapes. The Cleveland writer reported to *American Art News:*

> Visitors who throng the museum by the thousands, looked with bewilderment at the ultra-modern paintings, trying to see something to admire in strange hued landscapes and portraits whose ghastly greens and purples suggest decomposition.[20]

Similar articles in the *American Art News* documented the spread of modern art awareness, and the shock of the first exposure to recent principles of modernism throughout the smaller cities of Western America.

Major Galleries and Groups

Société Anonyme, Inc.

The major sources for information on recent modern art in New York were smaller organizations and galleries rather than the established institutions such as the Metropolitan and Brooklyn Museums. Among these smaller organizations the least commercial and most significant was the Société Anonyme, founded by Katherine Dreier and Marcel Duchamp in 1920.[21] At the time of its founding the full name of the Société Anonyme included "Museum of Modern Art," a title Dreier adopted to give status to the art.[22] The Société Anonyme created the most complete display program of contemporary art in New York, particularly during the first half of the 1920s.

The primary spirit within the Société Anonyme was Katherine Dreier. Her background, like that of several active promoters of modern art in the 1920s, was in the Progressive movement. She was committed to helping others and to bringing art to the average person. She believed that modern art was a source of spiritual enrichment, a belief grounded in a study of theosophy and of the theories of Wassily Kandinsky.[23] Because of her commitment to education, Dreier assumed an aggressive, didactic attitude toward the endeavor of the

Société Anonyme. This crusading spirit was a sharp contrast to her partner Marcel Duchamp. Duchamp was a brilliant but soft-spoken artist, whose understanding of the avant-garde helped shape the exceptional quality of the art shown at the gallery. Duchamp remained involved in varying capacities with the Société Anonyme throughout its history.[24]

The opening statement of the Société Anonyme focused on the problem of distinguishing authentic modern art from the "men who wanted to dupe." The Société Anonyme sought "to create some order from this confusion." It planned to present an exhibition every six weeks "to study the serious expression of serious men."[25] Dreier saw the Société Anonyme applying the democratic process to art. She wanted to be open to all forms of art, rather than to promote a particular school. She accompanied the exhibitions with brief flyers identifying the style of the artists, and with an elaborate educational program of brochures, catalogs, lectures and symposia. The major critics of modern art contributed to the program, as well as Dreier herself. Dreier lectured widely to civic groups and schools, bringing original paintings with her as examples. These lectures formed the basis of her book on modern art, *Western Art and the New Era,* published in 1923.[26]

During the first exhibition year, which extended from April 1920 to June 1921, the Société Anonyme gave a virtually continuous series of six week exhibitions. These displays were marked by a strange interlacing of Duchamp's predilection for the cerebral French artists, with whom he was closely acquainted, and Dreier's interest in the German Expressionists. Thus, the Société showed a mixture of Cubism, Expressionism and Dada. The major Dada artists included were Francis Picabia, Man Ray, Marcel Duchamp and Kurt Schwitters. Other artists frequently shown were Georges Braque, Juan Gris, Pablo Picasso, Albert Gleizes and Jacques Villon. While Van Gogh and Gauguin were also included, the absence of Cézanne and many other major artists reflects the tenuous understanding of the development of modern art in the 1920s.[27] Some of the shows appear haphazard and accidental in their combinations of artists. The fifth exhibition, for example, included Expressionists like Kandinsky, Marsden Hartley and Abraham Walkowitz, French painters such as André Derain, Dada artists and others. The first major one-person exhibition was for the eccentric American painter Louis Eilshemius, a Duchamp discovery.

American modern art appeared spasmodically among the European-dominated exhibitions at the Société Anonyme. Several American atists, most notably Marsden Hartley and Man Ray, were among the founding figures. Hartley and Man Ray had both been active in avant-garde circles of the teens— Man Ray as a leader in American Dada activities and Hartley in the orbit of Alfred Stieglitz. Duchamp invited Man Ray to join the Société Anonyme, but Ray never took an active part after the first exhibitions. Hartley, in contrast, was prominent in the programs and lectures.

Another important American artist who took a major part in the Société Anonyme was Joseph Stella, the American Futurist. He participated in the opening exhibition and appeared on the programs during the first year. Dreier held a major one-person exhibition of his paintings in January and February of 1923 and purchased some of the artist's work to help support him.[28]

Important Cubist-influenced American artists that Dreier sponsored or exhibited included John Covert, John Storrs and Jan Matulka.[29] Dreier also gave first exposure to the French-influenced geometric abstraction of Patrick Henry Bruce, Jay van Everen and James Daugherty. Thus, the American artists shown at or involved in the Société Anonyme were a disparate group that reflected the diversity of the American art world, but with a fairly consistent bias toward the more abstract artists.

When Duchamp went to Paris, and Dreier on a trip to China in 1921 to 1922, the activity of the Société Anonyme stopped with the exception of a major travelling exhibition seen in Worcester, Detroit and other cities. Dreier returned in 1923 and reactivated the group, creating a series of outstanding one-person exhibitions devoted to such major figures as Wassily Kandinsky, Paul Klee, Heinrich Campendonk and Fernand Léger. The culminating event of the 1920s for the Société Anonyme was the International Exhibition of Modern Art in 1926, an extraordinary cross section of the most recent art from Europe. The predominance of abstract artists, ranging from the first American showing of Joan Miró and Piet Mondrian to the more familiar Kandinsky, was a significant development for modern art in New York.[30]

Dreier's own interpretation of modern art pervaded the organization. While the Société Anonyme publications featured catalogs by Christian Brinton, Walter Pach and other major writers, Dreier's explanation of the meaning of art revealed the underlying motivation for her organization. Although she wrote many essays, her 1923 book *Western Art and the New Era* is her longest theoretical argument. In it she traced the history of modern art from "the Byzantine to Post-Impressionism" followed by several chapters on "modern art." Her study emphasized the idea of "spiritual laws" as the basis of all art from the first tools to the most recent modern art.[31] She spoke of the importance of "the essence" more than the externals of life and art,[32] and of the need to reintegrate art and life to create an art that reflected the "spirit of the people of today, their love of power and speed, the spirit of freedom as well as the spirit of slavery."[33] Dreier's reiteration of the spiritual as the basis for art was influenced by her admiration for Kandinsky's ideas, as is seen in this passage:

It was because man had to give expression to an inner need which at first could be expressed only through feeling that the arts came into being.[34]

Yet, she also referred to the importance of the mind, perhaps as a result of her close relationship to the cerebral Duchamp.

Dreier's overriding purpose in her book, her lectures and in the Société Anonyme exhibitions and catalogs was to enlighten the unseeing masses who did not understand the new art because of their inability to see beyond externals. Although close to American critics in opposing a purely mimetic approach to art, Dreier's acceptance of completely abstract art was unusual. She made abstract art understandable by interpreting it as a moral endeavor that could enlighten and uplift the public. Underlying her acceptance of abstract art was her belief in the power of the spirit:

> All new impetus in the arts ... springs from a desire to recall the spirit of life which has fled: to introduce those new forces which are leaving their vital influence on the people of this day.[35]

It was her fervent belief in the spirit that was the central motivation for Dreier. That belief made her a major force in proselytizing for modern art as if it were a born-again religion.

Jane Heap and The Little Review

Even more radical, if less organized, than the Société Anonyme was the *Little Review* magazine and gallery. The gallery displayed Dada and Constructivist work as an adjunct to the activities of the *Little Review* from 1924. The magazine established its avant-garde reputation in the teens by publishing James Joyce's *Ulysses* for the first time.[36] The director of the gallery and editor of the magazine after 1923 was Jane Heap. Heap briefly attended art school at the Chicago Art Institute in the teens, then joined the *Little Review* as coeditor in 1916.[37] When Margaret Anderson, the founder and editor of the magazine, decided to settle permanently in Europe in 1923, Heap continued running the *Little Review* herself. She presented the Dadas, Constructivists and Surrealists.

Heap's activities complemented those of Dreier on some occasions. In the fall of 1922 the *Little Review* presented a Stella number that announced on the inside of the front cover Stella's one-person exhibition at the Société Anonyme. A more obvious collaboration was the publication of Guillaume Apollinaire's *Aesthetic Meditations* which was translated by the chair of the library committee of the Société Anonyme and published by the *Little Review*.[38]

Despite these connections, Dreier and Heap could not have been more different. While Dreier presented a heavy, philosophical interpretation for the radical work she sponsored, Heap generally let the work stand by itself or offered a comment by the artist. She wrote in the magazine only occasionally.

Heap made several major contributions to the introduction of modern art in America. She presented the first English translation of Fernand Léger's seminal essay "The Aesthetics of the Machine," in 1923/1924.[39] She also catalyzed the New York showing of the International Theatre Exposition, a massive display of avant-garde Constructivist theater which brought Frederick Kiesler to America in 1926 as its director. Last, she created the important Machine Age Exposition of 1927. The catalogs accompanying these two exhibitions are major documents in the introduction of modern art theory in America.[40] Heap was a perceptive supporter of the art of the 1920s. While she did not expound on it or proselytize with the religious fervor of Dreier, she played a crucial role in presenting the raw data of international modernism to America. In the closing issue of the *Little Review* Heap came closest to expressing her attitude to her work:

> For years we offered the *Little Review* as a trial-track for racers. We hoped to find artists who could run with the great artists of the past or men who could make new records. . . . I do not believe that the conditions of our life can produce men who can give us master-pieces. Master-pieces are not made from chaos. If there is confusion of life there will be confusion of art. This is in no way a criticism of the men who are working in the arts. They can only express what is here to express.[41]

Heap's comment contrasts with the spiritual bias of Dreier's writings in its blunt, matter-of-fact style. Yet, Heap's close contacts with the European avant-garde, as well as her willingness to publish their writings and display their art made her a significant, if today little documented, supporter of the avant-garde.[42]

Alfred Stieglitz

Alfred Stieglitz continued to have an important role in the art world of the 1920s. Scholars of his earlier career have virtually dismissed this period, seeing an eclipse of his significance after the closing of the 291 Gallery in 1917 and the suspension of the publication of *Camera Work,* a magazine that had presented avant-garde theory in the teens.[43] While the departure of many Europeans and avant-garde American artists from the Stieglitz entourage changed the nature of his enterprise to a more specifically American gallery for a selected group of artists, Stieglitz still had an almost hypnotic presence in the art world of the 1920s in New York. One example of the impact of his mesmerizing personality is reflected in this review by Murdoch Pemberton, the new critic of the *New Yorker:*

> Of course, we have known the legend, have read the documents. . . . We never quite believed. But rushing in to spend a few minutes viewing John Marin we stayed a couple of hours and

reluctantly dragged ourselves from the room and on our way to make a living we kept saying to ourselves 'He can't be true, he can't be true.' Even now we are a bit timid about going back. . . .

There he sits, the world's remaining philosopher, amid the jumbled Marins, content to be honest with himself and gaze upon the far off star. He has been father to the great, he has seen them come and go, and he knows no bitterness. Some of them are still with him, Dove, Hartley, Demuth, O'Keeffe, Marin. . . . Well, well, we rhapsodize; but we meant to in a way. There is always one kick to an art season and we have had ours. . . . Go if you are jaded, go if you are naive. We bet you will like it.[44]

In the early part of the decade, Mitchell Kennerley, president of the Anderson Galleries, played a key role in providing Stieglitz with an exhibition environment. Their first collaboration was an auction of the work of Marsden Hartley and James Rosenberg. Rosenberg, a wealthy lawyer and painter, was overwhelmed with Stieglitz when Kennerley introduced them:

Through Mitchell Kennerley I came to know the amazing Alfred Stieglitz, husband of Georgia O'Keeffe, champion of John Marin, Marsden Hartley and of other pioneers. When I occasionally visited Stieglitz he would hold me with his glittering eyes and pour forth torrents of brilliant talk until I fled exhausted. I wish I had had a tape recorder. . . . In 1919 Kennerley and Stieglitz cooked up the idea of persuading Hartley . . . and me to hold a joint unrestricted sale of our pictures.[45]

Thus Rosenberg and Hartley appeared together in a highly successful auction in 1921. When the auction netted over five thousand dollars, a second auction followed in February 1922. A more ambitious enterprise, the second sale included works by over thirty modern artists and realized about ten thousand dollars. Stieglitz dramatically explained the reason for the auction in the catalog introduction:

Blood had been drawn. Suddenly there appeared upon the scene innumerable American artists of the modern tendencies who looked upon auctions as their economic and spiritual salvation. . . . In view of the numerous requests for auctions, and in view of the fact that the sale of pictures through dealers and exhibitions in New York in the year 1922 is at its lowest level, the Anderson Galleries has decided to offer the Desirous Ones . . . as well as those who love to work and like fun, an opportunity to come together in friendly combat with each other and the public.[46]

Among the artists included in the auction were Charles Demuth, Morton Schamberg, Thomas Hart Benton, Charles Sheeler, John Covert and Alfred Maurer, as well as Stieglitz' usual group of Georgia O'Keeffe, Arthur Dove and John Marin. The auctions as public sales reflect the more commerical aspect of the 1920s art scene that touched even the elite Stieglitz.

Ideologically, Stieglitz was also changing. Three catalogs for exhibitions of Stieglitz' own photographs show changes in Stieglitz' art theory between

1921 and 1924.[47] The first catalog still reflected the spirit of scientific, process-oriented analysis that characterized the years of Gallery 291. Stieglitz commented in a straightforward way that "Many of my prints exist in one example only. Negatives of the earlier work have nearly all been lost or destroyed."[48] But at the end of the essay Stieglitz proclaimed that he was uninterested in aesthetic jargon, the very terminology that he sponsored as editor of *Camera Work:*

> PLEASE NOTE: In the above STATEMENT the following, fast becoming "obsolete," terms do not appear: ART, SCIENCE, BEAUTY, RELIGION, every ISM, ABSTRACTION, FORM, PLASTICITY, OBJECTIVITY, SUBJECTIVITY, OLD MASTERS, MODERN ART, PSYCHOANALYSIS, AESTHETICS, PICTORIAL PHOTOGRAPHY, DEMOCRACY, CEZANNE, '291', PROHIBITION. The term TRUTH did creep in but may be kicked out by anyone.[49]

In contrast, by 1924 Stieglitz was writing for his exhibition titled "Songs of the Sky—Secrets of the Skies as Revealed by My Camera":

> These are tiny photographs, direct revelations of a man's world in the sky—documents of eternal revelations—perhaps even a philosophy.[50]

Such a contradiction to the earlier statement reveals Stieglitz' more transcendental attitude toward art during the 1920s. It is partially a return to the Symbolist orientation that characterized his pre-291 days, but it also reflects the influence of the American poet Walt Whitman and Stieglitz' new colleagues in New York, the writers Paul Rosenfeld and Waldo Frank.[51] In seeing a spiritual significance in the literal object Stieglitz paralleled the interpretations of Dreier, but he did not base it on an awareness of abstract art, rather a feeling of the transcendent spirituality of nature.

In March 1925 the Anderson Galleries held the exhibition "Alfred Stieglitz Presents Seven Americans." The artists included were Arthur Dove, Marsden Hartley, John Marin, Charles Demuth, Paul Strand, Georgia O'Keeffe and Stieglitz himself. The catalog had a statement by Stieglitz and comments by other writers. As the *Arts* reviewer succinctly summarized the show: "emotionalism and Americanism [were] stressed on all sides."[52] The tone of the catalog was a simplistic celebration of America, written in the style of Walt Whitman's nineteenth century prose poems. While Stieglitz supported the major modern artists working in America, he never discussed their connection to European modern art.

In December 1925 Stieglitz opened the Intimate Gallery at the Anderson Galleries building, also with the support of Kennerley and the help of Paul Strand.[53] The Intimate Gallery, as stated in the announcement, was intended

for the Intimate study of Seven Americans...
 It will be in the Intimate Gallery only that the complete evolution and more important examples of these American workers can be seen and studied.
 Intimacy and Concentration, we believe, in this instance, will breed a broader appreciation. This may lead to a wider distribution of the work.
 The Intimate Gallery will be a Direct Point of Contact Between the Public and Artist. It is the Artist's Room. Alfred Stieglitz has volunteered his services. He will direct the spirit of the Room...
 All the not overtired will be welcome.[54]

Stieglitz was in the gallery all day, like a priest in his temple. He even instituted hours of silence. The exhibitions he held were of the same few artists, primarily the "Seven Americans." The concentration on one artist at a time, and the repetition, generated an extensive critical literature, as well as an understanding of the artists' development.

The religious fervor of the Stieglitz entourage appeared in a book by Herbert Seligmann which recorded Stieglitz challenging the visitors in his gallery to be "spiritual."[55] If a person offered to buy a work, he was usually quoted an outrageous price or told that the work was not for sale. Stieglitz saw his artists as a beleaguered minority on guard against a public that was hopelessly commercialized.

During the early 1920s Stieglitz also edited the magazine *MMS* (Manuscripts) which lasted for six issues from 1922 to 1923. Some issues were devoted to topics such as "What is True Art," or "Can a Photograph Have the Significance of Art," to which a large number of artists and writers addressed comment. Other issues featured miscellaneous collections of essays and poems reprinted from earlier publications. The magazine still catered to a narrow audience of intellectuals. Stieglitz had no interest in educating the masses, but the magazine did reflect his much broader contact with a network of artists and writers than characterized in his publication of the teens.[56]

Stieglitz had a heart attack in 1928 but continued to hold exhibitions at the Intimate Gallery until the Anderson Galleries building was sold. In December 1929 he opened a new gallery at 509 Madison Avenue which he called "An American Place." There Stieglitz continued to display the art of John Marin, Georgia O'Keeffe, Arthur Dove, Paul Strand and in later years, Ansel Adams. Stieglitz died in 1944, but he continued to go to his gallery until the day of his death.

Stieglitz' commitment to a particular aspect of American modern art had a permanent impact on the history of modern art in America; his activities in the twenties were more focused on a select group of artists, and therefore his particular importance more evident. He was a publicly revered figure throughout his life and familiar to an increasingly diverse audience of critics

and artists. To focus exclusively on Stieglitz' 291 Gallery is a simplification and even a distortion of his role in history.

Gertrude Vanderbilt Whitney and the Whitney Studio Club

While Katherine Dreier and Jane Heap presented the cutting edge of the European avant-garde, and Stieglitz presented his clique of outstanding American moderns, another individual was working to support a broad spectrum of less radical modern American art. Gertrude Vanderbilt Whitney, the daughter of Cornelius Vanderbilt Whitney, one of the wealthiest men in the country, sponsored a variety of art activities in the 1920s. She herself was a sculptor, but her main interest was to offer material support to young artists and give them an opportunity to show their work.[57] Whitney saw herself challenging the academy by providing an environment for young artists of non-academic tendencies.

Whitney had little abstract philosophical justification for her activities, but she contributed to the exposure given to modern art. She published only one series of articles on art which she titled "The End of America's Apprenticeship in the Arts." She proclaimed the end of American artists' dependence on European models for their architecture, sculpture, music and painting.[58] With this theme Whitney planted the seeds of an anti-European attitude in the modern art scene in America, an aspect of the Whitney activities that would emerge clearly only in the 1930s.

Whitney's main purpose was not to explain the art to the public, but as Forbes Watson characterized it at a talk, "the object [was]... essentially informal, unorthodox, liberal, human and romantic."[59] In other words Whitney was not, like Dreier, a didact on a crusade to educate the American public in the mysteries of modern art as a source of spitirual uplift. Rather, she was trying to improve the living and working conditions of the impoverished artist.

Whitney's enterprise began when she purchased four paintings from the Independent exhibition of 1908 (the so-called "ash can" artists).[60] From 1914 she began to hold exhibitions in her studio in Greenwich Village. Although at first the exhibitions were created by juries, Whitney gave purchase prizes beginning in 1917, the source of her considerable collection of art that formed the core of the Whitney Museum in 1931. The shift from juried shows may have been related to her involvement with the Society of Independent Artists.[61] In addition to exhibitions, Whitney sponsored artists in study abroad. Morgan Russell, for example, received an allowance from 1908 to 1911. She sent Stuart Davis to Paris in 1928.

Whitney promoted interaction among artists as early as 1915, when she began the Friends of Young Artists. This group included artists such as Stuart

Davis, Louis Bouché, Alexander Brook, Glenn Coleman, William Glackens and Guy Pène du Bois, a core group that remained at the center of the Whitney activities throughout the 1920s.[60] The Friends of Young Artists became the Whitney Studio Club around June 1918 when Whitney completed remodelling a space adjacent to her studio as a place for artists to relax. Whitney described her reason for setting up a library, billiard room and squash court for the artists: "I have often asked artists and students where they went when they were not working, what they did in the evenings and what library they used. The answers opened up a vista of dreariness which appalled me, revealing a terrible lack in our city's capacities."[63]

The artist-members of the club were, with only a few exceptions, not among the leading innovators in the 1920s, perhaps because artists responding to such aristocratic philanthropy were less likely to push themselves to experimental creativity. The art that the club displayed was surprisingly homogeneous. It can be characterized as mildly modern, for the most part figurative, with a slight degree of modern flattening or bright color. Artists such as Alexander Brook or Samuel Halpert knew the art of Cézanne and even Picasso, but failed to integrate modern formal principles into a sophisticated expression. The main exceptions to this aesthetic of mild modernism were Stuart Davis and Charles Sheeler, both major figures.

Juliana Force, the secretary for the Whitney art activities, figured prominently in the planning of the exhibitions. Force had no training in art, however, so relied heavily on her advisers such as Forbes Watson, Alexander Brook and Eugene Speicher. As Lloyd Goodrich later recalled, "in particular Forbes Watson, then critic of the *World,* and a leading champion of modern art and native artists, had much to do with shaping the policies of the Whitney Studio and Whitney Studio Club.[64]

Watson was also editor of the *Arts* from 1923, a magazine sponsored from that year by Mrs. Whitney. Although it was a leading publication in the presentation of modern art, its coverage of American art was heavily slanted toward the type of art shown at the Whitney Studio. While the Whitney sponsorship seems not to have influenced Watson,[65] he was clearly biased toward the art shown at the club.

Alexander Brook, director of the club's gallery from 1923 to 1928, also encouraged the support of the mildly modern artists. The exhibitions of historical note were a Stuart Davis retrospective in December 1926 and smaller displays of Konrad Cramer, Charles Sheeler, Joseph Stella and Edward Hopper.[66] There were also theme shows that were more amusing than important, such as the circus exhibition created by Louis Bouché. One endeavor that stands out among the Whitney activities is the encouragement of printmaking, a fairly new pursuit for non academic American artists.

Charles Sheeler and Marius de Zayas curated the shows that were of greatest interest. de Zayas, a former associate of Alfred Stieglitz, put together a display of Picasso and Black sculpture in May 1923 and a display of Greek sculpture in March 1925. Charles Sheeler arranged an exhibition of the paintings of Picasso, Braque, Duchamp and de Zayas in March 1924.

Even their confidantes admitted that Force and Whitney were less concerned with aesthetics than with friendship. John Sloan commented: [Whitney] might almost be said to have had very little interest in art—in art anyway as art...[s]he dealt with the producers...[Force] would sacrifice the chance of having a good exhibition in order to give someone a break, even if she knew it might be the last appearance of his work."[67] As a result of these policies, the club had 400 members with 400 on the waiting list by the time it closed in 1928. The *Art News* reported that the club was closing because "Mrs. Whitney feels the Club has fulfilled its purpose."[68] The members were asked to reorganize and make the club self-supporting. From 1928 to 1930 the Whitney Studio Gallery held exhibitions of a more selective type.

Carl Zigrosser, director of the Weyhe Gallery in the 1920s, commented in his autobiography on the changing temper of the club during the decade, mentioning that the parties accompanying the openings of the exhibitions became increasingly wild. Juliana Force was initially "natural, warm and outgoing." Later, the strain of being a "buffer between Gertrude Vanderbilt Whitney and a horde of hungry artists began to leave its mark. She became artful and politic in an artificial world of indirection and deceit—outwardly *toujours la politisse,* but inwardly a cut throat game indeed."[69]

The Whitney Museum of American Art opened in November 1931. A statement issued at that time claimed that the museum would include the "new and experimental" and look at "universal rather than national values."[70] The reality was that the Whitney collection, as seen in the works held by 1931, was still mildly modern and American. This conservative aspect was obscured by the critics' enthusiasm for the type of art that Whitney sponsored.

Forbes Watson wrote in 1927 that "the Whitney Club has done more than any other single institution to bring to the notice of the public, the creative, younger artists."[71] He also claimed that the club was "a place that no one who wishes to be in touch with what the younger artists are thinking about and doing can afford to overlook....[There is] a note of endeavor and excitement...freshness and variety."[72] Writers for other periodicals also celebrated the club. The *Art News* wrote that the large Tenth Annual exhibition held at the Anderson Galleries in 1925 was "as adequately representative of what the younger and more 'modern' artists are doing as has been offered in New York."[73] Guy Eglington, an editor of *Art News,* parodied the "Modernistic Gloom at the Whitney Club."[74] Henry McBride writing for the *Dial* commented that a "whiff of fresh air was let into the stuffy parlors

usually occupied by the Academicians, and the group that did the trick could be recognized . . . as the Whitney Studio Club."[75]

McBride, one of the most astute critics of the 1920s, struck exactly the right tone in this article, for Whitney's main contribution to the exposure given to modernism in the 1920s was support of the middle-of-the-road art that was neither at the cutting edge of the avant-garde, nor the late Impressionist academics. Her artists were struggling with the new lessons of modern structural principals without fully moving away from an almost pedantic handling of the composition.

Yet, despite her conservatism with respect to modern art, Gertrude Whitney was committed to the idea of artistic independence, to providing the opportunity to show work, and to encouraging younger artists by means of purchase. Therein lies the importance of her endeavor in the context of the support and responses to modern art in the 1920s. For Whitney, "modern," meant freedom to be individual. She had no real understanding of the profound pictorial revolution that was the basis for the modern movement. She believed in the opportunity for artists to exhibit and interact, and she provided an alternative to academic taste for an audience and a group of artists who did not understand the activities of Dreier, Heap, and perhaps even Stieglitz.

Stephan Bourgeois

Although Stephan Bourgeois was a commercial dealer, in his personal style he was closer to Alfred Stieglitz. He had strong convictions about the art that he showed that connected it to a spiritual experience. The son of a German art dealer, Bourgeois came to the United States in 1911. His first recorded exhibition, titled "Exposition des tableaux anciens et modernes," held in February 1914, featured a miscellaneous group of Japanese prints, and paintings by Manet, Monet, Van Gogh, Cézanne, El Greco and others. In 1916 he instituted an annual exhibition of modern art and began publishing more substantial catalogs, as well as inviting artists to select exhibitions.

Bourgeois' exhibitions included some of the most avant-garde artists then working in New York, such as Francis Picabia, Man Ray and Morton Schamberg. Bourgeois first showed Gaston Lachaise's sculpture, gave Joseph Stella a major retrospective in 1920 and presented experimental stage designs. He also exhibited children's art, Edvard Munch and oriental art. In group exhibitions of American artists until 1923, he featured such little known moderns as Stephan Hirsch, Arnold Friedman and Emile Branchard. Bourgeois' final group exhibition was held in 1929. The gallery closed during the depression.

The role that Bourgeois played in the support of modern art was more ephemeral than that of Stieglitz, but his philosophy was similarly mystical. In

his writings he focused on the importance of the mind as the life spirit directly expressed in art. In 1917 Bourgeois wrote simply of the correspondence between artists and the condition of the world: "younger artists ... are capable of recognizing the direction of the world's thought [and] seize upon those elements of it that admit of development."[76] Bourgeois' thinking was influenced in the late teens by artists such as Albert Gleizes and Oscar Bluemner[77] who wrote catalog essays for Bourgeois' exhibitions. Gleizes emphasized the collective, nonindividual approach to art. Bluemner, a peripheral member of the Stieglitz entourage, wrote about the elements of modern art in abstract terms.[78] Jennings Tofel, a lesser known writer today, wrote several catalogs for Bourgeois, as well as essays for the Société Anonyme. He commented on the universality of the modern vision.[79]

For Bourgeois, the mind was not analytical, but the area of dreams. He advocated a mystical approach to understanding art that allied him with Taoist philosophy.[80] He certainly also knew the writings of Wassily Kandinsky, for he often used the term "inner necessity" and used analogies between art and music.[81] Bourgeois adopted an evolutionary approach to the development of art:

> The growth and decline of art from the spontaneous efflorescence of the spirit, through the dance of the senses to intellectual combinations of form and color, is now visible like a thread which binds the beginning to the end.[82]

Yet, he also saw the importance of a balance of the intuitive and the intellect. He believed that artists must have "patience ... [to] wait until a work gives itself to us and helps us to overcome all those inhibitions of our emotions and that lack of intuitive experience which prevents us from reaching its meaning easily."[83] Bourgeois saw children's art, primitive art and folk art as a direct expression of a mental reality. The best art ignored the superficial materialism of nature's outward form and expressed the inner life spirit. In these ideas Bourgeois was close to not only Stieglitz, but also to Dreier.

In 1928 Bourgeois wrote a modified history of modern art for a catalog of modern French painting and sculpture. He analyzed the importance of the major artists, using his own perspective and terminology. Of Cézanne, he commented:

> we can already measure in this early work the importance of the courageous step he took in laying the accentuation on characterization and drama. ... He realized the necessity of identifying himself with his subject from the inside and following out its plastic logic.[84]

Here, Bourgeois combined his interest in Eastern mysticism and Western Expressionism to formulate an original interpretation of Cézanne. Such an endeavor is characteristic of the 1920s before the canons of modern work had been clearly formulated.

Bourgeois' intellectual convictions were stronger than his connoisseurship. Consequently, his exhibitions focused on eccentric combinations of artists whom he saw as being in tune with his philosophy.[85] That most of his American moderns are today little known is perhaps an accident of history that needs to be reexamined. He had a special place in the art world of the 1920s as evidenced by the loyalty with which other critics and artists refer to him. There is, however, a lack of documentation on Bourgeois, for unlike Stieglitz, he was not the center of a cult, so his words and deeds were not tirelessly recorded.

Charles Daniel

Louis Bouché, in his reminiscences, commented that "the Daniel Gallery...displayed most of the budding talent."[86] Charles Daniel was a café proprietor when he became acquainted with artists as patrons of his drinking establishment. Glenn Coleman, one of those patrons, began taking him to galleries around 1906. Daniel recalled later that "at first I was considerably bothered because I was used to the photographic kind of art, but I was eager to learn."[87] Emily Farnham, Charles Demuth's biographer, records, perhaps apocryphally, that Daniel's collection began when he accepted paintings by Ernst Lawson in lieu of payment of his bar bill.[88] Daniel became interested in John Marin as early as 1910, during a visit to Stieglitz' 291 Gallery.[89] By the time he opened his own gallery in December 1913, he had acquired works by most of the well known modern artists, as well as many who have since been obscured by time.

Daniel's assistant, Alanson Hartpence, was a part of the avant-garde group that gathered around the *Others* poetry magazine in the teens.[90] As a close friend of Hartley's, he had met Daniel at the Stieglitz Gallery. The circumstance of his appointment as Daniel's assistant has not been recorded, but clearly Hartpence was responsible for Daniel's showing the avant-garde art of Man Ray for the first time.[91] Hartpence may actually have set the tone for all of Daniel's modern exhibitions, although more research on this elusive figure remains to be done. McCausland describes Hartpence as a tempering influence on Daniel's enthusiasm.[92] Man Ray claims that he was the "guiding spirit of the gallery."[93]

Although Daniel had been an early patron of Stieglitz' artists, he had a peculiar relation with the other dealer. Daniel's more commercial, unintellectual attitude to art would certainly not have endeared him to

Stieglitz. In conversations recorded by Herbert Seligmann, Stieglitz refers to Daniel with scorn and sarcasm.[94] This attitude may simply be a result of professional jealousy, because Daniel carried many of Stieglitz' artists and gave them regular exhibitions, particularly when the Stieglitz gallery was closed from 1917 to 1925. His support allowed Marsden Hartley to paint in New Mexico for a year in 1918. Charles Demuth was associated with both Daniel and Stieglitz. From 1914 to 1923 he showed at the Daniel Gallery, exhibitions which established his reputation. Although Stieglitz and Demuth were already corresponding during those years, Demuth did not join Stieglitz until 1925 in the "Seven Americans" exhibition.

Daniel's non-intellectual approach to his exhibitions contrasted markedly with Stieglitz' approach. He never analyzed work or even published brief catalog notes; he simply presented a checklist. Daniel's commercial success also contrasted to Stieglitz' anticommercialism. Daniel sold many of the Stieglitz artists to major collectors such as Duncan Phillips, Lillie Bliss, Albert Barnes, Abby Rockefeller and most importantly, Ferdinand Howald. Howald, an engineer from Ohio, supported the gallery with his purchases of American art.[95] Daniel described Howald in his reminiscences as

> someone sent from Heaven . . . Retired from business in 1908 at the age of 50, he was free and he had a growing interest in art. In the early days of the gallery he was the only collector who would buy. The others dawdled and hemmed around, but Mr. Howald was there and bought. He made a wonderful collection.[96]

The Howald collection provides a record of the major artists of the Daniel Gallery.[97] The centerpiece of the gallery were the Immaculates, as they were called in the 1920s; today the group is commonly identified as the Precisionists. They include Charles Demuth, Charles Scheeler, Preston Dickinson, Niles Spencer, Karl Knaths, Henry Billings, Elsie Driggs, George Ault and Stephan Hirsch. All of these artists are included in the Howald collection.

Daniel, primarily committed to American art, juxtaposed the Immaculates with his other favorite artists, the "ash can" group that includes Ernst Lawson, William Glackens, Robert Henri and George Bellows. Daniel's unintellectual, pragmatic approach to art dealing suited the American artists he featured in his gallery. McBride summarized the goal of the Daniel Gallery in a review of 1929: "the Daniel Gallery has a commendable ambition. It aims to forward what is rare and distinguished in the local production and to stake its all upon what is local."[98]

One of Daniel's strengths was his open-minded attitude to little-known artists throughout his career. When Albert Bloch, then a little-known painter, returned from Germany in 1921, Daniel gave him his first one-person show. Daniel also first showed Yasuo Kuniyoshi's eccentric combinations of fantasy

and modernism in 1923. Even more bold was Daniel's support of the first exhibition of the important Blue Four group of Expressionists in February 1925, a departure from his usual emphasis on Americans.

Art critics received Daniel's exhibitions favorably. Even the academic critic Royal Cortissoz praised the work of the avant-garde artist Charles Demuth when he saw his watercolors at Daniel's gallery. Cortissoz divided the Daniel exhibitions into two categories, the progressive and the advanced. The progressives were ash can artists; the advanced were artists like Demuth.[99]

Another moderate critic who was supportive of Daniel was Murdock Pemberton, the *New Yorker* art critic. Daniel acknowledged Pemberton in his own reminiscences, commenting that "Pemberton of *The New Yorker* gave me some splendid articles. He didn't know too much about art, but he'd been around the theatre, he knew life, he had horse sense and he could see thru [*sic*] things. He once said to me, if you were in any other business you'd be a millionaire."[100] Pemberton recalled in his own memoirs that "Daniel probably never made a nickel out of art. He was that rare genius—a patron-dealer who came to art only for the love of it."[101] Pemberton's loyalty to Daniel appeared in a review of Daniel's artists when they turned up at another gallery in 1926:

> In theatrical circles when Ethel Barrymore takes a flier under new auspices...the program notes that her appearance is permitted by courtesy of her manager. There are no program notes about Charles Demuth, Yasuo Kuniyoshi and Niles Spencer, so we take it that these young Americans have been lent for the occasion by that infallible genius at discovery— Daniel. We confess we were a little surprised at finding these chicks out from under the parental wing, artists being so hard to find these days.[102]

The Immaculates that Daniel was the first to display as a group, as well as the other individual artists that he supported, remained identified with his patronage during the 1920s. Daniel's straightforward atmosphere made these modern artists accessible and understandable. While Daniel did form personal ties with the artists, he never concerned himself with intellectualizing their work in a philosophical way, an approach well suited to the art that he supported.

Brief Notes on Other Galleries and Groups

N.E. Montross

Newman E. Montross occassionally showed modern art from the time of the Armory Show in 1913. At the end of the nineteenth century, he was identified with The Ten, an Impressionist group, at that time a progressive direction in the American art world. In the mid-teens Montross made a shift to modern art

with an exhibition of Matisse in February 1915 and Cézanne in January 1916. As a result of this shift, The Ten left the Montross Gallery. Montross then turned to twentieth century American art combining the ash can artists, the Stieglitz group and the Armory Show artists such as Walt Kuhn and Arthur B. Davies. His shows often featured drawings or watercolors, but he usually mixed different styles; for example, combining Charles Burchfield, Arthur B. Davies and Charles Demuth in a single display. This mixing of different styles of modern art was common among many of the galleries of the 1920s that showed only a few modern artists. Montross also offered financial support to artists, although he was quieter about these activities than was Stieglitz or Whitney.

Marius de Zayas: The Modern Gallery and the de Zayas Gallery

Marius de Zayas played a minor role in the 1920s, but he justifies a brief discussion. De Zayas' most signficant contribution to the articulation of modern art theory and the display of painting and sculpture occurred between 1910 and 1918. He was affiliated with Stieglitz from 1909 and close enough to Picasso by 1911 to arrange the first New York display of Picasso's work. De Zayas' book, *A Study of the Modern Evolution of Plastic Expression,* of 1913 was based on the idea that "the religion of today is science and the modern movement in art reflects this characteristic intellectual and analytical attitude of mind."[103] He viewed emotional art as from an earlier stage of evolution, but believed that the modern artist needed to look at it to be inspired. Modern artists needed to achieve the same intensity to express in formal terms the psychology and metaphysics of the modern world.

In 1915 de Zayas broke with Stieglitz in order to establish a more commercial environment for the sale of modern art.[104] His Modern Gallery displayed a stunning sequence of works by all the major artists from Cézanne to Picabia, as well as important exhibitions of African sculpture and some earlier European art.[105] In 1920 de Zayas tried to refinance his gallery through a sale of graphic work at the Anderson Galleries, but by April 1921 his gallery had closed. During the final 1920-21 season he held a series of one-person exhibitions of Charles Sheeler, Walt Kuhn, Paul Gauguin, John Covert, Henri Rousseau and Arthur Davies, interspersed with Chinese sculpture and group shows. His theoretical ideas in the 1920s were consistent with his 1913 book.[106]

Following the closing of the gallery, de Zayas organized several large international exhibitions. One show seen in London, Paris and New York, and sponsored by the prestigious Durand-Ruel Gallery, included a cross section of schools from the most conservative to the avant-garde. De Zayas' support for these large, popular exhibitions reflected his personal shift away from the elite

intellectualism of the Stieglitz circle, as well as the changing atmosphere of the gallery world in the 1920s.[107]

The Weyhe Gallery

Carl Zigrosser directed the Weyhe Gallery from 1919 to 1940. Located above the Weyhe Bookstore, it has been in the same location since 1923. While Weyhe himself sold antiquarian books, Zigrosser developed the gallery with a focus on modern prints; the first of its kind in New York. Zigrosser served an apprenticeship at the Keppel Gallery from 1912 to 1918, while also publishing a magazine "Devoted to Libertarian Ideas in Education." Initially, Zigrosser was hesitant about accepting the most recent modern art, particularly Cubism, but during his tenure as gallery director he became a supporter of the avant-garde. In 1923 Zigrosser visited the Bauhaus and purchased the first graphics portfolio published by Lyonel Feininger.[108] Zigrosser, unlike many dealers in the 1920s, was open to both German and French art.

The Weyhe's primary contribution to the support of modernism was to establish the importance of modern printmaking as an alternative to the conservative style of artists such as Seymour Hayden and Joseph Pennell. Zigrosser explained his goal in his autobiography:

> To one nurtured to appreciate only the charm of the etched line, works slanted toward realism or experimentation in design seemed, if not ugly, at least strange and repellent. Therefore the task confronting the Gallery was to educate an entirely new public to respond to the work of the young creative artist, rather than of the technically competent craftsman.[109]

Zigrosser wrote leaflets to encourage the public to buy the work of younger artists, indicating that he was not supporting a special clique, but interested in "searchers."[110] Post-Impressionism, Expressionism and the Mexican School all appeared at the Weyhe. The American printmakers included the ash can artists and the Whitney Studio circle.

The Weyhe also pioneered the idea of publishing editions of sculpture. Some of the artists supported through this program were Aristide Maillol, Gaston Lachaise, and John Flannagan. In 1924 the Weyhe created a sensation in the art world by purchasing the entire contents of Alfred Maurer's studio.[111] Weyhe's other activities included the production of lavish portfolios and monographs. The gallery also sponsored a trip to the United States for the eminent German art critic, Julius Meier-Graefe, on the occasion of his sixtieth birthday.

During the 1920s Zigrosser made the Weyhe "a real meeting place of the old and new, of the art lover of conservative taste and the modernist."[112]

Although innovative and creative in the 1920s, the gallery became less exploratory in the 1930s when finances were more restricted. In 1941 Zigrosser became curator of prints at the Philadelphia Museum. His success as curator of a small, unknown gallery was certainly confirmed by the museum appointment and underlines the important role that galleries played in the 1920s as a training ground for the next generation of museum curators committed to modern art.

The New Gallery

The New Gallery of James Rosenberg lasted for only two seasons from 1922 to 1924. Rosenberg, a wealthy and successful lawyer, had been peripherally involved with the art world since the mid teens as both a painter and writer. He opened a gallery to introduce important, unknown artists to the American art market.[113] The editor of Rosenberg's papers celebrates the lawyer's support of modern art as motivated by a desire to stimulate popular interest: "Rosenberg was ... interested, not in private gain, but in the public appreciation of these modern paintings."[114]

The curatorial aspect of the New Gallery was haphazard, with no distinctive artist or group emphasized, but rather a mixed selection of modern artists who were also available at other galleries. A few obscure Europeans were also shown.[115] Yet, Rosenberg himself acted with a sense of the pioneer. He said in his summary of the gallery's first season, "the New Gallery has been frankly an experiment to ascertain whether there is a public ready to take an interest in contemporary pictures which are something more than slick and servile patterns of the past."[116] That sense of risk and adventure, almost of proselytizing, gives Rosenberg a place beside major figures such as Dreier. Like her, he wished to enlighten people, although he did not have the sophistication and intellectual background of the leader of the Société Anonyme. But he was inherently a product of the spirit of the 1920s in his motivations and his aspirations.

Belmaison Gallery

John Wanamaker's department store sponsored the Belmaison Gallery of Decorative Arts as a means of attracting business to its decorating department. Wanamaker's had a tradition of sponsoring concerts for advertising and publicity, and had long had a representative in Paris supplying works of art to the store for sale. The director of the decorating division, Ruby Goodenow, hired the artist Louis Bouché to run the art gallery in 1922.

Bouché had been slightly involved with the avant-garde Arensberg Salon during the late teens, but he was primarily affiliated with the artists of the Whitney Studio Club like Alexander Brook and Walt Kuhn. These same artists

came together in the summer at the Woodstock community and at the Penguin Club, a creation of Walt Kuhn that specialized more in parties than in art.[117] Bouché's own art adopted the use of Nottingham lace in a decorative Cubist style. As an artist, he easily understood contemporary art, or "living" art as it was often called in the twenties. He accepted modern art up to Dada, and even enjoyed the humor of that movement without adopting its extreme implications in his own work.

The exhibitions that he planned for the Belmaison were not theoretically oriented or accompanied by pedantic catalogs, but were often simply a presentation of the School of Paris and recent American art. In 1923 he wrote a catalog introduction that gives an insight into his perspective on the gallery and the status of modern art in general. It documents the assimilation of modern art and awareness of the new French classicism:

> New York is now familiar with the work of the Modern French painters and has weathered the invasion of the "Fauves." Cézanne, Matisse and Picasso are familiar names.
>
> These radiant stars have long been acknowledged masters of their art and cannot be looked upon as young bloods. There will be a time possibly not far distant when their likenesses will be seen in our Sunday papers, grey-bearded and bespectacled.
>
> Who are the French painters of today? The question is answered by our present exhibitions in which may be found some of the most interesting paintings of the younger group. Their incentives and their direction may be studied from what they have sent us.
>
> The Fauve has been tamed and, from the present outlook, muzzles and iron cages can be dispensed with. The younger generation has turned to a realism à la Ingres.[118]

Some of his exhibitions were experimental. One group show included Natalia Goncharova and Mikhail Larionov, the Russian Cubo-Futurists, apparently for the first time in this country.[119] Another included Giorgio de Chirico in his earliest recorded display.[120] The Belmaison also was famous for its theme shows on topics such as sports or the city of New York, but more important was the display of such objects as wool ship pictures, ship models, scrimshaw and marine artifacts, Epinal prints, and early maps. Appropriately, as an adjunct to the decorating department, the gallery also included decorative screens and murals by the leading artists in New York.

The atmosphere at Belmaison was anti-elitist and humorous, in contrast to the pretentiousness of some other environments for the showing of modern art. Forbes Watson commented in one headline "Stodgy Routine Unknown to Belmaison—Bouché Objects to Boring Visitors to his Gallery."[121] While Bouché's tenure at the gallery ended in 1927, the work that he did there made a significant contribution to the exposure given to modern art. Because of his many contacts in the art world, his exhibitions received good coverage. The placement of the gallery in a department store was a pioneering idea that brought modern art to a new audience. Other department stores, such as R.H.

Macy's and Lord and Taylor's participated in the display of modern art later in the decade.

J.B. Neumann

Joseph B. Neumann's several art galleries are a significant chapter in twentieth century modern art that deserve a detailed study, but only the briefest summary of his background, philosophy and activities in New York can be included here. When Neumann came to New York in 1923, he had already been a sponsor of experimental art in Germany for thirteen years. His first bookstore and art gallery opened in Berlin in 1910. The store was, from around 1913, "a permanent continuation on a smaller scale of the International Exhibition of the Sonderbund in Cologne."[122] He became particularly identified with Die Brücke artists from the early teens. In addition, the Dada artists staged events in his gallery.[123] By 1922 he had established branch galleries in Bremen, Düsseldorf and Munich, but emigrated to the United State in 1923. His move coincided with the large German Expressionist exhibition in New York, as well as the worst period of inflation in Germany, but his specific motivation has not been recorded.

The print room and bookshop that Neumann opened in 1924 on 57th Street had the motto on the window: To Love Art Truly Means to Improve Life.[124] Neumann was committed to bringing modern European art to America, as well as to supporting younger artists, a tradition that he had begun with his patronage of Die Brücke. He wanted to sponsor the "new generation of progressive American artists." He explained the result:

> Over a period of 37 years I backed up my conviction with numerous exhibitions in my gallery. At the same time I made extensive purchases of the artists' work. I was activated not by commercial consideration (as an experienced art dealer I knew that no quick profits could be wrung out of young contemporaries), but rather by the belief that in the long run my faith in these artists would be justified and my judgement upheld.[125]

His circular for the summer of 1925 promoted both American and German writers in "changing and permanent exhibitions." The American artists included Stieglitz and Whitney artists, along with a variety of names unfamiliar even today. The Europeans were artists like Georges Rouault, Max Beckmann, and others, whom he had shown in Germany. The exhibitions featured the American artists, however, perhaps to draw in the New Yorkers with familiar names. Later in the decade the names became increasingly obscure. Neumann was adamant about exploration:

> At no time have we been content to pander to tradition or fashion, regardless of whether these spurious forms of appreciation have now and then by chance, aligned themselves with

art movements of value. . . . [T]here is but one art, . . . modernity or antiquity in itself neither makes nor destroys it.[126]

With that attitude he was able to show both ancient and modern work, primitive and European, prints and paintings. He believed that all the arts were interrelated, that a connection could be found between all expressions; thus, his shows were intentionally miscellaneous. That seemingly haphazard effect was reinforced by scattered philosophical quotes in his *Artlover,* a pamphlet that provided a vaguely literary context for the shows.

Murdock Pemberton gave Neumann numerous favorable reviews in the *New Yorker.* Toward the beginning of Neumann's activities he wrote in a statement reprinted later in the *Artlover* pamphlet:

> One thing Mr. Neumann has that you seldom found in other dealers: an interest in the painters over and above the square of canvas they had used as the medium of their dreams. . . . He went back always to that pleading the case for the soul of the artists. If the artist was sometimes inarticulate, Neumann would translate that idiom; if the artist faltered in his vision, Neumann was there to project [his] idea.[127]

Neumann's committment to the young American artists was accompanied by his desire to present the German Expressionists. In October 1926 he held a major Expressionist show. Max Beckmann's paintings were first shown in a major display in America in April 1927.

At the time of the founding of the Museum of Modern Art in 1929, Neuman finally emerged as an influential person in the art world in New York. In his correspondence he claimed to have hung the second exhibition at the Museum and to be coordinating the German exhibition at the Museum. He also claimed to be influential with Mrs. John D. Rockefeller.[128] During the 1930s his exhibitions were more concentrated on German art; he became Kandinsky's agent in America. He also gave lectures on the topic of "living art" that preached his idea that the modern spirit was present in all art.

One of Neumann's goals for the gallery had been to create a New Art Circle, a group of modern artists who would band together for the common cause of modern art. This "circle" never materialized, perhaps because there were already so many other groups in New York by the time he arrived. In addition, his exhibitions were only occasionally reviewed, except by Pemberton, or reviewed negatively. The coverage of Bouché's Belmaison was far more extensive than Neumann's New Art Circle, although Neumann's shows were equally important. Neumann, a respected and important dealer in Europe, until the 1930s lacked the political contacts to penetrate the strong networks of artists and activities that were already established at the time of his arrival in New York.

Neumann took his activity seriously, as reflected in his *Artlover* pamphlets and his correspondence. Yet, many of his New York artists have fallen into obscurity despite his expertise in finding young talent. Unfortunately no Neue Sezession or Die Brücke equivalents emerged at the Neumann gallery in the 1920s. Murdock Pemberton alone captured the spirit of the enterprise in his description of Neumann's response to America:

> No immigrant gazing at the skyline of the harbor was more enthused than J.B. Neumann entering the American market. He seemed to have been reared on the stories of the Sunday supplements and the latter day Horatio Alger sagas...
> ...[He was] sometimes brooding and quizzical. Why was it that this great land that produced such great bridges, such great projects, could not produce an appreciation of art?... Neumann had a few patrons, but he could count them on his hand. The country was teeming, bursting with genius, but no one seemed to be aware of it. And Neumann would drag out from some East Side garret another tortured soul that he had great faith in, but that the public could not stomach.[129]

Joseph Brummer

Joseph Brummer showed modern art erratically. Primarily a dealer in Greek, Romanesque and Gothic sculpture, Brummer played a small role in the sponsoring of modern art in America. He showed the group known as the Modern Artists of America, Inc. They included the same Whitney group of active moderns mentioned so often, along with the more avant-garde artists Abraham Walkowitz and Alfred Maurer. Bernard Karfiol was an artist in whom Brummer had a particular interest. Karfiol was one of the most conservative artists to be influenced by modern structural theories, but he was very popular in the 1920s. He had even been a protégé of Hamilton Easter Field, editor of the *Arts*. Brummer gave him four one-person shows in seven years, more than he devoted to any other artist. Other major exhibitions of modern art at Brummer's were Matisse (March 1924), Seurat (December 1924), Maillol (January 1926) and Brancusi (December 1926). Brummer's background as an apprentice stonecutter in Rodin's Paris studio and a student in Matisse's class oriented him toward European art, particularly sculpture. He saw himself as intermediary between the artist and the public. His shows usually had catalogs with his reminiscences about his life in Europe, or major statements by important writers such as Walter Pach, Andre Salmon and Waldemar George.[130]

Frank Rehn

One other gallery that ventured into some sponsorship of modern art while remaining basically conservative, was the Frank Rehn Gallery. Established by

the son of an academician, the gallery had already made a reputation with conservative collectors by 1920. On the other hand, Rehn supported Edward Hopper and Charles Burchfield in the 1920s, enabling both artists to give up commerical jobs and be full time artists. While these artists were not part of any of the avant-garde or even semi-modern groups, they played a significant role in twentieth century American art.[131]

Other Galleries

A trio of older galleries, Knoedler's, Kraushaar's and Wildenstein's, began to display modern art in the 1920s. Knoedler's showed the fewest artists, although it did sponsor Elie Nadelman, one of the finest sculptors to emerge during the decade. Kraushaar initially had "modern" shows that featured John Sloan and Jerome Myers, but made a committment to Abraham Walkowitz in 1924. The exhibitions were haphazard, mixing artists of various styles as in the 1927 show that included Charles Demuth, Pablo Picasso, Georges Braque, Abraham Walkowitz and William Zorach.

The prestigious Wildenstein Gallery had strong French contacts that led to the display of Paul Rosenberg's collection of Post-Impressionists in 1923 and 1927. Its favorite American artist was the conservative Rockwell Kent. Wildenstein showed a group of sixty Picasso drawings in December 1927 that was particularly outstanding.

Durand-Ruel, like Wildenstein, was basically a European operation. The only departure from its dedication to French Impressionism was the George Bellows Memorial in 1925. Bellows died abruptly in 1925 and was widely honored by conservative institutions, including the Metropolitan.

Modern art was occasionally displayed in other places such as the galleries of Reinhardt, Sterner, Scott and Fowles, Fearon, Keppel, De Hauke, Dudensing, Valentine and even the Junior League. Modern art, after Impressionism, was thus increasingly available as the 1920s progressed, sponsored by an ever more diverse group of galleries. Some dealers presented modernism with a heavy philosophical explanation, others mixed it with various styles, but all reflected an increasing interest and concern for the phenomenon of modern art.

The awareness of modernism spread to the most conservative dealers by the end of the 1920s, but gradually became mixed with a concern for the status of modern American art. This issue was highlighted by a series of articles in the *Art News* in October 1924. The editors asked a cross section of commercial dealers to express their opinions about the condition of modernism. The appearance of the series was a form of promotion for modern art. One conservative, Howard Young, saw art becoming more sane:

The public did not follow the extremists and the extremists have come back to a more sane foundation where the public can see them better.... Picasso and Derain are among those who are painting more intelligibly and I might name several Americans in the same class who have given up the idea of painting as a *tour de force* and are seeking to express themselves in works of strength and beauty.[132]

Milch, a specialist in American Art, also saw a shift to conservative directions:

I see a tendency on the part of several well-known painters who have been quite radical to paint more—well, sanely....[Picasso] advertised himself by painting radically and when people wanted his advertised name on portraits which they insisted should look like their subjects, he obliged them by going back to the classic manner.[133]

Rehn promoted American art, but his statement demonstrated a subtle perspective:

This country is no longer so peculiarly and so succulently...[the Frenchman's] oyster. Our critical faculties are laying aside their foreign swaddling clothes. Mr. and Mrs. Average American are taking an interest... So-called modern art has been a big factor in this change. It has shocked people into convictions, shaken others out of ruts and largely dissipated the humble-of-course-I-know-nothing-about-art attitude as though art was a thing apart from life and not a matter of emotion, perception and reaction like all the rest of existence.[134]

Among the dealers more oriented to modern art Dudensing supported the contemporary artists, but claimed the death of Cubism despite the fact that it "served a good purpose by emphasizing form and composition and the abstract." He went on to say that "mere brushwork or painting done for experimental purposes will not endure."[135] Montross primarily supported Cézanne, Matisse and Van Gogh; the New Gallery opposed the idea of the decline of modern art:

It is not only here to stay, but it is influencing the academic painters to paint more broadly so that the Academician is coming toward Modernism, instead of Modernism surrendering any of the ground it has won.[136]

Daniel made the most vehement statement in favor of modern art:

[Modernistic art] is more alive than ever. All great art was modernistic when created because real art is always original...[T]he demand for striking, original, modernistic paintings and sculptures will be greater than ever this year.

Modernistic art is here to stay.... Academic painters don't approve it because academic painters work according to formula. And it is easier to work that way and please a public...that does not like to be surprised. Modernistic art requires imagination and invention.[137]

The series of articles is only one indication of the widespread discussion of the importance of modern art, its decline or change, its significance or meaninglessness, that appeared in the newspapers and magazines of the 1920s. While the motive of the *Art News* was to document the financial security of investing in modern, particularly American, art, the series also reflected how dealers were more than just businessmen in those years. The dealers consulted were virtually assuming the role of curators of modern art, for no such curatorial expertise had yet been developed. The interlacing of commercial, philanthropic, and philosophical motives in the showing of modern art created a unique atmosphere. It complemented the criticism of the official art columns with a veritable flood of shows and statements.

Artists' Groups

Artists' groups further increased the exposure of modern art provided by dealers. Most of these groups were intended to promote modern art in a non-commercial environment. The Whitney Studio Club, already discussed, was the most vocal and longest lasting of these groups. Other groups frequently included some of the same artists, such as The Modern Artists of America (loosely connected to the Brummer Gallery) and The New Society of Painters. The New Society, one of the most conservative groups, was predominantly the ash can artists.

The largest of the independent groups was the Society of Independent Artists, formed in 1917 by Marcel Duchamp, Katherine Dreier and several of the organizers of the Armory Show such as Walter Pach and Arthur B. Davies. Modeled on the idea of the French Salon des Indépendants, the Society used the no-jury principal for organizing exhibitions. The annual shows were hung at random, based on an alphabetical letter drawn out of a hat. The result of combining non-stylistic groupings with a non-juried show was chaos. Hundreds of unfamiliar artists were included in the displays, but the critics found them virtually impossible to evaluate. The catalogs reflected an increasingly conservative trend, but the exhibition remained important, despite its flaws, as an opportunity for any artist to be shown.

The large group events, combined with the increasing number of galleries that supported some version of modern art, were a factor in the impact of modernism on the National Academy itself by the end of the decade. In 1927 the academy offered modern artists the opportunity to show in their annual exhibition. The invitation led to a strange quarrel among the moderns as to whether they should accept the opportunity.[138] That same year Henri Matisse was awarded first prize at the conservative Carnegie International Exhibition,[139] another indication that academics were receptive to at least some aspects of modern art. In 1930 Matisse was invited to join the jury for the

Carnegie prizes, and Picasso was awarded a prize.[140] While the paintings selected for awards were in a figurative style surprisingly close to the mild modernism of the Whitney circle, the awarding of the prizes to the leaders of what had been considered ultra-modernism only fifteen years earlier was a landmark in the history of acceptance of modern art in America. Bouché's prediction in his 1923 catalog that Picasso and Matisse would soon be Sunday supplement material came true in 1930.

2

The Critics and Their Premises

The most prominent professional art critics of the 1920s were Walter Pach, Christian Brinton, Forbes Watson, Henry McBride, Sheldon Cheney, Paul Rosenfeld and Thomas Craven. Of these, Paul Rosenfeld, Sheldon Cheney and Thomas Craven first came to prominence in the 1920s. Pach, Brinton, Watson, and McBride all began writing criticism at the time of the Armory Show in 1913. Yet, just as an overview of the galleries of the 1920s reveals a broader focus on the individuals whose careers began in the teens, a monographic study of each of these critics is not sufficient as a discussion of the criticism of modern art in the 1920s. Equally important is the large group of articles by obscure and even anonymous writers that filled pages of publications both within and without the art world.

Within the art world itself, the unsigned articles in the weekly publication *Art News* were a major source of information on modern art. Also in that publication were the writings of the coeditor, Guy Eglington, and the Berlin Columnist Flora Turkel, both virtually unknown today.

The art magazines such as the *Arts, Arts and Decoration* or *Studio International*, all had coverage of modernism mixed with articles on furniture design and earlier periods of art. *Arts and Decoration*, for example, carried as its subtitle: *A Magazine of Social Life and the Fine and Industrial Arts*. The *Arts* was the most consistently committed to modern art, but it failed to provide adequate coverage of European art after Cubism and neglected art outside of France. Toward the end of the 1920s *Art Digest* began presenting a survey of the criticism on modern art by excerpting articles from other magazines, but did so with a distinctly American bias. *Creative Arts*, founded in the late 1920s, also covered modern art in the last years of the decade.

Outside the art world articles on modern art appeared in a range of publications. The elite *Dial*, directed to a self-consciously sophisticated audience of intellectuals, employed both Henry McBride and Thomas Craven, as well as other prominent writers on art including the German art critic Julius Meier-Graefe. Political newspapers such as the *Freeman*, the *Nation*, and the

New Republic published articles by people such as Walter Pach, Louis Lozowick and Leo Stein. Inconsistencies abound in the discussions of modernism in these publications according to the author of the particular article. Yet, these occasional articles are often more historically important than the pedantic and self-conscious commentary of the official art magazines. Thus a popular but sophisticated magazine such as *Vanity Fair* invited both Jean Cocteau and Tristan Tzara to write articles, while the *Arts* under the editorship of Forbes Watson still plodded through early modernism and the impact of Cubism.

In order to introduce the individual critics of the twenties, yet emphasize that they are only part of the total picture, this chapter focuses on the critical premises of formalism and expressionism. Most of the critical writing from these years utilized a strangely diluted methodology that combined an understanding of the importance of objective analysis of form with a degree of subjective emotional interpretation that had its basis in a wide variety of sources, ranging from nineteenth-century symbolism to German theater after the war. The first part of this chapter examines affiliations with the theories of formalism. The second part of the chapter examines Expressionism as a theory, as used by Sheldon Cheney and the critics of the Stieglitz circle.

Formalism

Formalism, or the analysis of art in terms of its stylistic elements rather than its story, was familiar to American writers almost from its earliest formulation as a critical method. Clive Bell articulated the idea of "significant form" and "aesthetic emotion" in his book *Art* written in 1913 in response to the Grafton Gallery exhibitions of Post-Impressionism arranged by Roger Fry in London in 1910 and 1912.[1] The most important idea presented in the book was the separateness of aesthetic experience from day-to-day life. Bell created the term "aesthetic emotion" to suggest that separateness. He formulated his ideas in reaction to the literary and moral approach to art criticism that prevailed in the nineteenth century, particularly in the writings of the English critic John Ruskin.

During the early 1920s Bell also wrote for American periodicals,[2] thus reinforcing awareness of his idea. His terms became widely used by art critics. The accessibility and popularity of Bell's terminology was parodied in a humorous glossary of art terms written in 1925:

> Form. An ancient deity whose empire, however, only reached its widest sway in the year 1920, which saw the publication of Mr. Clive Bell's *Art*. True, He bore a brand-new name having been hailed by Mr. Bell by the title of Significant, but neither Mr. Bell, nor any of his followers were at all clear as to the meaning of this new distinction. Having prostrated

themselves before the altar of an Unknown God, they merely hoped that the addition of a still more ineffable and, by the same token, indefinable, title, would render His throne for all time unassailable.[3]

The tone of parody in this "dictionary" suggests that Bell's terminology was adopted as a cliché during the course of the 1920s.

Roger Fry also wrote articles in American periodicals and published his collected essays in New York in the early 1920s.[4] Fry's subtle and more poetic use of the formalist method to analyze a range of different types of art generally found a response among the more intellectual critics such as Arthur Wesley Dow, professor of art at Columbia University, or Hamilton Easter Field, the first editor of the *Arts*.[5] Fry's writings were already recognized in the 1920s as more sophisticated than Bell's easily understood concepts.[6]

Specific analysis of the writings of certain critics demonstrates how they responded to the ideas of Bell and Fry in theory and how they used formalism in their criticism. In very few cases did a critic adopt formalism as his only perspective. The nature of the art under review determined how usable the formal approach was. Naturally it appeared more frequently in articles on modern artists who were versed in formal principals themselves.

Forbes Watson

Forbes Watson's career in art criticism was based on training at Harvard University and Columbia Law School.[7] Perhaps for that reason he usually adopted an intellectual approach to art. Watson was both a regular columnist for the *World* newspaper and editor of the *Arts* from 1923 to its demise during the depression. Watson's criticism in the newspaper emphasized the formal method in order to demonstrate to a general audience that modern art was not illustration. His admiration for Roger Fry was stated outright.[8]

Watson's most notable contribution to the criticism of modern art were long monographic articles in the *Arts*, a novelty for criticism in those years. These articles often covered members of the Whitney Studio Club or the critic's particular favorites such as the Renoiresque William Glackens. Watson's article on Sheeler is an important document of the early responses to modernism in American art. It combines the critic's adept use of a formalist method of analysis with his own formulation of the American element in Sheeler's work:

> What he evidently looks at and strives, successfully I believe, to put down, is its [the barn's] structural character—the relation of its planes, the inherent quality of its materials, the meaning of its forms. How do the planes move one against the other...?
> ...[He seeks] to interpret, through design, his understanding of the fundamental character of the natural object and to permit the medium to interface as little as possible with

the spectator's vision of the pictorial result ... Finally, in his exquisite arrangement of space, in his complete destruction of the superfluous, Sheeler reaches the cool, refreshing heights of the best periods of American design and, most important of all, his work is imbued with that necessary element of life, the native tang and fragrance, that sense of inherent quality without which art cannot rise above logic.[9]

In Sheeler, Watson found a combination of form consciousness and meaning that he felt lacking in other modern art in America. His reference to "native" elements is also an early indication of his American bias.

In the *Arts*, Watson increasingly bemoaned the theoretical aspects of modern art while simultaneously, for his newspaper readers in the *World*, he emphasized the absence of literalism and photographic qualities, using more formal language. About Picasso's work in 1923 he wrote "the parts are welded together into a whole, the quality of the form and the quality of the color belong together ... "[10]

Watson's underlying dependence on theory contributed to his subsequent rejection of modern art. He repeatedly demonstrated his inability to see the works; he approached them instead as an issue in his political positions. His formal analysis was therefore general, not critical; it lacked the substance of a writer like Fry who was actually looking at art. As the decade progressed Watson increasingly became a foe of modernism and a promoter of nativism. His attitudes were shared by a group of critics he collected at the *Arts* that included Virgil Barker and Lloyd Goodrich. Watson and the *Arts* in conjunction with the Whitney Studio Club artists and writers all shared a similarly conservative modernism that formed a major presence in the 1920s art world.

Henry McBride

Henry McBride began as a painter in New York City and created an art school for the Educational Alliance in the late years of the nineteenth century. He then became director of the Trenton Industrial Art School. From 1900 to 1912 he travelled extensively in the United States and Europe. His critical career began with the *New York Sun* in 1912; the Sunday art page of that newspaper remained his main affiliation until 1920. In that year he also joined the *Dial* when it moved to New York and remained its regular art reviewer throughout the decade. McBride knew Roger Fry as early as 1910 for he described Fry showing him Matisse's bronze relief sculpture at that time in London.[11] As a result of his early awareness of modern art and literature (he was also a close friend of Gertrude Stein), McBride's perspective was more sophisticated than that of many other critics. He admitted his bias of looking at formal components more than subjects, in a 1924 review of Abraham Walkowitz in

which he referred to "one of the rare instances in which I find myself as a critic thinking of the matter that an artist presents rather than the manner."[12]

On the other hand, his style of analysis was Whitmanesque or perhaps influenced by the aesthete Walter Pater, for like them he felt the energy of the work as much as the form. About Charles Demuth he said evocatively "The Demuth color is like light that has glanced through jewels on its way to the paper." On John Marin, McBride wrote "The opposing currents of modern life beat in upon Marin's spirit relentlessly. He feels each jerky jazzlike force that comes along and, to the death, must translate it into rhythms."[13] McBride believed that Elie Nadelman had "a sure enough knowledge of form, but doesn't hesitate to sacrifice a muscle or two for the sake of greater rhythms."[14]

Frequently McBride's column contained gossip about the art world or reflected his intolerance for American materialism. Although he knew formal aesthetics, his use of analysis was more impulsive and intuitive than systematic. He believed that people should learn about art by looking at it.[15]

Walter Pach

Walter Pach's criticism also combined formalism and other theories. Pach was trained as a painter and lived in Paris for many years. Although he was more directly involved with French aesthetic theory than with English formalism, he acknowledged a specific and long term debt to Roger Fry in an article of 1922.[16] As early as 1913 Pach had written on modern art as one of the principle informed commentators at the Armory Show (he had played a key role in organizing the exhibition). In a 1913 magazine article he wrote that Post-Impressionism was "the embodiment of living ideas in forms which respond to the sense of beauty in men.... [It is] the conveying of the particular emotion which has seemed important to the producer.... [It is] an aesthetic equivalent of thought."[17] While Pach gave the "particular emotion" a more intellectual quality than did Fry, the concepts were very close in their separation of art from other types of experiences.

Pach was usually vague when he wrote about an artist's work, preferring to use sweeping generalities that implied an ongoing development or evolution, rather than examining a piece in detail. For example, he identified Picasso's "investigation of pictorial structures." When he looked at a painting by Matisse he interpreted it as an intellectual act: "...[The] purity of design, the calm beauty of color... are guarantees that the image has passed through the alembic of his mind." His wedding of an intellectual version of formalism with evolutionary determinism is clear in his comment on Diego Rivera: "[T]he lines and colors of his frescoes are brought to a unity even severer, more organic than that which he could attain in the previous stage of his evolution."[18]

By the mid twenties Pach's combination of formalism and evolutionary determinism was considered obsolete as a method of analysis of modern art by the more up-to-date commentators. The clearest statement on Pach's critical position as a promulgator of formal aesthetics was made by Guy Eglington in a review of Pach's book *The Masters of Modern Art*:

> [O]ne is grateful to Pach for reminding us that there are still a few people in the world capable of thinking clearly on art and presenting their conclusions logically and with concision... [This book] gives such a definite expression to accepted modern esthetic theory, that one is tempted to wonder whether that theory has not seen its best days...
>
> It has long been growing evident that the greatness of these men is dependent on other things besides their mastery over light.... [L]ikewise... the concept of *form* too is a useful illusion that has had its day.... Pach's book carries the ... theory to a point where further development is almost impossible.[19]

Guy Eglington

Guy Eglington was one of the most outspoken critics of the period. He is unknown today because his career was cut short when he drowned at the age of thirty-two in June 1928.[20] An Englishman who had studied in Germany, Eglington came to the United States as editor of the *International Studio*, a post he held from November 1920 to March 1922. He later became coeditor of the *Art News*. While his signed articles in that publication were very few, he probably played some part in the excellent reviews that the *Art News* carried during the middle years of the 1920s.

Eglington's relationship to formalism was sophisticated. He used it as a means to analyze art, but never let it become a limitation in his interpretation of the object. In 1925 he wrote an article specifically analyzing Seurat's painting *La Baignade*:

> [The *Baignade*] is the outcome of two preoccupations which he was later to subordinate, the preoccupation with light,... which grew out of his crayon drawings, and a preoccupation with mass, which he had been developing simultaneously in the drawings and in his early essays in paint. If he relies here as later on the horizontal, it is by instinct and not in response to any compositional theory, and the too logical corollary of the horizontal, the perpendicular is conspicously missing.
>
> ... he is not concerned with subtle distortions in the direction of composition angles, but is content to let figures and trees keep their own shapes, only simplifying, rounding, rendering more and more palpable, dissolving in one breath in the brilliance of his *eclairage*, in the next throwing into relief by the sharpness of his contrasts.[21]

Eglington's analysis combined formalism with a subtle determinist or evolutionary strain that he shared with Walter Pach: he looked at an early work in relationship to what he knew would come next.[22] On the other hand, the

freshness and accuracy of the formal analysis puts him in a separate class from the other critics considered here.

Eglington's main contribution to the art criticism of the 1920s was his skeptical attitude toward the overuse of the language of criticism. He chose to use his sensitivity to mock the use of language in art writing, rather than develop another approach to art. Yet, his writings do underline the pervasive self-consciousness of the art critics of the 1920s and suggest the problems of the overdependence on the formalist method. His most complete statement of this problem is his amusing "Complete Dictionary of Modern Art Terms," a series of articles that appeared in *Arts and Decoration*. In them he lists the various terms of criticism and parodies their role in art writing.[23]

Thomas Craven

Thomas Craven owed a surprisingly heavy debt to the theories of Roger Fry and Clive Bell. During the early part of the 1920s he engaged in an extensive discussion and debate in the pages of the *Dial* on the merits and shortcomings of Roger Fry's book *Vision and Design*[24]. In these articles, Craven found himself defending Fry's approach against the criticism of other writers. Craven's debate over the importance of Fry marked a major step in the development of his career as an art critic. Prior to his articles in the *Dial* he had been a poet and English teacher.[25] His inexperience as a critic may relate to his subsequent total abnegation of formalism in the 1930s.

Craven published his most specific critical articles in *Shadowland*, a theater and movie publication, from 1921 to 1923. In these articles he looked at the art of Thomas Hart Benton, John Marin, Edwin Dickinson, Charles Demuth, Joseph Stella and Charles Sheeler. Usuallly focusing on theoretical rather than factual issues, Craven generalized about compositions and colors, rarely speaking of individual works. His writing on Sheeler most clearly displayed his effective use of the formal approach to art:

> Compare his oil study of skyscrapers with his camera study of the same. In the painting I find a certain definite quality, a linear precision and a remarkable tonal range which suggest the photograph, but the beauty of the painting lies in its design, in the imaginative reconstruction of the basic planes to produce a new form stronger than the literal object of the negative.[26]

In an article on John Marin, he primarily presented Marin's own art theories, but finally commented about the recent painting that "his design is larger, more direct and more strengthened in general effect by heavier masses and sharper more assured drawing."[27]

Perhaps most intriguing from the point of view of later developments was Craven's piece on Thomas Hart Benton. He opened with a discussion on the

connections between modern and classic art, showing their dependence on the same principles of form. Then in speaking of Benton's compositions, he commented that they were "still an exceedingly conscious process with him and his struggles to make a form obey a certain curve or fill a given amount of space are evinced in the finished work."[28] This accurate response to Benton's art revealed the problem that would lead Benton to begin adopting a more illustrative style and combine that with an emphasis on the American scene. Craven took up Benton's new direction in the last third of the 1920s, celebrating it because of its link to the American environment. He abandoned intellectual subtlety for simplistic chauvinism in the 1930s; The discussions of his early articles were replaced with a narrow-minded denigration of modern art. Yet even at the height of his Regionalism, an underlying respect for Bell and Fry continued. Craven completed a bibliographic note for his survey called *Men of Art* in 1931 as follows:

> Fry *Vision and Design, Transformations*. Miscellaneous essays by one of the best living critics. Fry is an ardent champion of the modernist art which he defends with the highest of intelligence. Bell *Art, Since Cézanne*, (art for art's sake applied to the Modernists).[29]

John Dewey

Perhaps the most surprising analysis from the waning days of the first wave of formalism came from John Dewey, the mentor of the critics who sought an alternative to formalism in the relationship of art and life. Dewey brilliantly analyzed what the artist brought to his art, and the extent to which this affected him, in a lecture of 1931 reprinted in *Art as Experience* in 1934. His starting point was the ideas of Roger Fry. Dewey acknowledged the importance of Fry with lengthy quotations from the English critic about aesthetic vision. Dewey commented that Fry gave

> an excellent account of the sort of thing that takes place in artistic perception and construction. It makes clear two things; representation is not, if the vision has been artistic . . . of 'objects as such,' . . . It is *not* the *kind* of representation that a camera would report.[30]

Dewey then goes on to add that "one thing may be added . . . the painter did not approach the scene with an empty head, but with a background of experiences."[31] Thus Dewey's position that experience is important to art was developed against the background of formalist preoccupations.

As formalism pervades all of the art criticism of the 1920s, it becomes a focal point for evaluation of the critics' understanding of modern principles of form. It reveals critical hesitations and shortcomings and provides a measuring stick for the sophistication of the writers on modern art.

Expressionism

Expressionism as a concept is far more difficult to trace as a method in art criticism. Its sources are more diffuse and its use less consistent. Thus, Sheldon Cheney is here used as a case study of one way in which formalism and expressionism could be used by a single critic. Since Cheney has been neglected as a major critic of the 1920s, his development is traced here in order to explain the complexity of his use of expressionist method in his criticism. Each critic discussed above also used a measure of expressionism, but only Sheldon Cheney based his writings on an understanding of the modern expressionism of twentieth century German art.[32]

Sheldon Cheney

Cheney was born in Berkeley, California and as a college student at the University of California, attended performances of Greek dramas at the open air Greek theater, then a "modern" concept in theater. This experience appears to have profoundly affected Cheney. He was impressed with the simplified settings, the emotional impact and the democratic aspect of open air theater, that made it accessible to a wider spectrum of the public.[33]

Shortly after college, Cheney, through a Berkeley friend, was introduced to the radical stagecraft theories of Gordon Craig. Craig, a prophet more than a technician, advocated the elimination of detail in stage settings and the use of suggestion rather than description to capture the mood of a play. He also called for unity in acting, lighting and movement. All of these innovations allowed the human emotions to be the main animating element of the play.[34] These ideas were profoundly influential on avant-garde theories of expressionist stage design in Russian and Germany in the teens. Cheney wrote of them as early as 1914 in his first critical book.[35] In the late teens Cheney edited *Theatre Arts Magazine*, an important publication which introduced Craig's ideas as well as those of the new theater artists who were adopting more expressionistic methods in their stage designs.

The transition from the theater to the art world occurred when Cheney moved to New York in 1917.[36] In creating an exhibition of "Modern American Stage Designs" at the Bourgeois Gallery he moved into an environment that was supporting avant-garde visual art.[37] In 1920 Cheney also joined the Société Anonyme and was part of its library committee.[38] Cheney and Dreier shared a similar sense of mission: that modern art could be a catalyst for change, although Cheney looked for social as well as spiritual change.[39] In the Société Anonyme library Cheney would have had the most recent literature on visual aesthetics available to him.

The impact of the contacts with the art world and modern art theory was immediate. In 1921 Cheney wrote a major article under the title of "Expressionism" linking avant-garde theater and art concerns.[40] Far more significant for the history of modernism was Cheney's *Primer of Modern Art* published in 1924. Cheney's book was the first survey of modernism published in this country that attempted a complete historical overview and combined the theoretical premises of formalism and expressionism. As a result of his contacts at the Société Anonyme, Cheney combined his understanding of expressionism with the ideas of Clive Bell and Roger Fry, coining the term "expressive form."[41] While he continued to consider expressionism as the central concept of modernism, he added this to a consideration of structural theories:

> *Expressiveness*... arise[s] from three sorts of intensification: of the essential or structural quality or 'rhythm' of the object as against its outward aspects; of the artist's subjective emotion, of the "image" emotionally conceived out of his passion for absolute... aesthetic form; and of the essential characteristics of his materials. The *significant form*... is doubtless achieved ordinarily out of the virtues of all three elements... but it is the second, subjective, emotional expression, which is at the heart of the matter.[42]

The *Primer*'s categories and distinctions in discussions of specific artists are sometimes confusing,[43] but from our perspective today more valid than those of other writers of the period. In the same year as Cheney's *Primer*, Dreier published *Western Art and the New Era*, and Walter Pach presented *Masters of Modern Art*. Dreier's book utilizes an underlying committment to Kandinsky and is thus an important record of that particular artist's influence, but of little use as an overview of modern art. Pach's book is biased toward an intellectual formalism that is based on his close affiliations to the French Cubists.[44] Only Cheney draws from both expressionism and formalism as a basis for explaining modern art.

In the later 1920s Cheney continued to play a pioneering role in the promotion of avant-garde art. By the end of the 1920s he was familiar with the new architecture of the Bauhaus and Constructivism, again through his knowledge of stage design.[45] In 1934 he published *Expressionism in Art*, the first popular book with a large circulation in America devoted specifically to the theories of Hans Hofmann.[46] Thus Cheney's early exposure to expressionism, based on the radical stagecraft theories of Gordon Craig, connected to the mainstream of modern art theory. His articles and books constitute a major contribution to the interpretation of modern art in America, a contribution which influenced generations of students of modern art in the following decades.[47] While his starting point was eccentric from the perspective of the established New York art world, his contribution was fundamental.

Stieglitz Circle Critics

While Sheldon Cheney utilized expressionism as a critical theory to approach modern art in general, certain types of art shown in New York, particularly that of the artists in the Stieglitz orbit, stimulated what can be characterized as a more generic expressionism in criticism. Critics associated with Stieglitz shifted their interest in the 1920s from avant-garde French aesthetics to a more unscientific, lyrical analysis. The shift is clearest in the contrast between the criticism of Paul Strand, who continued to base his ideas on a more rational, process-oriented vocabulary, and the writings of Paul Rosenfeld, an effusive writer with little interest in systematic analysis. Ironically though, Strand saw Rosenfeld and his colleague Waldo Frank as using an

> objective method . . . to illuminate a particular thing by relating it to other forms of energy. . . .
> . . . It is a method which removes these phenomena from a sanctified and therefore quite meaningless isolation, opens up new ways of re-vitalizing their respective terminologies and suggests a fresh orientation of aesthetic criteria.[48]

Strand thus created an opposition between the Stieglitz critics and what those critics saw as the cerebral and intellectual discussions of the formalists, particularly Walter Pach. Criticism of Stieglitz' artists centered on an analysis of the specific works and an emotional response. This criticism evoked the style of the work as the artists experienced it, creating a generic expressionism in their writings. It is distinctly different from both the ideas and theories of Kandinsky as adopted by Katherine Dreier, for example, and of expressionism as understood by Sheldon Cheney. Kandinsky sought to eliminate the object from his work; he focused on the unconscious, while the Stieglitz orbit saw universal meaning in the objective world—a more transcendental approach.

Closely related to an expressionism that reflected a transcendental attitude to the art object, was the concern that art express its environment. While this idea had been related to the idea of a "Zeitgeist," or general spirit of the time during the teens, Paul Rosenfeld and his colleagues in the 1920s emphasized the importance of contact with the native American environment and the expression of that environment directly in art. The model for this approach to art was Walt Whitman, who was admired for both his content and style. In the 1920s John Dewey provided a philosophical basis for the interconnections of art and the environment that was reinforced by critics such as Lewis Mumford.

Expressionism in American criticism had a range of different sources, only a few of which have been touched on here. Yet the generic expressionism as

cited here, is not without importance in the history of modernism in America. It forms an important precedent and a striking contrast to the writings of the post-World War II critics of Abstract Expressionism, that adopted a similarly emotional and lyrical approach to art.

3

Expressionism

While dissection of expressionism as a critical theory and method presents a set of complex issues, the criticism of expressionist art presents a contradiction. This chapter characterizes the Stieglitz artists as American Expressionists, and contrasts them to the German Expressionists in the critical responses that the artwork provoked. These two bodies of literature form a dramatic contrast. In considering the American work, the major critics of the period viewed the expression of emotion positively, while in the German work they considered emotion as a negative quality. Juxtaposition of the criticism of these two groups of artists highlights this contradiction.

The Stieglitz Artists

While not all the Stieglitz artists can be considered equally Expressionist from our perspective today, in the 1920s John Marin, Georgia O'Keeffe, Marsden Hartley, Charles Demuth and Arthur Dove were seen as part of a coherent group with strong stylistic connections. While the differences in their own attitude to their work and in the style of their art are great, their reviewers used a similar terminology and a similar set of critical concerns which swept them up into a Whitmanesque glory of adjectival exuberance.

John Marin

Of all the Stieglitz artists, John Marin corresponded most legitimately to this approach, in both his own writings and his art. His writings echo themes of the spiritual in nature that are similiar in content and style to those of Alfred Stieglitz:

<div align="center">HERE IT IS</div>

This thing

<div align="center">this human is a nature product</div>

—He has bones and over and round about layers of soft stuff-flesh-concealed therein and binding-nerves-muscle and lots of things—He seems to be Nature's highest product in that he has the ability to use and to form into combinations other of nature's products—These forms—Used—by a certain Kind of Human—are called—Art products—and these forms used by this Certain Kind of Human have an exalted value in that they put in motion the— S p i r i t—through the eye—and approach the great—Seeing—not as reminders of other— seeings—but in themselves. [1]

The use of capital letters, the terminology and the spirit of the piece all share a close affinity with the approach of Stieglitz.

Critics almost universally admired Marin's combination of recognizable imagery, references to modern structural concerns and exuberance. Paul Strand set the tone for Marin criticism in the twenties with his comments on Marin's work in a group show in Brooklyn in 1921:

Marin is keenly aware, as [Winslow] Homer was not, that every element included in a picture must be felt, each part related so irrevocably to the other that nothing can be changed without disturbing the unity of the whole. He is seen struggling, not always successfully, but always with a closer approximation to the point where every part of his picture is.... meaningful, without dead spots. Here, indeed, is the problem of Cézanne, the essential problems of those whom we choose to call the great artists of all times, whose expressiveness and livingness is in direct proportion to their having achieved complete organisms, born always of the very particular world of which they were the product and to which they were able, disinterestedly, to adjust themselves.

It is towards such an organism that Marin is seen moving with all of Homer's virility, and as directly, into the American scene. His work attests frankly to a conscious recognition on his part that he is rooted in this American continent. The rocks and hills of Maine, its turbulent icy seas, its vast skies, claim his love inevitably. [2]

With his references to Cézanne and the structural and organic aspect of painting, Strand reflected Marin's understanding of modern aesthetic theory combined with a connection to the American land and tradition.

Paul Rosenfeld spoke of Marin as a workman "with feet firmly planted upon the ground." [3] In a long essay of 1922, he expounded on the artist's relationship to the American soil. His language is powerful, combining a sense of the physical reality of the artwork and the physical environment from which it was taken:

Everything can produce in Marin his lyrical states of being, his sudden rhythmical, flashing visions: a street-corner in down-town Manhattan, a sachem pine on Maine shoreland, summer-green hills in Delaware County, sand and fog and breakers of Stonington, a thousand unnotable niches.... A skyscraper has but to jab its giant thumb into falling skies, or rapids of traffic to course under wedging walls and jagged masonries; a squall has but to comb the waters of Casco Bay as clawing fingers comb tumbling tresses, or sunset splinters to pour javelin-like over spruce-tops.... Something within imitates joyously the play of elements one against the other; the countermovement of towers and skylands; the landscape

thrown violently to one side as the eye follows the upward thrust of a tree-trunk; the rocking of the bluffs about the put-put in the billows....

In those electric moments of vision, the objects present to the painter's sense are suddenly caught in the terms of a magical wash. The tangled shapeless world has suddenly given way before a delicious and contrapuntal watercolor, rivulets and pools of aquatint, blank hard white meeting vibrant thick green and crushed tender rose, red celluloid lightenings, nuggets of somber and mystical color-ore.[4]

Rosenfeld's energy flows through his verbal description of both real objects and painted imagery, capturing them in a theme of universal energy and spirituality that was an undercurrent of all of his criticism. Rosenfeld, like Strand, considered both process and subject, but with his subjective, intuitive terminology he made the point of connection between artist, subject and art more directly than Strand.

Rosenfeld completely omitted the intellectuality of French aesthetics in response to Marin, preferring to celebrate instinctive sensuality:

No fear of sense breaks...[Marin], thrusting a floating baseless mind between him and the testimony of his senses; making him seek to force his experiences to conform to preconceived theories. Feeling and thought are one in him inseparable.[5]

Marin's use of watercolor called attention to his process. It enabled critics to respond more directly to that aspect of his work. Marsden Hartley's comment on his colleague at the Stieglitz gallery addressed this question directly. Unlike Rosenfeld, Hartley did allow for some intentionality:

John Marin employs all the restrictions of water-color with the wisdom that is necessary in the case. He says that paper plus water, plus emotion will give a result in themselves and proceeds with the idea at hand in what may without the least temerity be called a masterly fashion; he has run the gamut of experience with his materials from the earliest Turner tonalities through Whistlerian vagaries on to American definiteness.

...[but] we are not satisfied as once we were with this passion for audacity and virtuousity. We have learned that spatial existence and spatial relationships are the important essentials in any work of art. The precise ratio of thought accompanied by exactitude of emotion for the given idea is a matter of serious consideration with the modern artists of today.[6]

Hartley's criticism of Marin is poignant because he speaks in it as much to his own struggle between thought and feeling as to the art of Marin.

The usually cool and urbane Henry McBride continuously celebrated Marin as a poet with the use of stirring adjectives and superlatives unusual for a McBride article:

The feeling that runs throughout his work shows the inevitable tendency to deepen as the years draw on. At first he was a lyric poet content with the 'wind on the heath' and the play of

clouds on a summer day, but lately his pictures sound a dour and tragic note ... It seems to me that all of these pictures were painted in a furious state of mind and that the brushes were not dipped in love. ... But I think them great. There is an exaltation of feeling in them that I can match nowhere else in contemporary American art, and a sweep of the brush that makes all other water-colours, both here and in Europe, seem infantile.[7]

While McBride praised Marin's art consistently as the best of American modernism in the 1920s, he also utilized Marin for another purpose. He considered appreciation of Marin as a barometer of an individual's ability to understand and appreciate modern art in general. Late in the decade he commented on Marin's annual exhibitions:

This is one of the tests that candidates for connoisseurship in the arts are put through annually. ... More and more people make the grade, aided no doubt by the initiated, who begin proselytizing like devotees of a new religion as soon as they themselves get the cue. Soon we shall have in our midst the thing that has been so much talked about, an intelligentsia.[8]

The comment touches on several different themes. McBride found Marin's art the best modern art in America, but he also found it a statement understandable only to the initiated. The language of his comment, probably intentionally, corresponded to the attitudes of the Stieglitz circle, with its religious overtones, and the idea of a schism between believers and non-believers. McBride himself also adopted a persistently superior attitude to people who did not understand modern art.

Thomas Craven, later known for his energetic defense of American Scene art, wrote an analysis of Marin in the beginning of the 1920s that contrasts to the exuberant enthusiasm outlined above. Craven's strikingly intellectual and rational approach skillfully analyzed the presence of modern design in Marin's paintings, rather than praising their American subject matter:

Mr. Marin sees in a landscape the potentialities of balanced identities analogous to the correlated members of the human figure. Each part must be a unit of structure and yet must operate within itself and in conjunction with the other parts to achieve the full unity of form. If the several members are made to assume false positions, the balance is broken; if the contacts are true, the connecting lines evocative of rhythm, and the colors justly proportioned, an order is established which stimulates the spirit into activity and which creates a quality designated as the beautiful.[9]

On the other hand, Craven was also affected by the importance of the nature in Marin's paintings, so he contrasted the use of scientific formula by some artists to "the work of Mr. Marin [who] presents the artist actuated by living forces, the investigator who views nature directly and independently, who looks at the world profoundly in the effort to discover the secrets of permanence."[10]

The writers for the *Arts* all found Marin's work praiseworthy; it elicited some of the best criticism by Forbes Watson, Alexander Brook and Virgil Barker. Again, as with McBride and Craven, these critics emphasized the artist's formal qualities and process, more than subject matter. Yet, these normally restrained critics wrote of Marin's technique with considerable energy. A 1923 article by Alexander Brook commented:

> The extreme velocity of Marin's visions, impulse and power of projection is such, the precision and perhaps the mercurial evanescence of his impressions is so great, that watercolor must be the medium best adaptable to his rare collection of gifts and faculties. [11]

Virgil Barker spoke of Marin's process in comparison to Winslow Homer with real sensitivity:

> The quality of his wash has been acclaimed superior to that of every other water colorist; the only comparison which to other critics seems adequate is with the ancient Chinese masters. Marin's wash is not the broad-flowing precision of Winslow Homer's tropical scenes; it is more nervous and subtle.... It is something wholly personal in its complete responsiveness to his perceptions. It dashes boldly across the paper with a scurrying wave or pauses in still pools; it builds itself up solidly with a Maine hillside or floats in transparent depths of sky; it takes captive those instantaneous flashes of life which occur as often in calm as in tempest; it makes permanent the most evanescent aspects of the shaggy-lovely world. Marin's technique is great because it carries great matter, because it says superbly just what its medium is best fitted to say....
>
> Look at his New York buildings.... Into his driving brush-slaps he concentrates all the confusion, all the noise, all the straining hurry with which New York assaults the nerves. Its buildings unite into a clanging paean of power run amuck. [12]

Barker's vivid, evocative language is similar to Rosenfeld's, but Barker placed Marin more in the context of art history, distinguishing him technically from the earlier American watercolorists. Elsewhere in the article Barker contrasted Marin's intuitive approach to realism with the intellectual abstractions of Cubism.

Forbes Watson similarly stressed the "instinctive" aspect of Marin, claiming that the artist

> thinks in watercolor. It is only when he thinks in words and translates into watercolor that he fails.... [He has] the thought of the poet, the painter, the musician who is able to eliminate everything that is unnecessary to his expression. [13]

In a stunning one-paragraph overview of the painter's art Guy Eglington focused on the emotion and energy in Marin:

> One by one, all the Marins I had ever known passed in review before me. Early landscapes, delicate in color and touch; aquarelles of the Maine islands; the gradual keying up of color

sensation, color that grew more and more vibrant, touch more rapid and more nervous; the growing use of red, at first to frame cool tones, then more generously, in rich strokes that formed the very architecture of the composition; the New York group, that marked the culmination of both trends, the uttermost of vibration alongside of a veritable sunburst of hot and sanguine tones; finally, the later aquarelles, dispensing with vibration for the rendering of color intensity in favor of a fuller, more generous wash, moving towards a deeper appreciation of space values, a greater depth and breadth, an all-pervading calm.[14]

Eglington here displayed his sophisticated grasp of the language of form, but he also included references to the unconscious and the spirit:

[Marin is] not vastly moved by anything which has not sprung from his own loins, giving the matter no conscious thought, [he] was content to take from foreign tradition only so much as he could absorb....

...[He] has always been mindful that a picture, in so far as it aspires to be more than a mere *tour de main* is a house for the human spirit.[15]

One reviewer suggested that the paintings affected the appearance of the gallery and vice versa:

[The gallery has] an informal air that is excellently in keeping with the nature of Marin's aquarelles. They are on the wall and yet not of it.... They are in some sort the flying column of art demanding above all space and light and a minimum of encumbrance.... The gallery itself has undergone a change under his hand, the plush being covered with a light gauze which doubles its size and eases the breathing.[16]

Gradually, toward the end of the decade emphasis shifted more to the subjects of the paintings and away from the process and the emotion. The impact of Marin's art continued to be great, but the language of the criticism began to forecast the rhetorical excesses of the 1930s. For example, in 1928 Louis Kalonyme characterized Marin's work as music written by a "Promethean" American:

Marin is a Promethean who affirmatively tears beauty from the life of our new world: from its vibrant, fragrant patches of sparkling salty blue bays which tug at a fragile windblown white winged three master; and from its tumultuous roaring cities racing madly into adjectival skies. Marin is the viking of watercolor music.[17]

The criticism devoted to Marin in the twenties forms a crucial record of responses to an artist accepted by a broad spectrum of critics.[18] His consistency aided in the formulation of a critical perspective and gave him an identifiable image. Marin was one of those rare artists whose vision and expression exactly corresponded to what his audience could understand. The criticism of Marin's art in the 1920s, in articulating this expression, provides a fascinating

combination of sophisticated formal analysis, effusive emotionalism and pre-Regionalism.

Georgia O'Keeffe

Stieglitz' other artists presented more difficulty for the critics primarily because they were less consistent. Georgia O'Keeffe, at the very center of the Stieglitz entourage in the 1920s, tended to be seen with the same perspective as Marin, although her art was quite different. Paul Rosenfeld's poetic eulogies honor her art as feminine, an approach she particularly abhorred:

> O'Keeffe shows no traces of intellectualization and has a mind born of profoundest feeling. . . . O'Keeffe gives her perceptions utterly immediate, quivering, warm. She gives the world as it is known to women. No man could feel as Georgia O'Keeffe and utter himself in precisely such curves and colors; for in those curves and spots and prismatic color there is the woman referring the universe to her own frame, her own balance.[19]

Rosenfeld introduced the term "precision" elsewhere in the essay, an interesting forecast of the place which O'Keeffe would ultimately be allocated in American art.

O'Keeffe's own approach to her art was matter-of-fact and non-mystical. An *Art News* article quoted from her comment on her own work in a 1923 review:

> Miss O'Keeffe says that she paints the way she does in order to say what she wants to, things for which she has no words. With this much from the artist it would seem foolhardy on the part of a critic to try to put into words what her pictures are about. This does not mean that all of her pictures are so abstract that the subject can only be guessed at. There is a series of Zinnias painted with deadly simplicity and an air of being dead in earnest on the subject of presenting a zinnia, its roundness, its spotty petals, in the most direct and adequate terms.[20]

The writer of the review accepted O'Keeffe's own interpretation and responded with language as matter-of-fact as that of O'Keeffe.

The two contrasting approaches to O'Keeffe's work, one symbolic and evocative, the other more factual, created ambiguity for critics. One frustrated writer spoke at length about this problem:

> For five years we have been trying to arrive at some definite, tangible conclusion about O'Keeffe, without success. She eludes us still. Her paintings of 1926 leave us almost as baffled as did those of 1920.
>
> It is not that we are looking for hidden meanings. The patient search for nudes on staircases which so delighted the groundling ten years back no longer interests us. There may be a hidden meaning in the paintings of Georgia O'Keeffe. . . . Once [a work of art] leaves the

hand of the artist, [it] takes on an existence entirely independent of its maker, to whose
intentions it might even run counter.
The difficulty we experience with O'Keeffe is far less one of comprehension than of
enjoyment and thence of evaluation.[21]

The review reflects both the ambiguity of O'Keeffe's work and the acceptance
and even expectation of elusiveness in modern art, with its reference to
Duchamp's *Nude Descending the Staircase*. O'Keeffe's seemingly
straightforward style only made her many shifts from expressionist, almost
totally abstract imagery of the teens, to hard edged office buildings, then to
flowers, all the more enigmatic. Grouping O'Keeffe with American
Expressionism here underlines the ambiguity of her art, close to Stieglitz in its
romanticism, yet distinct from his in its down-to-earth imagery.

Arthur Dove

Arthur Dove showed only at Stieglitz' gallery throughout his early career,
although he maintained a private life outside the New York art community.
Dove's philosophy was similar to Stieglitz' in his concern for intuition, but
closer to Kandinsky in his independence from nature. Dove owned
Kandinsky's book *Concerning the Spiritual in Art*, suggesting that he was more
deeply involved in German Expressionism than Stieglitz.[22] At the same time his
writing on art had a factual quality, without any suggestion of mysticism: "The
music things were done to speed the line up to the pace which we live today. The
line is the result of reducing dimension from the solid to the plane then to the
point."[23] Such a straightforward comment contrasts to the gently lyrical
appearance of his work, a quality that critics enjoyed.

Rosenfeld linked Dove to the sensuous, organic experience that he
frequently evoked in his writing:

> There was present a brown and blue pastel of Dove's; and there is not a pastel or drawing or
> painting of Dove's that does not communicate some love and direct sensuous feeling of the
> earth. . . . [Dove] brings a spirit which does not separate any one function of life from others.
> It does not know noble and ignoble organs. Hence, it has the power of making all
> function. . . . When this man paints, the pressure of the brush in his hand carries the weight of
> his body as a whole, and the life of the body as a whole.[24]

Rosenfeld came to terms with the greater degree of abstraction in Dove by
associating the shapes with bodily movements, a concept that can be compared
to analysis of Abstract Expressionism in more recent criticism, and which
stemmed from the writings of Willard Huntington Wright in the teens. Wright
saw modern art through his understanding of the large body rhythms of
Michelangelo's work, a concept that was carried on by Rosenfeld without the
classical reference.

Dove's more abstract style caused some reviewers to stretch their understanding of art, as in this review:

> [Dove] has adventured far into the refinement of plastic expressions in some of his new abstractions drawn out of nature such as "Storm Clouds in Silver." They have grace, but they leave one less stirred than his Pure Painting no. 1 . . . whose subjects are negligible, but where the artist has considered only the medium of paint, giving it a life of its own, independent of form.[25]

Other critics had difficulty with Dove's avant-garde collages, but for the most part were supportive of his art. An *Art News* reviewer commented on the design of the collages, downgrading their content:

> With Dove, although his point of departure may be a sewing machine or a tugboat, the result is much more important than the subject. Out of a Gershwin Rhapsody or an outboard motor he evokes a work of art. He has no concern with realism and even less with natural appearances. Something he sees suggests to him a fine design. He puts it down in color and line and the result is harmony and beauty.[26]

McBride adopted his characteristically superior attitude in treating the collages. He suggested that Dove's work appealed to the imaginative, not to the literal-minded individual:

> Dove renounces subject most completely. In that he is the most modern of a group, all of whom pride themselves upon modernity. At the same time he acknowledges motifs and names them. His pictures have titles, but on the other hand people who like literalism and nothing else in art will not get much help from these titles. . . . [His pictures] would be sure to speak to the imagination of its owner, if he had an imagination. . . .
> . . . To be sure the person who has already seen and appreciated the work of Kandinsky and Klee, two extreme modernists, will vaguely apprehend the solution of the artistic problem Dove has now posed for himself.[27]

McBride was the only critic who saw the connection to the German Expressionists. On the whole, other writers simply analyzed what they saw rather than considering a European context for the work. Curiously, the avant-garde work of Dove was more acceptable than that of most Europeans. The aura of Stieglitz' gallery may have made the collages less alien.

Charles Demuth

Charles Demuth officially joined the Stieglitz circle only in the second half of the 1920s. Demuth appears to have been less dependent on Stieglitz emotionally, intellectually, and financially than the other members of the group. Although Demuth first had contact with Stieglitz as early as 1914,[28] he showed his work with the other Stieglitz artists only in 1925 at the "Seven

Americans" exhibition. Demuth believed that art spoke its own language and that art talk was too serious and wordy,[29] which is perhaps why he delayed exhibiting under the Stieglitz auspices for so many years.

Reviews of Demuth's work reflect a variety of perspectives that form an almost complete catalog of the critical responses to modernism in the 1920s. Paul Rosenfeld touched on Demuth only briefly, but predictably emphasized the romanticism of Demuth's handling of the image:

> [Demuth's] washes and tempera-paintings show him a very delicate lyric poet, gifted with almost infallible taste, daintiness of touch, distinction of conception...There is always the suspicion of an almost feminine refinement in his wash. The factory chimneys on which he bases some of his painting, instead of 'biting the skyline with stub teeth' are softened and romanticized by use of a sort of *una corda pedal.*[30]

Forbes Watson, on the other hand, wrote of Demuth with a combination of formalist analysis and incipient nativism:

> His compositions are complex in their rhythms, but the method is almost scientific in its precision. If there is such a thing as national quality in art it may be said that Demuth is distinctively American, for in its refinement, its reticence, its disdain of all that is heavy handed, his note is in tune with everything that has hitherto been finest in American art.[31]

Henry McBride, in contrast, characterized Demuth as an intellectual and scientific artist, underlining the contrast to Marin and the issue of the definition of modern:

> Demuth with the aid of science doubtless wraps himself in some sort of a transparent cloak and shields himself from the contrary winds.... But can Demuth be modern you ask if Marin is? Why not? The oddest fallacy amid all those that persist is that there must be a formula for modern art. Both men connect with the times though they connect differently. The submerged inner life of Marin revolts at science and fights it. But the science that kills Marin keeps Demuth alive.[32]

Demuth was modern even to the conservative critic Royal Cortissoz because he displayed exquisite technical control that Cortissoz could compare to his favorite academic artist, Ingres.[33] Demuth's concern for modern structural issues, combined with Dada and Precisionist qualities, made him more difficult to analyze than the characteristic Stieglitz artist who combined modern simplification of form with romanticized expressionism. The diversity of interpretations of Demuth's art reflects the complexity of his place within the modern art criticism of the 1920s.

Marsden Hartley

Marsden Hartley was the only member of the Stieglitz circle who loved to theorize about art. His theory is not startlingly original and he shifted from one premise to another between 1920 and 1930, yet he is central to a consideration of modernism because in his very contradictions he embodied the crosscurrents of criticism in the 1920s. Hartley was, like Stieglitz, unable to simply pursue Truth. He was too aware of the conflict of intellect and emotion. He could not follow his instincts as Marin did; he was too unsure of himself.

As early as 1912, Hartley had been deeply immersed in German Expressionism as a result of an extended stay in Berlin. In the 1920s Hartley increasingly rejected the interest in the spiritual that had been prominent in his art during the teens.[34] An article of 1921 set out his new perspective on art and emotion:

> It is the privilege of the artist then to reform his own sensations and ideas to correspond according to a system he has evolved with the sensation drawn out of life itself. It is a matter of direct contact which we have to consider.... [T]he special and peculiar office of modern art [is] to arrive at a species of purism, native to ourselves in our own concentrated period, to produce the newness of the "nowness" of individual experience.[35]

Here, Hartley treated art as a rational, not a mystical, process connected to the immediate environment. His terms "contact," "native" and "individual experience" all relate to ideas prominent in exchanges Hartley had with William Carlos Williams in the last years of the teens.[36] Yet, despite his theoretical committment to the connection of art and its environment, he rejected his own environment to return to Europe for much of the 1920s.

Hartley's years in Europe turned him towards the principles of Cézanne and a further consideration of the intellectual approach to nature:

> I have joined, once and for all, the ranks of the intellectual experimentalists. I can hardly bear the sound of the words "expressionism," "emotionalism," "personality" and such because they imply the wish to express the personal life, and I prefer to have no personal life....
> I have lived the life of imagination, but at too great an expense. I have made the complete return to nature and nature is as we all know, primarily an intellectual idea.[37]

Such a comment separates Hartley from Stieglitz' philosophy of the transcendental importance of the objective world, and also distinguishes him from his own earlier statement about the importance of contact with the environment.

Likewise the critics celebrated Hartley's work for its connection to New England, but they also recognized its European elements. Rosenfeld found

fault with Hartley's failure to lose himself in the "object" or to take what he calls the "headlong plunge," but still praised Hartley's paintings:

> To go to New England mountain country in fall-time is to see early Hartleys strewn up every furry hillside and 'round every blue-black lake, so perfectly has he translated into impressionistic spots of pigment the cool wistful blue of the skies above dainty pricked forests wine-colored and golden, the waiting stillness of the royal decline. . . . In his large flamboyant Germanic set, Hartley has gotten electrical colors and shapes.[38]

Similarly, Herbert Seligmann commented on the impact of Hartley's expatriate experience, even as he underlined the influence of the New England landscape:

> Stamped indelibly and unmistakably with the something people profess to recognize as New England, he dared a gesture. . . .
> . . . Luscious as was Hartley's sense of paint as expressive material, easy and balanced as his juxtaposition of pure white, yellow and bright red on black, one felt the expatriate in the very pageantry he chose to represent.[39]

Hartley's contradictions between theory and image, and between intellect and emotion, emerged most prominently during the 1920s. His later work resolved some of these conflicts. The criticism of his art focused on these issues because he showed little work during that decade, but was still supported by and considered part of the Stieglitz entourage; thus critics gave him serious consideration despite his erratic changes of direction.

The Stieglitz circle as a group was unified primarily by critical ideas imposed on it by Stieglitz himself and by his most avid supporters among the critics, such as Paul Rosenfeld. Those ideas formed an effusive, expressive aura around the work of artists ranging from the romantic Cubist style of John Marin to the cerebral Charles Demuth. It distorted the clarity of O'Keeffe and simplified the art of Dove. While the best critics appreciated the complexities of these artists, perception of the Stieglitz artists was often dominated by Stieglitz' own perspective and his concern for the expresson of a universal spirituality.

German Expressionism

Treatment of German Expressionism in American art criticism contrasted in several ways with that of the Stieglitz entourage. While prominent critics treated the Stieglitz artists, little-known writers, theater critics or European writers interpreted German Expressionism. The same critics who could not stop praising the emotional aspect of Marin's art were intolerant of emotion as expressed in German art. Clearly this response was in part a result of prejudice against Germany still remaining from the war, in part a result of ignorance.

Most American art critics were more well-versed in French art and aesthetics than in the art of Germany. French art was more appealing than what was interpreted as the crude tonalities of the Germans. So while expressionism in American artists was praised, German Expressionism was considered inferior by the most prominent critics, with the exception of Sheldon Cheney and Katherine Dreier. Exhibitions of German art were almost ignored by major critics such as McBride and Watson.

Perhaps prejudice or ignorance led to this article which appeared in the important art magazine *Studio International* in 1918:

> The true greatness of national expression whether it be in art, science or literature, is that while retaining its racial spirit, its catholicity renders it valuable and intelligible to all civilized races and periods. The fact that a nation's art is devoid of this quality simply reflects the character of its citizenship... Modern Germany has not contributed to art.[40]

Early Articles

The general understanding of German Expressionism was still negative in 1921 for as prominent a publication as *American Art News*:

> As another expression of Germany's post-war extravagance 'Expressionism' has sprung up overnight as the official art of the new republic.
> Expressionism which has not supplanted Post-Impressionism, is nothing more than a revolt against honest work. Finer explanations have been found for it by its exponents. It is a revolt against realism, against convention, against the academic, against the obvious, they say—a revolt against anything and everything under the sun except the expression of the artist's individuality in his individual search for the abstract truth underlying life and nature. His end aim is to eliminate from his work all the stock-in-trade of the schools and studios until what he insists is only the essential remains.
> It is in this elimination that his extravagance runs riot. In such examples as have reached us nothing, indeed, remains save childish scrawls or self-conscious imitation of primitive, of Byzantine, of savage art, too often combined curiously enough with a suggestiveness a decadency [*sic*] which is as far as can be from the freshness, the simplicity, the frankness of the child or the primitives.[41]

One of the first intelligent articles on German art appeared without a byline in the primarily literary and political publication *Current Opinion*. The article surveyed German art: it characterized the Berlin Secession as bourgeois and then covered the November Group and Der Sturm, concluding with mention of the Bauhaus and Walter Gropius. This remarkable article, while superficial in its detail, was not matched in scope or accuracy by any art writers in New York for many years.[42]

Oscar Bie, a German writer, enumerated the principles of German Expressionism as "cosmic feeling, imagination and [concern with] inner

world." He distinguished it from Futurism with its "visible motion," from Cubism, with its "mathematics," and from the " 'general' expressionists," who are not bound to any one principle, but who gyrate on the various degrees of the scale that arrests the objective and subjective." He discussed Kandinsky as an "intellectual influence," calling his book *The Intellectual Side of Painting*. He praised Franz Marc for his "certainty of form invention, power of vision and fantasy," while he saw Kandinsky mainly using color. Bie described Kandinsky's painting with florid energy:

> Instead of every day objects one sees for instance, yellow planes, invaded by furious black strokes. These thicken into balls, out of which again flows a sea of blue-green inks. The sea darkens into red and runs away in myriad rivulets, only to unite again in a paradise of all the colors of the spectrum.[43]

No American critic accustomed to the restraint of French art captured Kandinsky as well, although Bie's description had some of the same evocative quality as a Rosenfeld review. The illustrations for the article included Kandinsky, Oscar Kokoschka, Heinrich Campendonk, Paul Klee and Marc Chagall. Bie classified Ernst Kirchner, Erich Heckel and Max Pechstein as Impressionists, Lyonel Feininger as a Cubist and concluded with George Grosz and Paul Klee as figurative artists. He claimed that Klee "conjures up visions of super-earthly landscapes... without regard to the trivial laws of nature, of gravitation, of order, causality, sense and purpose so that all this Lilliputian loveliness, the finely drawn and tenderly colored world may celebrate its feast in the blessed nowhere or anywhere—even in the face of man."[44] Despite Bie's confusing classifications, his understanding of Klee was sensitive and true to the spirit of the work.

In September 1920 the *Freeman* published an article on "The Expressionist Movement" by C. Kay Scott, a little-known writer who primarily wrote book reviews. It opened with a comment about the dearth of literature on Expressionism:

> It would be interesting to speculate as to the reasons why an occasional trivial leak into American periodical literature is the slight and sole sign of any public interest in the Expressionist movement that has inundated Central Europe and via France, is steadily permeating the entire Continent. Of course, it can never be forgiven that the leaders of this movement [even though they were Russians] actually worked in Germany.[45]

Scott then listed the many different definitions of Expressionism based on the most recent group of German interpretations. She selected Max Deri's terminology: "to use natural forms for the purpose of intense expression of emotion." Her discussion of specific artists owed much to the article by Bie just considered here, and even quoted from his description of Kandinsky, the same

passage cited above. She concluded: "Obviously these men are striving for an immediacy of emotional expression. . . . And the hope of expression is to give, not the invasion of the artist through his senses, but his projection of his own ego through colour, form, line, sound or words." Finally, she extended the term "Expressionism" to apply to all the moderns.[46]

Another source of information on German art in America was the Berlin columnist for *Art News*, the correspondent/critic Flora Turkel. Turkel detailed the changing Berlin art scene covering all aspects of the art world: galleries, artists, auctions and politics. One of her outstanding articles appeared in June of 1922, based on a December 1921 lecture by Kandinsky, only a few months after he returned to Berlin from Moscow. In the interview he characterized the emphasis on practical applications for art in Russia, speaking of a "younger generation imbued with their mission to bring forth a new and prolific era of art." He continued with comments on the contemporary situation in painting in Western Europe, which Turkel paraphrases:

> The present tendencies toward the quiet classical lines of Ingres are only a reaction against the deluge of Cubist and futurist pictures, but . . . according to his opinion the future belongs to abstract art.[47]

Turkel did not discuss Kandinsky's work in the article, but provided one of the earliest English language discussions of art in Russia after the revolution. The following November, Turkel reviewed a juryless show in Berlin that featured both Kandinsky and Gropius, as well as well known German Expressionists. Turkel described both Kandinsky's and Gropius' contribution:

> Kandinsky has decorated a whole room by painting his "absolute" ornaments on black burlap fixed on the walls. This has such a tasteful effect, one is induced to think that decorative art is the very field for his talent. Prof. W. Gropius, leader of a colony of artists residing in Weimar, exhibits architectural designs, ground plans and photos of factories, private buildings and settlement houses. A clear and logical arrangement guarantees ideal usefulness and is united with an aesthetic aspect. These principals are obviously influenced by America's tendencies in architecture.[48]

Turkel balanced information and critical analysis, but she included theory more as record than as rhetoric. She maintained a degree of open-mindedness; as the German art situation changed, she faithfully recorded it for *Art News*. She wrote on the Bauhaus, the "Neue Sachlichkeit," discussed major shows of non-German artists in Berlin and explained the background of German modernism. Turkel was not concerned about being a proselytizer, nor was she interested in appearing in her column as a major intellectual. But she provided the American art-viewing public with a great deal of objective and valuable factual information on art in Germany in the 1920s.

Theater and film critics also provided information on German Expressionism in American periodicals. The theater critics usually discussed the visual arts as well as the theater itself in various ways. Sheldon Cheney's combination of theater and art criticism, already analyzed, is by far the most informed and important of this type of writing, but there were other critics who wrote more exclusively on German Expressionist theater who also provided important insights. Kenneth MacGowan, well known as an important theater critic and theater historian, described Expressionism as "a violent storm beating up from the unconscious mind . . . only a distorted hint of the deep and mysterious sea of unconsciousness."[49] MacGowan directly compared Expressionism in the theater to

> the "modernistic" movements in painting—they represent an attempt on the part of art to escape from the literalism of yesterday and by simplification and exaggeration to present the essence of reality, rather than, as naturalism tried to do, merely the replica of its outer shell.[50]

MacGowan did not have as complete a grasp of modernist theory as did Cheney, but his comments at least contributed to the validity of German Expressionism as an important aspect of modernism.

Another friend of Cheney's who wrote several articles on German Expressionism was Herman George Scheffauer, a poet/historian from San Francisco, who turned from poetry to criticism and social history in the 1920s. Scheffauer's two articles on "The Vivifying of Space" covered the introduction of three-dimensional space into films, particularly highlighting *The Cabinet of Dr. Caligari*. That film, which was shown in American theaters in 1921, was hailed in *Vanity Fair* as a "successful adaptation of Expressionism."[51] Scheffauer's article used evocative language but provided insightful comments:

> [The film's forms are] no longer a dead, two dimensional background for the animate walking, kissing, dancing, murdering pantomines and automata, but expressive presences, immanent forces that act not, but *react* and *enact*. . . .
> . . . The frown of a tower, the scowl of a sinister alley, the pride and serenity of a white peak, the hypnotic draught of a straight road vanishing to a point—these exert their influences and express their natures; their essences flow over the scene and blend with the action . . .
> . . . The sculpturesque plastic treatment of space, that is, the three-dimensional, opposes itself to the two-dimensional world of the painted picture. . . .
> . . . The adaptation of these laws and theories to the film was not mystic or esoteric but very practical. A new instrument or medium is given us for playing upon the souls and imaginations of the Earth-dwellers.[52]

Scheffauer's flowing style is, like Oscar Bie's, similar to Paul Rosenfeld's; even the expression of an autonomous energy flowing between forms has a parallel

in Rosenfeld's writing. But Scheffauer's essay is more formal in its intention, less sensuous and objective in its description.

Scheffauer wrote several other articles that combined rich language and an informed description of Expressionism. In one, Scheffauer made a general statement about the difficulty of categorizing the artists of German Expressionism:

> To find one's way through the art of German Expressionism is like wandering with whirling brain under the livid glass firmament of some huge conservatory and attempting to label outrageous orchids; or adventuring through some vast machinery-hall with a thousand models working and stamping bewilderingly. In this exuberant art we encounter an individualism no longer arrayed in groups or in schools, but cloven sharp and sheer, isolated like so many islands, so many peaks. The encompassing medium, like the sea or the air, is all that the artists have in common—the concept of the expressionistic.[53]

Such florid imagery and exaggeration was not appealing to American critics. When Scheffauer collected these and other essays in a book called *The New Vision in the German Arts*, the review of the book in the *Arts* clearly reflected the prejudice against German art and theory:

> It would be hardly accurate to describe this book as criticism, for that implies a certain amount of detachment and objectivity. Possibly it should be classified as a religious book, the religion in this case being Expressionismus...
>
> From every page, words like "cosmic," "eternal," "elemental," "dynamic" rise up to smite us, until our senses are absolutely stunned. Of the real character of the men and work of which he writes we get only the vaguest idea.
>
> ...[Scheffauer says] we must free ourselves from the British Academy and the seductive poison of Paris. In order to become slaves to the bombast of Berlin we presume.[54]

Scheffauer did not continue to contribute articles to American publications, but turned his energies to such projects as the translation of Georg Kaiser's play *Gas*. Nonetheless, his brief contribution is a significant example of the information available to the American public on German Expressionism by a writer outside the traditional areas of painting and sculpture.

Scheffauer's flamboyant writing contrasted with the more analytical interpretations of Expressionism published in *Vanity Fair* around the same time. An article devoted to Herman Bahr's important book, *Expressionismus*, quoted from Bahr:

> A sharp distinction is drawn by Bahr between the physical and the mental vision. "The eye of the body is passive towards everything; it receives, and whatever is impressed upon it by external charm is more powerful than what it grasps of that outward charm. On the other hand, the eye of the mind is active and merely uses as the material of its own power the reflections of reality." In the rising generation, Bahr continues, "the mind is strongly

asserting itself. It is turning away from exterior to interior life, and listening to the voices of its own secrets; it again believes that man is not merely an echo of the world, but its creator, that he is as strong, at least, as it is. Such a generation will repudiate Impressionism and demand an art which sees with the eyes of the mind. Expressionism is the natural successor of Impressionism, again one sided, again denying one side of human nature; again half-truth."[55]

Bahr's analysis of Impressionism and German Expressionism as two modes of art, one exterior, the other interior, was influential among critics in both the theater and art world.

Exhibitions and Reviews

Exhibition and criticism of German Expressionist art was very erratic. Around 1920 the Société Anonyme began to exhibit German art, but without either a coherent presentation of all the Expressionists, or a complete explanation of their theory. The first show that emphasized Expressionism was the fifth exhibition in November 1920. Of the artists shown, Kandinsky, Rudolf Bauer, Carl Mense and Jacoba van Heemskerck were Expressionists; other artists included were Kurt Schwitters, Laszlo Mohly-Nagy, André Derain, Joseph Stella and Marsden Hartley. The show was characterized as "Modernist" in the press releases. Most of the reviewers singled out Kandinsky and Stella; the *American Art News* favored Stella over Kandinsky:

> The exhibitors include Kandinsky, the Russian painter who was made Commissioner of Art under the Soviet government in 1917. He is the author of "The Art of Spiritual Harmonies." His present examples express color harmonies with little comprehensive design. Carl Mense, who describes himself in the catalog as having fought for Germany and Democracy is represented by color harmonies regardless of pattern . . . Joseph Stella is the most interesting member of the group. He sends two brilliantly colored works of ultra-modern tendency. A "Pittsburgh Landscape" an abstract illustration of a steel foundry in full blast and an "An Italian Procession" which has action and harmony of color."[56]

Hamilton Easter Field wrote for the first time about the Société Anonyme on the occasion of this exhibition, but primarily discussed the interior decoration of the gallery. He also compared Kandinsky and Stella: "Of the paintings, the Kandinsky is the most suggestive of force. It has a strange rhythmic power which finds an echo in the rich 'American Landscape' of Joseph Stella." He simply listed the other artists, concluding that "each piece plays its role in an exhibition in which the keynote is unity," certainly an inaccurate comment given the range of artists included.[57]

Dreier organized a one-person exhibition of Kandinsky's work in March 1923, following her trip to Germany (and elsewhere) in the fall of 1922. On her trip she met Kandinsky for the first time, although she had been a supporter of his ideology for many years. Despite this invaluable contact, Dreier wrote a

catalog essay for the exhibition that was mainly biographical rather than analytical. Amazingly little criticism was generated by the show. The always thorough *Art News* commented only briefly:

> [The works are] all abstractions and all of singularly appealing color. . . . One of his older paintings, in contrast with the new, shows that the artist has grown toward the spacious in design.
> His patterns are made up of motifs in which only at times one may see faint indications of a naturalistic source. A riding crop occupies an important place in one of these puzzling aggregations, but most of the forms seem unintelligible, though by no means unenjoyable to those who like their form and color 'straight'.[58]

The *New York Times* published a brief review by Elizabeth Luther Cary:

> [It is] an exposition on the science of human reaction to form and color. After long study the forms seem gradually to become orderly and inevitable. These paintings are without any concrete appeal except in as far as they show the result of a powerful emotional and intellectual experience.[59]

Cary here was perhaps referring to the absence of objective content in Kandinsky, the quality that made the Stieglitz Expressionists so much more understandable to the American audience.

Even Dreier herself provided only a synoptic analysis of Expressionism. She preferred to extrapolate Kandinsky's ideas to all of art in a more general way. In her 1923 book *Western Art and the New Era*, she listed all the Expressionists, then gave Kandinsky primacy:

> Under the leadership of Kandinsky, they evolved a most interesting theory which was called Expressionismus. It was that the function of the eye towards color would in time be developed as vividly as is the function of the ear towards music. . . . Kandinsky gave birth to the idea that eventually the rhythm of line and color, of color in juxtaposition to color, will be built up architecturally on principles of construction as well as music.[60]

Although Dreier was an ardent supporter of Kandinsky, she never provided a complete explanation of German Expressionist art. Only in 1926 did she assemble the Expressionists as a group, but by then they were overshadowed by geometric abstraction.

The only coherent presentation of German Expressionism in the early 1920s was arranged by William Valentiner. Valentiner, an art historian who lived in Germany, was acutely aware of the anti-German feeling in the United States against German Expressionist art.[61] The exhibition that he arranged was a result of his personal dedication to the German artists and his desire to see them more understood in America.

Valentiner's perspective on German art was first presented in America with an advance article for his show in November 1922 (the show's original opening was to be February 1923). He spoke of Expressionism as "a new system of expression, ... the hidden and never entirely apparent beauties of life. ... " Later on, he defined the style as similar "in coloring and simplification to ... the work of Matisse and Picasso and that of Edvard Munch, the Norwegian ... and there may be some lingering traces of Cubism." Valentiner emphasized the relationship of the art to the suffering of society saying "humanity's sufferings in Central Europe have resulted in another birth of ... abstraction, or mysticism."[62]

Another article that was probably related to Valentiner's exhibition was by Dr. Max Deri, titled "Principles of Modern German Art." Deri had a balanced perspective on German Expressionism, although he perhaps overemphasized the structural aspect. The subtitle of the article stated succinctly "Tendency is away from nature, toward strength of structure and toward compactness." While mentioning the subject of the German Expressionist art as "dreams of the imagination," Deri claimed that these dreams

> showed them another stranger world, more glowing in color and weightier in form. This tendency—'strength, courage, force' dominates all new paintings in Germany. The words may well be considered a motto, standing as they do for the powerful and the monumental, for construction and for consideration.[63]

Deri's emphasis on Cézannesque structure distinguished his analysis from the more mystical perspectives of most other writers at this time, particularly those of Kandinsky. Kandinsky referred to composition and the art element in general, but did not speak of structure.

Even more unusual was Julius Meier-Graefe's major article of July 1923 for the *Dial*. Although titled "German Art After the War" it appears to have been written during the war because of a reference in the beginning to "the impossibility of determining the duration of the catastrophe." Meier-Graefe did not discuss the Expressionists as a viable group, but spoke in terms of Cubism and the influence of Picasso by saying that "Berlin became the cook-house for the formulas of the new doctrines [of Picasso]. ... Hundreds of little Picassos arose and Kandinsky and Archipenko became schools." He then praised Franz Marc as the "most gifted German Cubist," who showed "a way out of this tendency." He called for Germany to free itself from French Cubism, which he considered sterile, praising instead mysticism and emotion:

> They arise out of the desolate soil, and they seem to benefit by loneliness. In loneliness, the insatiable wish grows on them to assemble mankind about them. It is the Germans who have felt the tragedy of a dehumanized art and have fought passionately against it.[64]

Meier-Graefe had rejected the Expressionists as early as 1909, so the *Dial* article revealed a new interest in the modern art of Germany. While his interpretation was important because of his stature as a critic, it would not have aided the average, even very sophisticated, *Dial* reader to understand German Expressionism.

As the show was to open, a major discussion of "Modern Art in Germany" appeared in *International Studio*. The article divided Expressionism into two currents: the emotional and the mental. The first trend was represented by Emil Nolde, the second by Lyonel Feininger and Karl Schmidt-Rottluff. The article also cited Munch and Van Gogh and referred to the "Zeitgeist" as a source of inspiration.[65]

The exhibition itself was titled "A Collection of Modern German Art." It was held at the Anderson Galleries from October 1 to 20, 1923. It included almost 300 oils, graphics, drawings, and sculptures by 29 artists. Although originally intended to be accompanied by an auction, the final plans did not carry that out. Valentiner's lengthy catalog essay emphasized the same theme as his newspaper article, that the anguished source of the art led to an uningratiating appearance:

> One does not expect that an art born out of the soul of the people and expressing its deepest suffering shall ingratiate itself through charm and surface agreeability.... That which is born out of revolutions cannot be measured by the petty standards of an art based on luxury.[66]

He then distinguished between the artists who were more mystical, and those who were more formal in their emphasis. While the division is similar to that of the *International Studio* article just cited, the artists in each tendency were different. Klee and Campendonk "move around in an almost transcendental dream life," while Feininger was more "Cubistic."[67]

The exhibition, despite the efforts to educate the American public in advance, received little positive critical attention. The *Arts* reviewer did not even wait to see the oil paintings, but spoke of the graphics and sculpture as a "frank expression of powerful feelings.... A hysterical quality predominates."[68] The *Art News* distinguished the oils as more radical than the graphics. The oils required "an understanding [and] a psychological adjustment.... A recognition of the political and social changes that formed a background for these men's lives seems to be the key to their determination to paint with a new vision, to make new laws and standards." The sub-title of the article referred to the art's "intentional brutality."[69]

The longest review of the exhibition was by the conservative Royal Cortissoz. He carefully recited the Valentiner catalog premise that the art was related to spiritual turmoil. Cortissoz praised this concept as "the most lucid a

pronouncement as has come, to my knowledge, from the modernistic camp."
Predictably, he criticized the art for its lack of form and its "brutality of taste
which gave the whole show an air of coarseness and crudity."[70] While Cortissoz
shared the other critics' bias for French art and a restrained aesthetic, his article
gave the important exhibition the attention that it deserved.

Shortly after the Anderson Galleries display, the Weyhe Gallery showed
German watercolors and prints. McBride wrote about both shows in his review
of the smaller effort:

> It is somewhat easier to study this collection than the bigger collection of German works that
> appeared earlier in the season . . . —and this is chiefly because this show is limited to
> watercolors and prints. It was the oils that presented the stumbling blocks to the first
> exhibition. . . .
> While there is much cleverness and, in some cases, erudition, the call to arms is usually too
> loud in all these works. We are not deaf. We usually hear well enough when the voice is not
> too muffled. These German artists . . . give the impression of still shouting above the tumult
> of the war. In other words they force their efforts
> . . . Some disappointment has been expressed over the coolness with which we received the
> first German show, and it is inevitable that we shall be accused in return of being unreceptive.
> That is not the case. We are the most unbiased of people when it comes to supplying our
> wants. But that's it, we must be convinced of our need before we import.[71]

McBride clearly felt that German art was not needed in America. The reference
to the critical reception for the larger Anderson Galleries exhibition
corroborates the evidence already cited of a skimpy critical response. The art
critics were surprisingly unanimous in their rejection of German
Expressionism. Despite this rejection however, the show sold $4,000 worth of
art.[72]

One other example of the critical neglect of the German Expressionists is
the important show of the "Blue Four" at the Daniel Gallery in February 1925.
The group of artists sponsored by Galka Scheyer included Alexei von
Jawlensky, together with Feininger, Kandinsky and Klee. McBride's article
summarized Kandinsky's shows in America, then characterized his and Klee's
work in the exhibition:

> Kandinsky first bowed to America in the famous Lexington Avenue Armory Show and later
> on a splendid essay in abstract painting by him was shown in the rooms of the Société
> Anonyme. Since then his untrammelled imagination, not content with the earth and things
> earthly, has endeavored to harness the stars. He is undoubtedly sincere and serious, but he is
> also forbidding.
> Klee, on the other hand, is an Ariel. He is light, dancing, fantastic but always the charmer.
> No matter what the motif, he plays with it with astonishing agility and usually induces a
> mood. One of his pictures is called "Mathematic Vision," . . . A curiously illuminated
> pathway upon a strange world is ornamented with hieroglyphics, that as far as I'm

concerned, might easily pass for scientific notations. The artist is evidently mocking at the superman of a too scientific age, but he achieves also a highly decorative page. That ought to speak to the fancy of a playful mind. Feininger too is decorative.[73]

McBride neglected Jawlensky. The review was the first time Klee had been considered at such length. The exhibition toured the United States, apparently for several years. *Art Digest* referred to it in a collection of criticism it presented on the four artists, quoted from European sources, in mid-December 1929.[74]

In the second half of the 1920s, favorable reviews of German art began to appear. By the time of Max Beckmann's first one-person show in America at Neumann's gallery in 1927, Expressionism was an established style. Constructivism had replaced it as the cutting edge of the avant-garde that the critics rejected. The article on Beckmann in the *Arts* is a major contrast to that periodical's earlier writing about modern German art:

> [Beckmann] interprets his 'Zeit' with material found in the very depths of being and not by the surface manifestations of mechanism, so often employed as the justification for Constructivism, Purism and Compressionism....
> ... His strength lies in his unique approach to painting coupled with a philosophical turn of mind that we recognize as being definitely German.[75]

The same year the Carnegie International exhibition in Pittsburgh had a German room that included all the major young artists. Watson pronounced that it was

> so German, so masculine, so unfashionable and often in such appalling taste....
> ... The Germans [are] practically unknown to the Americans. The few spasmodic attempts 'to put over' German art here have failed, partly no doubt because our eyes are so trained to the Paris product and all those highly sophisticated eliminations which are now as proper in any correct modern collection as knickerbockers are on the golf course.[76]

In 1928 the *Arts* finally published a long discussion of German art with illustrations of work by Otto Dix, Oskar Kokoschka, Karl Hofer and others. The article was couched in the past tense and focused on the turmoil of the early years of the century as the period of greatest creativity in Expressionism. The writer considered the "psychic" aspects of the paintings, as well as the personal dimension.[77] Thus, by the late 1920s, German art was familiar even though still considered to be aesthetically difficult to tolerate.

4

Cubism

Interpretations of Cubism

Already at the time of the Armory Show, Cubism was a familiar word, making headlines in the newspapers. Primarily used as a term of derision, it was understood by intelligent commentators as part of a development from Cézanne through Futurism.[1] The style was identified with cubified landscapes and analytic Cubism, but most particularly with Marcel Duchamp's *Nude Descending a Staircase*. Collage was mainly associated with Dada in America.

The primary explicator of Cubism in the early teens was Francis Picabia. As the only European Cubist in New York at the time of the Armory Show, he naturally was sought after by the press. His phraseology, such as the idea that Cubism was the "objectivity of a subjectivity" or the "abstract reality of form and color" was continually quoted in articles on Cubism.[2] Stieglitz embraced Picabia and gave him a one-person show shortly after the Armory Show.[3] Picabia's theory was based on the Symbolist-influenced Puteaux Group. That same theory formed the primary source for Walter Pach, a major interpreter of Cubism in America.

Walter Pach

Walter Pach had been in Paris as early as 1904, and had witnessed the complete evolution of the modern movement up to World War I. He was a part of the Puteaux Group that included Albert Gleizes, Jean Metzinger, Marcel Duchamp, Jacques Villion and Raymond Duchamp-Villion, as well as Picabia. Pach's analysis of Cubism reached a broad audience. He wrote numerous articles and books, and lectured at the Metropolitan Museum of Art and the Société Anonyme. The analysis that he presented to America covered analytic Cubism, but stopped short of synthetic Cubism. Moreover, he never altered the principals that he acquired during the early years of Cubism.[4] The pamphlets that he wrote in 1913 and 1914 for the Armory show, his articles for

the *Freeman,* a weekly newspaper, and the catalogs for the Société Anonyme from 1920 to 1925, all share the same underlying ideas.

His central tenet, a concept first articulated by Gleizes and Metzinger in 1912, was the importance of the artist's inner concept of reality, not just of visual reality, in the creation of art. For Gleizes and Metzinger, the artwork was a manifestation of a higher reality that existed within the artist:

> There is nothing real outside ourselves; there is nothing real except the coincidence of a sensation and an individual mental direction. Far be it for us to throw any doubts upon the existence of the objects which strike our senses; but rationally speaking, we can only have certitude with regard to the images which they produce in the mind.[6]

Similarly, Pach wrote in his 1924 book *Masters of Modern Art:*

> Objects are copied for their own sake.... The objects come like a concrete fact or a date in a discussion of ideas ... The artists give us their equivalent ... [of] thought ... what we ask to 'recognize' is the spiritual value of the artists who did the work; something which is not expressed through resemblance to nature, but through aesthetic thought.[7]

This terminology clearly relied on Symbolist concepts.[8] Gleizes and Metzinger considered a work of art as an independent organism: "The true picture ... bears its *raison d'être* within itself. It does not harmonize with this or that ensemble; it harmonizes with things in general, with the universe; it is an organism."[9] Pach wrote that the

> Cubists take the elements of expression from the forms and colors of nature, and use them not to represent objects, but to produce an organism which will contain in terms of art what a given subject means in terms of sensation.[10]

The Symbolist orientation of Pach's ideas, centering on the equivalence of art and sensation and the autonomy of the art object, reflected the influence of Duchamp as well as of Gleizes and Metzinger.

Pach alone among the writers of the 1920s recognized that Marcel Duchamp was pursuing the ultimate implications of the intellectual, conceptual aspect of art. He did not discuss Duchamp as a Dada, a style that Pach downgraded, but as the "purest" example of intellectual art, saying, "experiments with the painting of motion (such as the *Nude Descending a Staircase*) carry him to a complete acceptance of the conception of pictorial space as a thing nonexistent outside the mind." He interpreted Duchamp's use of glass as a material as a way to

> orient his work in the direction of pure idea. Perhaps a new generation will have to come before the true effect of his research will be seen in the work of men who feel the current of life strongly enough to render it in such epitomized fashion once more.[11]

Such an accurate prediction of Duchamp's importance for later generations of artists suggests Pach's acuteness as a critic.

Pach also stressed the classical basis for Cubism, seeing it as part of an evolution in art:

> The parallel between our conditions and those of a hundred years ago lies in the need to unite the classic aesthetic principals (seen today in the work of Cézanne, Seurat and Matisse) with the vision of our time, especially that vision of the inner world, first predicated by Redon and carried by the Cubists to a point where it breaks entirely with the formula for appearances.... That [Cubism] is a great force negating the false things of our time and strengthening much that is best in art, I believe, to be beyond doubt. [12]

Pach owed a debt to Elie Faure in his emphasis on the classical element in art as well as in his use of evolution as a model. Faure's effusive books poetically presented a spiritual unity in art. [13] By combining the principal of the classical aesthetic element and evolution as Faure did, Pach was able to interpret Cubism, particularly analytic Cubism, as a part of a continuous classical style: he inserted Cubism between Ingres and the Ingresque works of the 1920s.

Pach's intellectual interpretations reinforced the idea held by many less sophisticated writers that Cubism was a sterile, intellectual expression. Aside from such writers as Willard Huntington Wright and Alfred Stieglitz, critics missed the relationship of the spiritual and sensual world of the mind and art. The general public perceived only the incomprehensibility of the theory. They failed to grasp the connection Pach made between art and life in a passage such as this:

> The life of our time has its more obvious expression in the size of buildings and the quantity of manufacturers. But such things, by the very weight they lay upon the imagination make it seek the more eagerly for an expression dealing with the essentials of our experience, not as they exist... but as we know them in their assimilation into our thought, and through the forms and colors which so refine them. [15]

Here Pach interpreted art as the transformation of the physical world into an abstract concept. This idea was reiterated when Albert Gleizes came to the United States. In a 1919 essay Gleizes stated that

> the aim of art has never been a material imitation with all the multiple consequences and compromises that implies; art has always been the plastic embodiment of spiritual values. [16]

In 1925 the *Forum* magazine invited a debate over the importance of Cubism between Pach and a writer named Alfred Churchill. Using a preanalytic Cubist painting by Picasso as an example, Pach spoke of "forces" and "principles," saying the art work was an "equivalent for the structure of the world." Churchill found Picasso's "abstract" work too removed from reality to

be understood, claiming that the organization and design had no meaning.[17] This issue was the central reason for the rejection of Cubism in America, despite Pach's sophisticated arguments.

Henry McBride

Henry McBride also spent many formative years in Paris,[18] but his criticism of cubism was a sharp contrast to Pach's. His reviews have a lighthearted tone without intellectual pretensions. He occasionally gave indications, however, that he shared Pach's premise as a point of departure for understanding Cubism. When the Société Anonyme translated Apollinaire's *Aesthetic Meditations*, an early interpretation of Cubism,[19] McBride excerpted a large section of the first chapter in his newspaper review of the book, with the explanation that

> this is so precise an exposition of what the best known cubists were after that it would have seemed that nothing further need have been written upon the subject, yet so slow is this vast modern world in getting to the true founts of knowledge that oceans, as the public knows, have been spilled.[20]

On the occasion of the redisplay of Duchamp's *Nude Descending a Staircase* in a group exhibition of Cubist artists in 1924, McBride came closest to spelling out his own philosophy:

> The 'crime' that the Messrs. Picasso, Braque and Duchamp committed was to speak to the imagination in the terms of the painter's language. No one ever supposed that the book and the bell and the candle, or the lemon, banana and peach of the former generation's still lifes, had anything sacred in themselves—it was merely the style of the painter who happened to see something in them that counted. The new men merely put into practice the theory that Whistler preached and added a few new angles from their own experiences and the text books of the scientists—and scandalized the world.
> The fact that this revulsion from the subject occurred at the time of the great war gives it a significance that it might not have had in times of peace, and we may be sure that the psychologists of the future will be most illuminating in their efforts to coordinate it with the other soul manifestations of the period.[21]

The references to Whistler suggest McBride's roots in a late nineteenth century *l'art pour l'art* tradition, while the last paragraph indicates that he saw a connection between the artists and their social conditions.

McBride alone distinguished the transformation of Cubism by various artists and recognized types of Cubism. At the time of the opening display of the Société Anonyme, a mixture of Picasso, Braque, Villon, Stella, Duchamp and Man Ray, he characterized the Société as a "shrine of Cubism," calling the work of Stella and the French-influenced color abstractionist Patrick Henry

Bruce, "old fashioned cubism." He then confused the issue by referring to all the art as "the various expressionistic schools."[22]

He separated Precisionism from Cubism in such artists as Niles Spencer and Charles Sheeler, saying of Sheeler's *Bucks Country Barns*:

> Mr. Sheeler's Barns are genuine Bucks Country Barns, in spite of something in the work that the uninstructed will call 'cubism,' but these same uninstructed persons . . . will doubtless sigh for a few more vulgar details.[23]

McBride characterized Niles Spencer's painting as a type of nature-based Cubism:

> Anyone who looks out of a New York window upon rooftops sees arrangements at times that are undoubtedly cubistic, but not everyone sees them so delightfully as Mr. Spencer. . . . It is cubism and not cubism. It could never have been painted in just that style had not cubism passed this way, yet the effect is almost a literal one. What we get in the apres cubism work, I suppose, is a keener sense of rhythm. The tones are flat, but the relationships between the flat tones are not only precise, but lively.[24]

McBride's criticism of Cubism sought to stem the tide of reaction against the style. He praised Marsden Hartley in 1921 for writing about a group of artists who were loosely categorized under the term "cubistic": "Better service still is rendered in essays devoted to the artists who delve into the abstract and from whom the public has been frightened by the disrepute of the term 'Cubistic.'"[25] In reviewing a 1925 Léger exhibition McBride again emphasized the continued importance of Cubism:

> The occasion was unlike some in the past for no one was heard to ask what the pictures meant. This indicates either that more people now understand cubism or that cubism itself has become clarified. Rumors have persisted of late that cubism is completely forgotten in Paris and that no one practices it anywhere anymore. The Léger exhibition quashed that rumor.[26]

He even found examples of Cubism in far away places such as Santa Fe, New Mexico:

> Cubism and all that sort of thing which our esteemed contemporary, the *American Art News* assures us is to be definitely suppressed this winter in New York and Paris, had become the question of the hour in that Western art center, Santa Fe. John Sloan who has just returned from a sojourn there reports that the entire social fabric is in danger of being rent over the latest production of Mr. Brer Nordfeldt and Mr. Harry Burlin. The Santa Fe opinion prevails that their paintings are nothing more nor less than Bolshevist propaganda.[27]

McBride's ongoing support of Cubism was partially related to his close friendship with Gertrude Stein. From the time of the Armory Show he corresponded with her and visited her in Paris, where he would have met many of the major Cubist artists and seen their work. Stein's writing, which he once imitated, used suggestive references and repeated sentences rather than factual description,[28] a faceting of reality similar to Cubism. McBride, while his criticism was much less radical in style than Stein's, also presented facets of the art such as its display, the people looking at it, the materials or the artist's personality. He suggested and alluded to ideas rather than making straightforward statements.

Analysis in Surveys of Modern Art

Katherine Dreier's *Western Art and the New Era,* considered Cubism only briefly. She called Cubism a "special form of dress in which the new idea was clothed," a phrase borrowed from Pach, but added that the cube is "only the outer dress, not the inner vision which these men were trying to express."[29] She interpreted a painting by Picasso called *Spring* as:

> the feelings which early Spring awakens in the artist.... This power to render sensation, which formerly could never be rendered through the medium belonging to the painter, is one of the main achievements which the modern vision in art has accomplished....[30]

By emphasizing emotion, Dreier defined Cubism within her larger interpretation of modern art as the expression of inner feelings.

Sheldon Cheney in his *Primer of Modern Art* was more strongly influenced by formalism in his treatment of Cubism than by either French aesthetics or Expressionism, although he does briefly cite Gleizes' book *Du Cubisme et les Moyens de le comprendre.* Cheney's chapter on Cubism is an early attempt to present a step-by-step evolution of the movement from Cézanne through Léger. He used the illustrations to underline that "we have been working closer and closer to abstraction. That indeed is the logical progression—attempted improvisation in abstract form—the final answer to the Cubists' desire to disorganize objective nature."[31] The last illustration in the Cubism chapter is by Kandinsky, making Cheney's point that Cubism and abstraction were connected. He saw Cubism as a byway that developed a rigid vocabulary, yet contained a principal that affected later art:

> The most valuable legacy of cubism, however, is in the indirect effect it had upon men who never subscribed to its coded principles. Many artists must have felt it a further warrant for cutting themselves off from literary and representative elements in painting; not a few ... found a structural strength which lasted over, or perhaps led them into, a more vital work in abstraction or Expressionism later.[32]

Frank Rutter in his 1926 book *Evolution in Modern Art* presented a step-by-step survey of Cubism up to Léger. Although more conservative than Cheney, he did discuss the influence of Cubism, as well as its history:

> Each year it is becoming more and more certain that twentieth century painting is evolving a new style and a new vision. That style has, to a great extent, been formed by Cubism, which is the first great constructive movement in modern art since Impressionism. Fauvism was a reaction: Cubism is an advance. Its theory and philosophy are of doubtful value, but its discipline is excellent, and it has prepared the way for a new vision of the world. . . . That is a vision that pierces to fundamentals and states the bedrock of humanity and life with crystal clarity and granite-like obduracy.[33]

The review of Rutter's text published in the *Arts* complained of the book's "tepidity," of the lack of coherent thinking, and the propensity to string ideas together.[34] Yet, since it offered some of the basic interpretations of modern art in a simplified language, Rutter's book contributed to the growing understanding of Cubism and other modern art movements.

Reginald Wilenski's *The Modern Movement in Art* adopted a more scientific approach to the subject by analyzing the procedures of modern art systematically. Significantly, it included collage under "flat pattern" Cubism:

> . . . those curious pictures where pieces of coloured paper, buttons and so forth were applied to the surface of the canvas as units in the creation of formal design—pictures which it is indisputable broke entirely fresh ground in pictorial technique.[35]

The *Arts* also objected to this book on the basis of its "system of pigeon holes," but admired Wilenski for clarifying the art of the modern movements.[36]

Jay Hambidge

Jay Hambidge's eccentric theories of Dynamic Symmetry can be identified as a bizarre response to Cubism. Hambidge, in an article of 1914, claimed that Cubism was based on conservative studio formula and mathematical principles, but without a system. He found that all art lacked a science of design, although he did believe that Picasso was informed by the principles of Plato:

> That great romanticist Plato who reduced all things ultimately to ideal geometrical forms in a search for the geometric soul of reality, in spirit furnishes Picasso with a working inspiration. Plato is reborn in Picasso, who consciously or not, attempts to express the Platonic ideal pictorially. Out of mathematics we are to make art; with mathematics we may set forth our inner feelings and our attitudes toward external solidities.[37]

Hambidge saw a follower of Cubism as "forced to utilize whatever broken and inefficient tools he can command for the building of his superstructure, because he has no scientific, coordinated principles of design."[38] Thus, Hambidge saw the Cubists, other than Picasso, as superficial and still utilizing the same formula that earlier art had used.

As a result of this attitude Hambidge pursued a study of what he called "dynamic symmetry" in Greek art, in order to provide a scientific basis for design in abstract art. Hambidge's theory led many artists to the idea that they could base their art on the application of a scientific system. The geometric appearance of Cubism was certainly the trigger for Hambidge's theory. Analytic Cubism did reflect an interest in new mathematical principals and scientific ideas, but Hambidge, rather than investigating the new concepts of geometry, attempted to discover mathematical systems from ancient art that could be used as a basis for new art.

Howard Giles, a founder of the group that used Hambidge's system, claimed in a 1921 lecture that the Cubists had "not gone far enough." They needed, he said, "symmetrical triangulation." He also objected to their limitation to two dimensions:

> This gives an almost puritanical and dogmatic expression and absolution. They could eliminate any possible manifestation of realism by this canon because they deal primarily with abstract form or we might say geometrical form . . . ultimately the artist will organize on his drawing surface a series of similar shapes based in symmetrical triangulation and the picture will grow in conformity with nature's plan.[39]

These ideas contrast to those of Walter Pach and other Symbolist-influenced interpretations of Cubism. Rather than being cerebral and philosophical, the Hambidge analysis is parochial and rational. The popularity of his interpretation with American artists suggests how distant the American mind was from the Symbolist aesthetics of France. Many artists seeking to modernize art, but totally unable to understand the esoteric principles of Cubism, responded to Hambidge's practical approach.

Andrew Dasburg

Unlike Hambidge, Dasburg was part of the art world, and aware of the evolution of modern art since Cézanne. Dasburg's essay "Cubism, Its Rise and Influence," presented yet another interpretation of the role of Cubism. Dasburg's interpretation appeared prominently in the *Arts*. He also presented it to the conservative artists of the Woodstock Art Colony.

Dasburg assimilated the available theory and put it into his own words. He recognized the derivative character of American modern art created under

the influence of Cubism, saying honestly that "not until it is realized that originality never follows from this attitude of assimilation and refinement can we become innovators."[40]

Dasburg's interpretation of Cubism identified "three developments—movement, spatiality and pure form." He summarized Cubism as "a geometry of rhythm and an architecture of matter," claiming that "the instinctive experience of our natures is then the truest guide for the proportioning and directing of form into significant symbols of rhythm."[41] Dasburg combined a watered down formalism with a watered down expressionism welded together by his literalism. He was commenting, however, on a phenomenon that is fundamental to understanding American art criticism in the 1920s, the pervasive importance of the Cubist principals and the way in which they were used in America:

> With a few distinguished exceptions, the idiosyncracies of Cubism rather than its functional ideas are understood. Cubism has permeated our art in varying degrees with a severity of line and acute angles just as impressionism did with blue and orange.[42]

The superficial understanding of Cubism by American artists as described here was a major cause for its rejection by critics in the middle of the decade. Seeing innumerable examples of Cubistic realism with little originality, critics had a basis for suggesting that Cubism was no longer an inspired source for art. Ironically, Dasburg himself painted in this manner in the 1920s. The majority of the members of the Whitney Studio Club, characterized here as mildly modern, also belonged to this category of derivitive stylists. The combination of Pach's intellectual explanations and the watered down or pseudoscientific application of Cubism to painting and sculpture gave Cubism a negative image in the 1920s.

The "Decline of Cubism" Criticism

Guy Eglington's "Complete Dictionary of Modern Art Terms" referred to Cubism in this laconic summary:

> CUBIST—Natural child of Pablo Picasso, abandoned on Albert Gleizes' doorstep. Still enjoys a certain subterranean fame, thanks to the tireless efforts of its foster-father. See GLEIZES and METZINGER.
> CUBISM—Gleizes "Ce qui devait sortir du Cubisme." *Coll.* vulgar synonym for modern art. *Phil* The ultimate mechanization of the painters materials i.e. color and line; differs, however, from useful mechanics in that, while the engineer is rather concerned to make a thing that will work and hardly stops to consider whether it looks like a machine, the cubist starts with the later preoccupation.[43]

Similar parodies appeared in the editorials of the *Art News* from 1925 to 1928, under the editorship of Deoch Fulton, assisted by Guy Eglington. The change in the *Art News* after their arrival was striking. In 1924 the newspaper wrote simply of a "discard of cubism."[44] In November 1925 an editorial appeared under the title "Passing and Permanent":

> The cubistic and post-impressionistic school seems to be fading among American painters....
>
> ...Novelty is accepted and becomes orthodoxy; Orthodoxy becomes moss-grown and itself begets heresy, heresy is accepted and in turn its essence is added to corrected, rejuvenated orthodoxy....
>
> School follows school in its effort to make permanent one man's way of seeing things and of setting them down. From the genius and his works, rules are deduced.... Even the crank and the freak may serve the purpose of expression for even his exaggeration causes reexamination of the established way and consequent correction and improvement....
>
> So there is no need to be patronizing toward cubism and post-impressionism and whatever seeming vagary. Schools, systems, methods, means are more or less momentary.... What is permanent is man's hunger for beauty. He can not choose but obey the impulse to satisfy, by all means, that dynamic divine craving for beauty.[45]

The following month, another lengthy editorial article pointed out two reactions to Cubism: pure abstraction and realism, suggesting that abstraction was being rejected in favor of a new concern for subjects:

> The modern critical hen seems about to cross the road. For quite a while she has been on the 'abstract' side and, whether because the pickings have been poor, or just because, she is casting furtive glances at the academic scratching ground. The most 'modern' critics now lapse occasionally into a discussion of the subject matter of a picture; we see fewer paintings with a bald numeral for subject organizations, fewer "Formal Arrangements." Picasso discovers to us new beauties in Ingres and the Greeks; Matisse becomes outwardly at least almost literal; The cubists seem to have designed their own tombstone.
>
> Undoubtedly part of the change is a genuflexion to a public which has refused to hang pure design.... We can be led to see beauty, but few of us have perceptions quick enough to recognize it in the abstract. We need the introduction which subject matter gives.[46]

At the same time that it editorialized in support of subject matter, the *Art News* recorded the many exhibitions of modern art and its increasing value. Ironically, it decided to drop the word "modern" as a description for contemporary French art because "modern as an adjective has been overworked and has lost its significance."[47]

The *Arts* also complained frequently about Cubism. Forbes Watson, as early as 1913, had complained about the literary qualities of the style.[48] He felt it was more important as an influence than as an art expression with its own significance. As a result he gave only slight coverage to the Société Anonyme exhibitions and other shows that included Cubism. On the occasion of the

International Exhibition of 1926 he asked Thomas Hart Benton, already a noted antagonist to modern art, to review it. When the De Hauke Gallery displayed a major survey of Cubist art in 1930, Watson included only a brief reference to it at the end of a long series of reviews on the shows of his favored Whitney artists. Watson saw Cubism as a fad that was passing:

> An artist who was recently experimenting with cubistic painting is now unwilling to show the results of his experiments for fear someone should say that he is old-fashioned. This gentleman keeps his ear to the ground listening to hear what the latest thing in modernity may be.[50]

Watson combined a concern for modern and American art, but the side effect of his desire for an American art was an increasing hostility to the intellectuality of Cubism. An article on Diego Rivera articulated this perspective:

> For me, now, cubism seems too intellectual, more occupied with virtuousity, with technical rarities, than with the natural fluidity of design, supported by a fixed law of inner structure.[51]

Clive Bell wrote in the American press on more than one occasion about the negative influence of Cubism. In a 1920 *Arts and Decoration* essay he characterized the role of Picasso in relation to other artists:

> Picasso is the liberator. His influence is ubiquitous.... Not only those who, for all their denials—denials that spring rather from ignorance than bad faith—owe almost all they have to the inventor of Cubism.... His is one of the most inventive minds in Europe.... [He] sets himself to analyze and disentangle.... He proceeds by experiment, applying his hypothesis.... At the end he is approaching that formula toward which his intellectual effort tends inevitably. It is time for a new discovery...
>
> While round the trunk of Cubism is a veritable sea of swaying, struggling, ravenous, creatures... Picasso himself is already far away, elaborating an idea that came to him one day as he contemplated a drawing by Ingres.[52]

In 1923 Clive Bell wrote more emphatically on the same theme in an article for *Vanity Fair* titled "The Rise and Decline of Cubism." He repeated the same accusations in relation to the "decline" as in his earlier article, but also affirmed the importance of Cubism:

> Cézanne freed artistic sensibility from a hampering and outworn convention; Cubism imposed on it an intelligent and reasonable discipline....
>
> For if Cézanne drew the attention of painting from what was superficial in natural forms to what was essential, from the fat to the muscle, it was Cubism that gave us the anatomy of the picture itself.... Certainly [the artists]... are trying to clothe the bones with flesh, but they do not forget that the bones must be there....[53]

Bell supported the original development of Cubism, but believed that by the 1920s it was no longer the cutting edge of art. This was a widely held and not inaccurate view. Yet, the rejection of Cubism and its subsequent progeny was mixed with a large measure of chauvinism in American critical writings.

Thomas Craven reflected this chauvinism most obviously in his complete turnaround in relation to Cubism. He shifted from support of modernism to support for subject matter in response to negative feelings about Cubism:

> A cubistic picture is solid assemblage of irrelative details. Its exponents have failed to see the necessity for the clean contour, to grasp the fact that decisive linear variations capable of being followed without strained attention are indispensable to rhythm. The movement has about run its course.[54]

His article at the same time in the *New Republic* was even more emphatic in condemning Cubism:

> Cubism has become an intricate and highly perfected mannerism.... By insisting on form [it] has been of great value to art, but it is not an art in itself. It is a great step leading to a new realism. Any effort to make it function as a finished rendition of emotional form is a sign of decadence with the pure abstractionists, it is hard to be tolerant. Unmoved by the nobler forces of life, these curious workmen resort to the alleged, psychic power of odd combinations of angles, lines and patches.[55]

Craven next rejected abstract art in favor of Regionalism, an art that related to the American environment. In Craven, frustration with the theoretical aspect of Cubism led to his support of its opposite, American scene realism.[56]

Julius Meier-Graefe wrote one of the last major articles to analyze the role of Cubism before the opening of the Museum of Modern Art in 1929. The subtitle "How the Cubists, Though Now in Eclipse, Have Influenced the Best Art of our Time" suggested the central role that Cubism played in the 1920s in relation to the newer directions in art such as the Bauhaus. Meier-Graefe felt that Cubism had been a catalyst that allowed artists "to extract a certain flavor from the machine age." Concluding that "we no longer speak of the sieve, which belongs in the kitchen, but of the one essential factor—the material sifted." So for Meier-Graefe the Cubists were a bridge between earlier and later art; they had transformed the accomplishment of Cézanne in a style that "went beyond geometry and became hieroglyphics."[57]

Most critics recognized that Cubism was a major event but felt that it was academic, theoretical and removed from the real world. As with all generalities, the idea of the decline of Cubism related to the actual situation, in that Cubism was no longer the current style except among a few artists. It was the avant-garde art of the teens. The critics took this actual situation and used it to denigrate the value of Cubism, declaring that the return to naturalism was a

logical result of the move by the Cubists to an art too far removed from the real world. At the same time, they praised Cubism for freeing art from imitative reproduction. The situation was further confused by the overlapping of Cubism and modernism. The two were frequently equated. The actual situation was more complex. Some indication of that appears in the struggles the critics had with criticism of art by individual Cubists.

Reviews of Exhibitions

Cubism as an idea generated much more literature than did Cubism in relation to specific artists and exhibitions. No single display provided a coherent survey of the development of the style; surprisingly few exhibitions even included Cubist art. Cubist artists were most frequently seen under the auspices of the Société Anonyme, where major displays featured Alexander Archipenko, Jacques Villon and Fernand Léger. Thus, awareness of exactly which European artists practiced Cubism was conditioned by the choices of the Société Anonyme.

Alexander Archipenko

Alexander Archipenko was to the mid twenties what Picabia had been to the early teens: a resident European interpreter. Even before he moved to the United States, his one-person show at both the Société Anonyme and the Daniel Gallery in 1921 stimulated the *American Art News* to write with a note of skepticism:

> If Alexander Archipenko, the Russian sculpto-painter succeeds in revolutionizing the art beliefs that have held the world for ages, he will have accomplished one of the greatest tasks yet known to art history. That this is his ambition is frankly expressed in the journal devoted mainly to his work published by the Société Anonyme....
>
> The catalog states that "Archipenko has swept Europe in past years by his inventive qualities." But if he is to "sweep America" he will have the double task of transforming the American mind, which yet adheres to the objective in art rather than to "cosmic bodies."[58]

In 1923 the *Art News* honored Archipenko's arrival in New York by the headline "Russian Modernist Would Have America the Central Point for a World-Wide Exchange of Ideas."[59] Archipenko, like J.B. Neumann, came to America with grand ideas for the spread of modern art. He proclaimed that in America the "external circumstances are favorable to that peculiar and concentrated state of mind which is necessary for the artist to create."[60] Archipenko opened an art school in Woodstock, New York in 1924 and around the same time provided a short statement on his theory of art. Awkwardly expressed, perhaps because of a language problem, the essay

presented the already familiar ideas of the non-imitative nature of modern art and its principles of formal design.[61]

Archipenko's work in the 1920s was a strange mixture of avant-garde Cubist experiments and more conventional figurative sculpture. The criticism of his exhibitions did not penetrate the nature of the sculpture, but only considered the contrast between his realistic and his "distorted" work:

> The marbles and bronzes are full of Archipenko's purposed distortions and disproportions of the human figure, combined with surfaces of very great beauty. Most striking of his "sculpto-paintings" is the "Woman" fashioned in the half-round of brass, copper, strips of lead taped on and painted, a piece of freakiness lamentably "old fashioned" even in the Modernist school. His "Portrait of Madame Archipenko" shows how well he can paint, even to such naive touches as the grain of the wood in the table top and the cubistic still-life objects standing on it.[62]

By 1926 critics, acknowledging Archipenko's swing to the figurative, commented that it was "hard to conceive that only a few years back [Archipenko] was the white hope of the moderns...[an] apostle of the new sculpture."[63] As his work emerged as increasingly figurative, Archipenko reinforced the "end of Cubism" theory; his polemic contributed to the heavy theoretical image of the style.

Christian Brinton's catalog for Archipenko's second one-person exhibition at the Société Anonyme in 1924 summarized Archipenko's rejection of Cubism as a formula, paired with acceptance of it as a source for his art:

> At first sympathetically disposed toward cubism, Archipenko soon renounced a formula that to him seemed doctrinaire and deficient in emotional content....
>
> The art of Archipenko in its definitive aspects is an art of pure, voluntary abstraction, assuming its own pre-ordered shapes, expressing its own specific concepts. Released from the emotional talk of realism and naturalism, it is sufficient unto itself, a perfect embodiment of plastic absolutism. These slender, rhythmic figures and glowing reliefs live, indeed, in a world where in the basic elements of line, form, movement, and colour have passed through a process of aesthetic sublimation, and have actually been born anew. Held in equilibrium by logically sustained laws, this art expresses for the first time relativity in the round. And above all is the mystic, stylistic vision of Aleksandr Archipenko essentially modern in air and appeal.[64]

Brinton combined his own animosity toward the source style, Cubism, with his theory of the importance of the mystical dimension in the art, to justify Archipenko's avant-garde sculpture. The passage is a typical example of the 1920s criticism because Brinton imposed his preconceived ideas about art on the work.

Jacques Villon

Unlike Archipenko's contradictory style Villon's art was a straightforward continuation of Cubism, a refutation of the idea that Cubism had exhausted itself.[65] Walter Pach in his catalog for the exhibition referred to his theme of the classical tradition as he traced the development of the Cubist work. He spoke in a characteristically amorphous way of the paintings as "the embodiment of that idea of art whose object is expressive and aesthetic values, independent of appearances... "[66] The *Art News* was more specific:

> He has added to his mastery of color, a strength and solidity of design which was not always apparent in the earlier canvases. And this in spite of the fact that he was far more scientific in his cubistic period....
> The purely mathematical side of his art has been made subservient to his joy of creation. Traces of the famous triangular planes remain to give depth and accent form, but over or through the solid structure play fresh, stirring color harmonies. He has advanced in the scale of greatness from the man of theories, concerned with scientific abstractions to the poet to whom all things are but means to the creation of beauty.[67]

The *Art News* reporter looked more closely at the individual paintings than Pach, and thus accurately distinguished the earlier from the later Cubist work.

Alexander Brook's positive analysis of Albert Gleizes' abstract paintings of the 1920s makes an interesting parallel to the Villon commentary. Brook, the director of the Whitney Studio Club's gallery, was able to accept Gleizes' paintings, although they were more radical than his own work:

> [T]hree dimensional forms and recognizable objects are equally absent from this collection, but design and color there are, as well as clean and assertive execution. It is, apparently, significant absence of form, rather than "significant form" that interests Gleizes and what a relief it is to get away occasionally from breadth, depth and atmosphere and to find oneself confronted by a sympathetic flat wall which commands one to halt, to sit and rest awhile.[68]

When writing on specific works by Cubist artists, such as in this commentary by Brook, responses were usually more positive than was the consideration of Cubism in more general terms.

Fernand Léger

Fernand Léger bridged Cubism and the next phases of modern art, Purism and Constructivism. Many critics saw him only in the context of Cubism despite the fact that Léger's first introduction to audiences in America on a large scale was as a set designer for ballets such as "Le Création du Monde," and "The Skating Rink." Since these ballets were not part of the official art world, they were

generally overlooked by art critics.[69] Lloyd Goodrich commented on Léger's Cubist heritage, while also connecting Léger's art and his environment:

> [Léger] has always been one of the ablest and most persistent followers of the Cubist faith, and his progress as contrasted to the brilliant divagations of Picasso has been steady and uncompromising... [W]e can see his Norman blood, as well... in the hard, barbaric vigor of his work. It is not ingratiating or subtle, but it has a distinct tonic value, a quality not to be ignored.[70]

Louis Lozowick, the Constructivist critic/artist, put Léger in the context of Cubism by combining his review of Léger's work with a summary of the history of Cubism. Lozowick's article provided a more complete and accurate analysis of Cubism than most writers were capable of in the mid-1920s. After explaining what he called the Cubist principles of simultaneity, complementarism and divisionism, he inserted a cogent paragraph on Léger's transformations of the style:

> This is not the whole of cubism, but this is as much as Léger's work illustrates in various degrees.... For the rest, he differs from most cubists in his predilection for bright, decorative color-combinations and in his preference for mechanical and urban subjects. And while his themes make him the most contemporary of all cubists, his polychrome effects in geometric patterns endow his work with wide appeal.[71]

Léger was easily the most popular of the European Cubists. By 1929 even the *Arts* featured him in a long article written by the French critic Waldemar George. The essay linked Léger to Cubism but also clarified Léger's use of large scale painting to revitalize his art.[72]

Stuart Davis

Among American artists, the clearest example of a Cubist-derived art was that of Stuart Davis. While involved with the Whitney Studio Club from its inception, Davis was easily the most avant-garde member of that group. McBride praised Davis' work in predictably glowing terms:

> [Davis] is revealed as one of the most considerable "modernists" of the city.
> His work is excellent in every way, in color, in design and better than all in exuberant and irresistable enthusiasm.... At times a semi-realist and at other times an out and out cubist, I believe that he holds that he is a realist all the time but that is as it may be....
> Mr. Davis' cubism seems to have been induced by good smokes. At least in most of them he sounds cubistic praise of well known brands of cigarettes.[73]

The *Arts* displayed its usual prejudice against Cubism in the review of Davis' work. In response to a two-person showing with the semimodern Glenn Coleman, Watson buried Davis' review in the bottom of the article:

Mr. Davis harks back to the time when, almost twenty years ago, the intellectual problems of abstract art inspired a great many witticisms which now seem rather flat, and a great many arguments which long ago lost their fire. As the foregoing remarks might suggest, the painting of Mr. Davis appears to derive from a fashion, more than from a personal need, and since the fashion which Mr. Davis affects goes back to another decade, his pictures, very naturally, appear to be curiously old-fashioned. [74]

Among the paintings were the now famous eggbeater compositions. The *Art News* immediately recognized the importance of the new work as

full of geometrical exactitudes and felicities of juxtaposed planes and angles frequently done in flat colors that carry a slight emotional appeal. His is an analytical mind that can dissect the movements and vibrations of an eggbeater into a series of geometrical compounds, that can reduce a percolator to decorative abstraction and elaborate even an electric bulb or lemons into the complexities of a draughtman's analysis of a new invention within the sterile confines he has set himself. He seems extremely skillful if a trifle misguided. [75]

At the very end of the decade the bias toward French influence had increased enough that even Henry McBride wrote of Davis, "It sticks in my gorge a trifle to see a swell American painter painting French." [76] Davis was one of the few American artists to integrate flat pattern Cubism with a strong personal style. The increasing reservations about his work demonstrate the rising hostility to all European influence that was obscuring critical judgment in the second half of the 1920s.

Pablo Picasso and the Problem of Neoclassicism

Criticism of Picasso demanded an understanding of Cubism that could include his changes in style, a challenge that distinguished the more sophisticated critics. Nevertheless the overall trend in the responses to Picasso was one of acceptance without real understanding. While he was primarily thought of as the inventor of analytic Cubism, his neoclassical work created a fascinating critical problem that related to the issue of the "decline of Cubism."

The reports of Picasso's Neoclassicism began reaching New York through the critics in Paris. The *Art News* correspondent spoke of Picasso's "handspring" and of his "new style, not in any way related to cubistic designs that set the pace for Imitations." [77] McBride first mentioned Ingres' influence on Picasso in the *Dial* as early as 1922:

> Now in Paris in the ateliers they are talking of something that has not yet reached the Vatican—*la retour à Ingres*. It's something sceptics laugh at, especially when the *retour* is headed by Pablo Picasso but it has been notoriously evident for some time that the sheep who flock in "movements" have been pining for a new direction and if they can be rescued in even a semblance of order from the Impasse Dada, the betting is at least even that the vast majority of the sheep will get no nearer to Ingres than Bougereau.[78]

McBride's dry comment captured exactly the effect of Picasso's new style on the late twenties' artists. He concisely summarized the problem of imitation and derivative stylistic influences. McBride was unique in his ability to separate authenticity and imitation among artists following Cubism and related styles.

Although some Ingresque works were shown at the Sculptor's Gallery in 1921, they were not reviewed. In 1923 Marius de Zayas presented a survey of the artist's late Cubist works from 1919 to 1923. The reviews indicated that the classicizing trend was not included:

> [Picasso is in] his most abstracted mood...[the] prints [are] purely abstract in subject matter...[made by] making a stencil from the original and filling in the color. The color which is applied in flat areas is really the picture. Relations of hue create the effect; the design seems secondary. This is entirely two-dimensional work, there is no hint of volume and whatever going forward or recession takes place is the result of the arrangement of the color.[79]

Seemingly in conjunction with this show, de Zayas arranged for the publication of the first statement by Picasso in English. It provided essentially a refutation of the idealist, evolution-oriented theories about Cubism that had been presented by Gleizes and Pach. Picasso discounted the idea that his art was research. He claimed his art was a present fact, not part of any evolution:

> Variation does not mean evolution. If an artist varies his mode of expression this only means that he has changed his manner of thinking and in changing it might be for the better or it might be for the worse.[80]

Picasso was clearly opposing the intellectual interpretations of Cubism as provided by the Puteaux artists and Americans such as Pach. The illustrations accompanying the article further refuted the idea of evolution by presenting the full range of his art, both Cubist and Neoclassical.

Wildenstein Gallery held a full scale survey of Picasso's new Ingresque style with sixteen oils and pastels in 1924. The *Art News* reported that here was

> A Picasso who is even more classical than David whose pictures have the immobility and the set passivity of Roman fresco.... Critical and symptomatic examination convinces one that the cubism of this modern has not been lost—that it is all there beneath the structural mastery of his new manner. It is as if Picasso had picked up the tradition of David and developed it by means of the experiments he had dared to make in Cubism.[81]

Watson, in his newspaper column, greeted Picasso's work with the headline "Pablo Picasso Knocks Loudly at the Doors of our Museum." His analysis strikingly contradicted Picasso's own statement about what he was doing:

> The real secret of Picasso is consistency of statement. The parts are welded together into a whole. The quality of the form and the quality of the color belong together. Everywhere in his best pictures may be discovered the same masculine, unseductive will power in the color contrasts as in the form. Precision is the essence of Picasso's art, synthesis its object. He has both a dominant will and a constructive instinct. What he gives in his representative and in his cubist pictures is an abstract statement of the idea that he considers aesthetically significant. With all its staggering force, the keynote of Picasso's art is order. Every picture is a demonstration of the truth that for an artist to make a complete statement, elaboration is not only not necessary, but a detriment.[82]

Watson's reference to consistency and to the presentation of an idea has an obvious connection to the theories about Cubism discussed above. It has little to do with Picasso's matter-of-fact comment on his own work. For his more art-specialized audience of the *Arts*, Watson was more negative. He quoted an artist on Picasso's "rotten romantic streak," then said that with each visit "these particular paintings have fallen a notch."[83]

Herbert Seligmann took a predictably lyrical approach to Picasso for the *Nation*. He completely obscured the character of the paintings with statements such as, "color and line seem like separate melodies interwoven in counterpoint." Seligmann also quipped about Picasso's arrival with the establishment:

> Young ladies, select and fashionable, in boarding school assortments, were taken to see them. Cultured young men were seen to faint with delight. Ladies of uncertain age struck attitudes giving one to understand that they felt—inexpressible things.[84]

As usual, McBride had the most astute comments, focussing on misunderstandings of the Ingresque work:

> He is first and foremost a stylist, as concerned with simplifications and purities of expression as ever he was; and it is also possible to believe that he shares in a humorous appreciation of the vogue that permits him to give many of his admirers the impression that they have been carried back to Ingres. Like Ingres he is the foremost draughtsman of his period—but otherwise there is no use dragging Ingres in. If there is any realism in the new pictures it certainly eludes me...a reformed Picasso? Academicians, don't you believe it.[85]

Even as critics struggled with Picasso's Cubism they also had to grapple with his Ingresque tendency. The result was peculiar comments such as Elizabeth Luther Cary's in the *New York Times* that Cubism was simply a "bridge upon which...[Picasso] crossed from realism to realism."[86] Guy

Eglington made the strange suggestion that Picasso's work "had the air of having been [made] expressly for American consumption."[87] The large Société Anonyme International Exhibition of 1926 downgraded Picasso's importance, perhaps because of Dreier's closeness to the more abstract Puteaux group. The catalog indicated that Picasso was

> a middle-aged gentleman who started life full of enthusiasm and helped to create the cubist movement which however, is far bigger than he. He is a master in his own way. Though a fighter in his youth, he settled down to retirement as far as the world of art goes today painting his own individual pictures.[88]

Instead of downgrading Picasso's importance, Lloyd Goodrich took another approach. His 1930 review virtually chastised Picasso for his lack of form and evolution. Goodrich was frustrated that his critical tools had been made useless by an obviously important artist:

> [There is the] constant pursuit of stylistic novelties rather than an organic development of a central artistic character, a process of going off at tangents instead of advancing steadily along a direct path; hence a certain lack of a sense of growth. Although there is no sign of weakening of Picasso's ability to create startling new styles, one is not conscious in his work of a continually more profound capacity for realization, as with Cézanne or Renoir, or any other painter of the first order.
> One unifying thread ... is that he has never remained interested for very long in the more fundamental problems of form. Even his cubist style did not achieve deep space or voluminous form, but rather a half round quality like bas relief; ... the overblown work of his 'colossal' period, in spite of its superficially statuesque quality is far from possessing the solidity and inner life of genuinely sculptural form. ... In spite of all his brilliant experimentation, the profoundest qualities of formal design seem to have remained unrealized by him.[89]

Goodrich's review is an example of the way in which theoretical explanations of modern art and Cubism made it difficult for the critics to respond directly to Picasso's work with a clear eye and understanding.

With the exception of Henry McBride, no American writers analyzed Picasso's art in a way that indicated they were even looking at the paintings. As a result, the critics failed to grasp the connection between Picasso's different styles, or the connection between Cubism and later developments in modern art. Yet, certainly, the dilution of Cubism and Picasso's Ingresque phase contributed to the idea that modern art was over—a past phase—now to be replaced by a more realistic, and therefore valid art. This analysis of modern art also contributed to later scholars' idea that modernism was in decline in the 1920s. Even while late Cubism was causing critical confusion, the major avant-garde art of the 1920s began inundating New York. For the criticism of this art, more obscure writers and magazines played an increasingly important role.

5

Dada, de Chirico and Surrealism

Dada

Events and Coverage to 1922

The examination of Dada in the New York press comprises two categories that overlap and interact: coverage of events in New York, and documentation of events in Europe. Dada, unlike Cubism, had a distinct primary development in New York. Although the artists were influenced by European developments and were primarily émigré Europeans, the display of proto-Dada and Dada works in the teens in New York made some primary sources of Dada art available to New York critics from the movement's inception.[1]

Responses to the radical Dada work in the teens were brief. Picabia's mechano-morphic pieces were received with humor rather than hostility in January 1916.[2] Duchamp's ready-mades were listed in a display the same year, without any critical response. In 1917 Duchamp submitted a ready-made—a urinal—to the Independents Exhibition under a pseudonym. It was rejected. Duchamp, in consciously defying bourgeois norms and extending the limits of art by including a mundane non-art object in an art exhibition, was acting in the spirit of the Dada, although he did not so label it. He responded to the rejection of his piece by creating two Dada-esque publications, *The Blind Man* and *Rong-Wrong*.[3]

Other Dada-performance related individuals in New York were Arthur Craven, the boxer,[4] and the Baroness Else Freitag von Loringhoven. The Baroness wore exotic clothes and wrote Dada-related poetry. Margaret Anderson of the *Little Review* described one of her outfits:

She walked slowly but impressively, with authority and a clanking of bracelets.... She wore a red Scotch plaid suit with a kilt hanging just below the knees, a bolero jacket with sleeves to the elbows and arms covered with a quantity of ten cent store bracelets—silver, gilt, bronze, green and yellow. She wore high white spats with a band of decorative furniture braid around the top. Hanging from her bust were two tea-balls from which the nickel had worn away. On

her head was a black velvet tam o-shanter with a feather and several spoons—long ice-cream-soda spoons. She had enormous earrings of tarnished silver and on her hands were many rings, on the little finger high peasant buttons filled with shot. Her hair was the color of a bay horse.[5]

The Baroness first emerged in New York as part of the Arensberg circle, a focal point for experimental artists in the late teens. That group has been considered a fountainhead of American avant-garde activities and its demise in 1921 is taken as proof by recent scholars of the end of modernism. The real result of the closing of the Arensberg Salon was, as with the closing of Stieglitz' gallery, that awareness of Dada shifted from an exclusive elite to a more public sphere, although many of the same people were still involved.

At the Société Anonyme, with two leading Dada figures, Duchamp and Man Ray as directors, the presence of Dada art was evident from the opening exhibition. The review by McBride suggested the limits of his tolerance in his description of a piece by Duchamp:

> [The] glass disc must be looked through from the back for about an hour, but it doesn't say why you must look through it. The glass panels framed in metal have been splintered in several pieces.... M. Duchamp is really too daring. Up to this point I had been with him. But this splintering of a splendidly built up mechanism is nothing more or less than an insult to labor. This is not the time to fool with labor.[6]

McBride's humor masked his reservations about the extreme Dada artists and allowed him to avoid actually evaluating the piece. He also improvised in his analysis of a piece by Man Ray in the same exhibition. In the piece, Man Ray unwrapped a lampshade and spiralled it around a spike from a dress form. While Man Ray himself referred to the piece as having a "pleasing spiral," the spirit of the piece was more an accidental arrangement of junk materials.[7] McBride attempted aesthetic evaluation, but with tongue in cheek:

> Turn to Man Ray's "Lamp Shade" with a certain sense of relief. Here we are comfortably psychic. Mr. Ray's "Lamp Shade" is not an actual lampshade but a shade of a bygone lampshade. It harks back to the period of the piano lamp as the standard is still there and as good as new, but the shade itself has become unglued and hangs in a handsome volute. I have seen lampshades like that...reading Dr. Jeckell [sic] and Mr. Hyde.[8]

The analysis probably would not have displeased Man Ray, although the piece had little relationship to McBride's interpretation. The improvisational aspect of McBride's associations were consonant with Man Ray's improvisational act in creating the piece.

Hamilton Easter Field's response to Man Ray's *Danger/ Dancer,* a Dada parody of gears intended to represent a dancer, related it to traditional aesthetic criteria while still maintaining an open mind:

Over the mantel in the first room is Man Ray, glittering cog-wheels on an intense black. You may say that he has gone outside the limits of art. Possibly he has, but who is the arbiter in such a matter? Of the decorative value of the work I feel that I do know something. I have seldom seen a more perfect composition, whether considered from the standpoint of color or of arrangement.[9]

Field totally missed the Dada element of ambiguity and the irony of representing a person as cogwheels; he probably did not even understand that the image was a dance, so caught up was he in a formalist response.

Around the same time as the opening of the Société Anonyme and its first exhibitions, indications of the European Dada movement began to appear randomly in the American art press. The *Art News* reported the public events in Paris staged by Tristan Tzara and others. A review of a "dadaistic exhibition" gave it importance in New York, regardless of its historical significance within the total Dada movement from our perspective today:

Lectures by dadaistic philosopher Dr. Serner were announced. The large audience that went to the first lecture displayed but little respect and soon showed displeasure by stamping, whistling and rowdyism. To their surprise Dr. Serner stepped from the platform, took the arm of a moving picture star, Francisco Bertini and began to tango with her. This aroused the anger of the audience who tried to stop the dancers. The dadaistic sympathizers interfered and soon a pitched battle ensued in which the public tore the pictures from the wall and destroyed them.[10]

Although only the facts were related, they captured the absurdity of the event. The anarchic flavor of the performance would have been alienating to any New York reader who was just learning to accept Cubism.

An early newspaper article on the Dada movement appeared in the *World* in January 1921.[11] The inspiration for the article was probably Tzara's demonstrations in Paris, but the author directly addressed the questions "What is Dada?" and "Who are the Dadaists?" by quoting the founder, Tzara, and talking to the participants in the Société Anonyme: Duchamp, Dreier, Man Ray and Stella. The subtitle indicated the author's attitude (or perhaps that of the newspaper editor): "Dada Will Get You if You Don't Watch Out; It is on the Way Here, Paris has Capitulated in New Literary Movement; London Laughs, but will Probably Be Next Victim and New York's Surrender is Just Matter of Time." While the headline still had a humorous touch, it also suggested a threat. The article quoted various opinions about the meaning of Dada, underlining the incoherent character of the style.

At the opposite end of the critical spectrum from the popularizing newspaper article was the coverage of Dada by Jane Heap in the *Little Review*. Heap's articles transmitted a primary source on European Dada to the American intellectual community. In the January/March 1921 issue of the

Little Review, the magazine carried a reproduction of a "Dada Manifesto" issued in Paris on January 12, 1921 and was signed by all the members of Paris Dada, as well as Man Ray and Walter Arensberg. The title of the Manifesto "Dada Souléve Tout" (Dada Stirs Up Everything) suggested its content. The declaration listed the principals of Dada such as "Dada spits on everything. Dada says nothing. Dada has no fixed ideas, Dada does not catch flies."[12] The *Little Review* published the manifesto without comment, just after the suppression of James Joyce's *Ulysses,*[13] an event that Heap found disenchanting and discouraging.[14]

The first actual discussion of Dada in the *Little Review* compared the poetry of the Baroness Else Freitag von Loringhoven to that of the French Dada poets. The commentary suggested a mystical union between Paris and New York through the presence of the baroness. It concluded that "this movement should capture America like a prairie fire."[15]

During the spring of 1921 the New York Dada movement crystallized when the Société Anonyme exhibited the collages of Kurt Schwitters in a group show, held a "Dada evening" and published *New York Dada,* the four page publication of the New York Dadas by Duchamp and Man Ray. The press gave wide coverage to these events.

The critics did not understand Dada. The works by Schwitters were called Dadaist but were not really distinguished from Cubism. The review in the *Art News* focused on the Dada philosophy, which it identified in the headline as the "Negation of Everything in World." The reviewer was unrestrained in his disgust:

> The Dada philosophy is the sickest, most paralyzing and most destructive thing that has ever originated in the brain of man. It is a negation of everything under the sun and the sun itself, and everything beyond the sun as far as infinitude can reach. To the Dadaist life means nothing, aspirations count for nothing, religion is nothing and atheism is nothing. Even Dada is nothing.
>
> And because they believe in the utter futility of everything, Dadaist [*sic*] write lunatic verse and paint meaningless pictures as jibes at the rest of mankind, which it holds in contempt. The more inexplicable the verse and pictures are, and the more exasperated the public gets, the better pleased the Dadaists are.[16]

The rest of the article detailed Tzara's activities in Zurich and Paris, then quoted from Paul Dermée and Picabia on the nature of Dada. Last, it cited an article by André Gide that connected Dada to the devastation of the war, suggesting that language should also have some ruins. The reviewer pointed out that Dada "established an understandable cleavage between Modernistic art and the extravagances of Extremism."[17] By becoming the new scapegoat, such a perception is an important critical statement for 1920: Dada made it easier for the New York audience to accept other modern art.

The Société Anonyme's "Dada Evening" was barely mentioned in the article. Dreier's friend, Mrs. Claire Dana Mumford, approached the evening as a seance. The official lecturer, Marsden Hartley, defined a Dada artist in contrast to an Expressionist artist:

> An Expressionist is one who expresses himself at all times in any way that is necessary and peculiar to him. A dada-ist is one who finds no one thing more important than any other thing....
>
> Dada-ism offers the first joyous dogma I have encountered which has been invented for the release and true freedom of art.... We shall learn through dada-ism that art is a witty and entertaining pastime and not to be accepted as our present and stultifying affliction.[18]

Hartley's emphasis on the humorous, positive aspect of Dada contrasted with the sensationalized newspaper reports, although the newspapers did give more primary information.

Hartley was a theorist. Dreier's choice of him as the speaker for the "Dada Evening" indicated her serious attitude toward her activities. She was primarily interested in informing and educating, not creating disruption and confusion in the spirit of Dada. Even the title of her evening, "Do you Want to Know What a Dada Is?" was inimical to the spirit of Dada. She was trying to identify and define a movement that was seeking to escape pedantry and definitions. Her own interpretation of Dada in *Western Art and the New Era* claimed that Dada destroyed the past in order to "prepare the ground" for future development:

> They express themselves through satire. The more cutting and biting their satire is, the better pleased they are. They laugh at you, but they do not spare themselves. Though cynical, they do not wish to destroy, for at bottom they are constructive....
>
> The Dadaists are the Bolshevists in art...in other words, the group who believe in destruction to prepare the ground for construction.[19]

The third manifestation of Dada in the spring of 1921 was the publication of *New York Dada*. More a four-page document than a magazine, it included an official authorization of New York Dada by Tristan Tzara. Duchamp designed the cover and Man Ray picked material at random, including a poem by Hartley, a cartoon by Rube Goldberg and photographs by Stieglitz.[20] McBride, after summarizing the contents of the magazine, extensively analyzed the cover on which the words "New York Dada" were endlessly repeated:

> At first glance the printing of the forest of words appears artless, but M. Duchamp requires you to take the second glance, and then it can be seen that there is a variety in the spacing, that certain words at one side form into parallel columns and the others meld into the mass.... As for the symbolism of it, hmmm—everyone may interpret it for himself. They say in Europe you know, that we are all dadas over here, and the countless repetition of the word

upon the title page may be M. Duchamp's sly allusion to that fact. . . . M. Duchamp always obtains his effect.[21]

McBride didn't completely understand the significance of the cover design, which had layers of complex allusions including the *alter-ego* self portrait of Duchamp, but he at least presented some accurate, detailed discussion of the publication.[22]

While the Société Anonyme events were reasonably celebratory in the authentic spirit of the Dada movement, the newspaper coverage continued to emphasize the negative, destructive aspect of Dada. One example is a discussion in the *World Magazine* called "Dada: The Cheerless Art of Idiocy."[23] It presented Dada activities in Europe, reproducing Man Ray's *Lampshade* and Jean Crotti's *Portrait of Marcel Duchamp*. During the same spring, the *Art News* reiterated its emphasis on the nihilism of Dada:

> Another take-off was on the spiritualist craze that has swept the world since the war. The lights went out and phosphorescent spectres emerged from trap doors and, all speaking at once in a hodge-podge of meaningless words delivered an address of welcome. It is the contention of Dada that everything means nothing, that even Dada means nothing. The Dada philosophy is a jibe at the rest of the world which insists on taking itself seriously. It is a manifestation of the pessimism and the loss of faith in everything which has come over certain minds, some of them the most brilliant, since the war.[24]

Around the same time, several other articles presented a similar attitude in discussing offshoots of the Dada movement, or reactions to it, by Italian and English artists.[25] In the New York press, the spring of 1921 was the high point for the reporting of Dada events in both New York and Paris.

Later Articles

By 1922 Dada was still reported,[26] but fewer articles detailed its meaning. Sheldon Cheney published "Why Dada?" in the *Century* in May 1922.[27] Cheney's interpretation was virtually the first discussion on Dada that was reasonably open-minded and thorough. Written as early as the fall of 1921, it was almost certainly inspired by the Société Anonyme events. The article cited a range of avant-garde Dada writers, presenting the idea that Dada was a means of renewal for bourgeois society, a theme he pursued in all his art writing. But more than renewal, Dada was for Cheney an opportunity to support the idea of tolerance.[28] Dreier's crusade reached a new audience by means of writers like Cheney.

After publication of the Dada Manifesto, the *Little Review* continued to cover Dada, partly because Picabia became the European editor in the spring of 1921. A "Picabia Number" featured eighteen reproductions of the artist's

work, an essay by Picabia titled "Anticoq" and statements by other writers, including Ezra Pound. Jane Heap's own statement responded to a challenge from another editor, Harriet Monroe of *Poetry* magazine, that the *Little Review* was being taken over by Dada:

> Is Miss Monroe against dada because dada laughs, jeers, grimaces, gibbers, denounces, explodes, introduces ridicule into a too churchly game? Dada has flung its crazy bridges to a new consciousness. They are quite strong enough to hold the few in this generation who will pass over. Dada is making a contribution to nonsense.[29]

Heap enjoyed Dada, although elsewhere she implied a more elitist attitude toward art.[30] Yet, the *Little Review* more than reported on Dada in specific issues: it *was* Dada in its disorganized and humorous approach to art throughout the 1920s. It also continued to carry articles on Dada by major figures from Paris.[31]

Vanity Fair published numerous articles on Dada. The first, titled "The Aesthetic Upheaval in France" of February 1922, was by Edmund Wilson, Jr., then a young new editor for the magazine and the person responsible for keeping the magazine up-to-date on recent European art. Wilson's first article featured the curious phenomenon of the French avant-garde embracing American culture. He summed up the irony of the situation in the first paragraph:

> Young Americans going lately to Paris in the hope of drinking culture at its source have been startled to find young Frenchmen looking longingly toward America.
>
> In France they discover that the very things that they have come abroad to get away from—the machines, the advertisements, the elevators and the jazz—have begun to fascinate the French at the expense of their own amenities. From the other side of the ocean the skyscrapers seem exotic, and the movies look like the record of a rich and heroic world full of new kinds of laughter and excitement.[32]

Wilson reproduced the first page of the same manifesto presented by the *Little Review,* as well as a work by Picabia and an illustration for a novel by Blaise Cendrars. He had reservations about Dada. He described Dada as "sophomoric," and suggested that Times Square "makes the Dadaists look timid; it is the masterpiece of Dadaism, produced naturally by our race.... Our monstrosities are at least created by peple who know no better."[33] Wilson was offended by the Dada artists' interest in what he considered the crassness of the contemporary commercial environment. Nonetheless, he ws intrigued enough to present a series of articles by Tristan Tzara in the magazine during the next two years. His continued presentation of Dada-related articles may have been the result of the influence of some of his literary friends in Paris, such as Matthew Josephson.

Tzara's articles rebutted Wilson's criticism. The first appeared in July 1922 as "Some Memoirs of Dadaism," with the subtitle, "An Account of the Movement Which Has Undertaken to Free French Art from its Classical Rigidities." It was an abbreviated history of the movement, focusing on the events in Paris since 1920. Tzara provided surprisingly detailed descriptions of the chaotic performances, commenting that the Dadas performed "wild, practical jokes, elaborately silly meetings and fantastic manifestoes which burlesqued, in their violence and absurdity... the life around them.[34]

The following fall, Tzara did an update of the activities of the previous spring in Paris; he also mentioned a marionette theater in Zurich and the Russian Dadaists.[35] A third article in April 1923, gave a mini-history of German avant-garde art since Expressionism, but mainly outlined recent events in German Dada with particular emphasis on Kurt Schwitters.[36] A passage on Schwitters is one example of intelligent writing by Tzara, with no trace of Dada confusion:

> [The novel of the German Revolution] was written by Kurt Schwitters. Schwitters lives in Hanover in a curious house, which he has covered with tramway tickets and bits of newspapers pasted together. He is young, and his mind has an intriguing twist. Although amusing, he yet spreads not a little awe about him, for he is a Dadaist. His wit is a singular blending of mockery, scepticism, satire and poetry....
>
> His pictures employ what we might call natural materials. He uses whatever he happens to find in the street: bits of rusty metal, padlocks, broken wheels. His pictures... emerge... half broken, rusty and dirty....[37]

Tzara's statement was almost the only detailed commentary on Schwitters available to Americans in the early 1920s.

The literary aspect of the Dada movement led writers to respond to the movement more sympathetically than did art critics. The Dada Manifesto printed in the *Little Review*, for example, might have been more noted by a writer than a painter because of its bizarre layout and anarchic content.

The humorous dimension of Dada was lost on the art critics, who, with the exception of Henry McBride, tended to take art too seriously to allow themselves to enjoy the ridiculous nature of the activities of the Dadas. McBride, as has been suggested, did not entirely understand the expressions of Dada, but he did share with them a sense of humor. That humor allowed him to gracefully extricate himself from a political conflict with respect to the meaning of Dada, a conflict that was played out in the pages of the *Dial*.

In November 1922 McBride suggested that Dada was at a standstill, but quoted a characterization of the movement by the French writer M. Pierre de Massot: "De cet ennui, est né Dada, le seul état d'esprit raisonnable... Dada qui symbolise le dégoût de tout."[38] McBride then commented that disgust was so prevalent in American society that Dada could be accepted by everyone,

even conservatives. Two months later an angry letter from M. Philippe Soupault rejected the idea of boredom as a source for Dada, saying that rather than being a school, it was "un état d'esprit... Nous étions poussés par Dada à détruire ce qui nous semblait inutile, à nier ce qu'on affirmait sans raison, à nous moquer de la logique traditionelle." McBride, after quoting the letter, responded:

> Thanks for putting us right. We have good eyes in America, I think, too, but not good enough yet, I fear to detect Dada wheat from Dada chaff. Then too we feel it is not our rightful wheat. That leaves us cool.... It is our quick interest, indeed, that leads us to bolt whole any bit of propagandism that comes our way.... Immense quantities of information did reach us, chiefly *via* the cables, in regard to [Picabia's] Dadaistic activities, and it is disconcerting, at this late date, to be obliged to reindex him. But it shall be done. Your letter is too authoritative to be denied.[39]

The exchange revealed both the political quarrels within the Paris Dada movement, and the large amount of information on Dada available in America. It is also an exemplary document of McBride's cool wit.

The following summer McBride attended a Dada event in Paris, an "Evening of the Bearded Heart," at the Théâtre Michel. The evening was near the end of the rush of Dada events in Paris from 1920 to 1923. McBride gave his impressions of the performance in the December 1923 *Dial*, then commented on a conversation with Tzara reflecting the latter's feeling that Paris Dada was losing its vitality. The article concluded with the idea that Tzara wanted to export Dada to the United States:

> He [Tzara] was somewhat sad and unsmiling as he talked of the evening at the Theatre Michel. He appeared to be conscious that there had been something of a formula about it and that an effort in a new country and under new conditions might help the cause. I said as little about our police as I conscientiously could, but nevertheless I fear I said enough to disturb him. If Mr. Tzara does not have an "evening" soon in the Sheridan Square Theatre I suppose I shall be to blame.[40]

McBride was the only critic to come close to Dada, but even he remained an outsider. His criticism is anecdotal, witty and descriptive, rather than evaluative. The insightful comments that mark his discussions of Cubism are absent.

The Literary Dadas

The last chapter of the critical response to Dada in America in the 1920s was a conflict between literary and art critics. The writers Matthew Josephson and Malcolm Cowley, as participants in European Dada, began celebrating such aspects of American culture as jazz, comic books and movies, as well as

commercial advertising. Other critics, particularly those of the Stieglitz circle, who still adhered to a more elite and mystical attitude to art, fought the idea of advertising and lowbrow expressions as an aspect of American culture.[41]

An imaginary conversation created by Edmund Wilson between Matthew Josephson and Paul Rosenfeld highlighted the conflict. Wilson drew on published statements by both writers to create the interchange. Josephson claimed that writers of advertising copy, not T.S. Eliot and Arnold Schoenberg, were creating the "true literature." He attacked traditional painting and sculpture, celebrating instead the commercial electric sign:

> And what is painting? What is sculpture? A bad patriotic monument and a silly landscape the size of a playing card in a gallery like a mausoleum which only a handful of people in New York will ever see and which the millions in the rest of the country will never hear about! How can you put this up against the electric sign which thousands of people see every day—a triumph of ingenuity, of color, of imagination! which slings its enormous gold-green-red symbol across the face of the heavens themselves ... I tell you that culture so-called is finished; the human race no longer believes in it. That is why I have given my support to the campaign for Henry Ford for President![42]

Josephson also celebrated the joyous gaiety of Dada. Rosenfeld answered by emphasizing the seriousness of art:

> Yes, I see ... For me it is a serious matter but for you it is only a game. I read your manifestos printed upside down, your assertions that "Oui=Non" and your plays in which the different acts have nothing to do with each other, and I see the point of their pointlessness; but I cannot quite laugh at the joke. You keep talking about this or that lacking reality or not representing anything real, but for me the artistic life of Europe, the life of feeling which it makes articulate, is the only reality.[43]

Josephson saw himself in touch with the vitality of life and scorned Rosenfeld's rarified approach.

A similar exchange appeared in a small magazine called *1924* between Waldo Frank and Malcolm Cowley, with emphasis on the different artistic needs for Europe and America. Frank, a colleague of Rosenfeld who shared his emotional aesthetic, suggested:

> Dada worked well in overmature Europe. We, by analogy, must be fundamental, formal. ... The first step in the absorption and control of our Dada Jungle is the achievement of a serious, of a literally religious temper.[44]

Cowley replied by celebrating the same "unaesthetic" expressions of which Josephson had written.[45] The Cowley/Frank interchange was pertinent to the ongoing course of American modernism; Frank's suggestion that America needed something different from what Europe needed was perceptive and

perhaps accurate. Yet, the issue ultimately centered around high art versus low art, seriousness versus playfulness, with the critics Rosenfeld and Frank able to accept only the more traditional high-minded approaches. All of these writers were interested in an American art that reflected the environment in which it was made. That is the larger significance of the discussions over Dada: they move beyond the impact of Dada to the meaning and importance of modern art in America.

Literary critics like Josephson and Cowley grasped the significance of Dada far better than did the American art critics, even those like Henry McBride who were in close contact with the Dada artists. Since Dada was primarily a literary movement, created by poets and writers and staged in theaters and cabarets, the understanding of the implications of these manifestations were more obvious to literary critics who sought to disrupt the genteel literary world. By 1925 the term Dada in America meant only, as Tashjian puts it, "committment to literature, . . . animosity toward established critics, and a general interest in formal literary values."[46]

One last prominent statement on Dada in the 1920s appeared in a 1925 publication called *Aesthete*. The only Dada element was an attack on established values in literature and a mockery of the writers who were not sympathetic to that idea.[47] While *Aesthete* kept the term "Dada" alive in the American press, the original impulses of the European and the New York Dada artists and writers had been considerably diluted.

Dada in American Art

Contemporary scholars postulate that the Dadas' enthusiastic attitude toward the machine stimulated artists like Charles Demuth and Charles Sheeler to break with Cubist principles. They also believe that the Dadas' use of experimental materials led Americans such as John Covert, Man Ray, Joseph Stella and Arthur Dove to create their "assemblage" work. No such connection to Dada was made by the critics of the 1920s. They simply believed that the more extreme phases of work by their favorite modern artists such as Dove and Demuth were a temporary experiment. What we see today as Dada influences was given a different interpretation in the 1920s.

One example of the complexity of this issue is the collage work of Arthur Dove. Only Dreier declared without elaboration in 1926 that "he is the only American Dadaist."[48] Goodrich wrote of Dove's collages:

> Framed in a sort of shadow box with a glass front would be some pieces of an old blue shirt, a section of a bamboo pole, a burnt log—the whole thing entitled "A fisherman." Others seem like cross sections of the bottom of the sea; while one which was dominated by a pair of scales and the cold stare of a magnifying glass was recognizable as "An Intellectual," even before

the title was read. It is evident that Mr. Dove's intentions are less serious and more satiric than those of the followers of Picasso who use somewhat similar methods.[49]

While the reference to satire suggested Dada, Goodrich's connection of Dove to Picasso related the artist more to late Cubism.

Likewise Demuth's *Poster Portraits* were not placed in a Dada context. Disappointment and lack of comprehension emerged in the *Art News:*

> We know that in change is life, but our knowledge does not make it easier for us to accept change when it arrives. . . . The pellucid quality of his aquarelles was touched with a strange and tremulous beauty. . . .
>
> All that has gone and we must be content to accept something infinitely less gracious, hard and rather metallic. . . . Whether we like [the poster portraits] . . . or not, they are the new Demuth. . . . We are unable to accept and unwilling utterly to reject. Since change must be, we prefer to wait until that change has fulfilled itself.[50]

The *Arts* review more calmly suggested that Demuth was "revolting from his own artistic past and expressing himself in new and radically different forms." It concluded that the *Poster Portraits* might be Demuth's response to a fear that "his art may degenerate into preciousness."[51] Only Watson made a direct link between Demuth and Duchamp, in connection with the titles of the paintings.[52] While close to Duchamp in the spirit with which he painted industrial imagery, Demuth was rarely placed in that context in the 1920s. The critics of those years took modern art too seriously to see the humor in Demuth's art.

Most of the critics did not connect Demuth's factory images to Dada despite their amusing titles, such as *Aucassin and Nicolette*; they were accepted as straight images of the American landscape and analyzed in formal terms. The *Art News* wrote that the factory paintings had a "personal and interesting manner . . . [with] brilliant harmonious colors and mainly architectural design and straight and horizontal lines interwoven with beautiful tones."[53]

One example of the watering down of the Dada impulse in America was Nottingham Dada. Louis Bouché painted Nottingham Victorian lace in response to the Dadas' ideas of incorporating bad taste into art. Bouché's paintings were well-received by critics. Watson revealed his understanding of Dada in his comment:

> The Dada is one who at all cost attacks the too sanctimoniously earnest attitude toward art and turns upon a self-righteously taste-ridden world the weapons of its own defense. The unsophisticated having only yesterday freed themselves from the domination of Nottingham lace and corresponding objects of the home, it behooves the Dadas immediately to rescue all these from oblivion and put them to the very latest sophisticated uses in the kind of humorous interior decorator painting that most appeals to their own bitterish sense of humor.[54]

Bouché's paintings were minor decorative works, thus making clear how far apart were the interests of the original New York and European Dadas and those of some American artists who called themselves Dada. Bouché himself had been directly involved in the Dada movement in Paris to the extent of acting as an intermediary between the Paris group and Walter Arensberg. The other participants in Nottingham Dada were familiar names, but hardly in the context of Dada. They were members of the Whitney Studio Club circle, like Peggy Bacon and Ernst Lawson.

The American press never really understood or accepted Dada, but it did provide it with a swan song. In 1927 the *Living Age* declared that "Dada is Dead," giving a brief history of the movement and explaining its demise as a predictable consequence of its anarchical nature. One of the German Dadaists, Wielande Herzfelde, was quoted in reference to the Dadas' basic assumptions:

> "We proceeded on the assumption that works of art must be a reflection of their period, and we considered it impossible to write like Goethe in an era of automobiles, flying machines and moving pictures." This aesthetic tenet was not, needless to say, original with the founders of the Dada movement, but they did succeed in bringing it sharply before the public attention where many others had failed. Mr. Herzfelde wistfully appreciates that Dada's work is done. It was a picnic while it lasted.[55]

Significantly, this last major discussion of Dada finally turned to the German Dadas. The earlier coverage was entirely devoted to Parisian and New York Dadas, with the exception of Tzara's articles. That lacuna in the American press coverage is yet another example of the pro-French bias that dominated the art world.

Giorgio de Chirico

Histories of modern art sometimes fail to note that styles exist simultaneously, overlap and continue after their period of greatest importance to history. Moreover, the impact of a style is often not the same in its first years as later historians suggest. In the mid 1920s in America, awareness of Surrealism and the Scuola Metaphysica of de Chirico came in reverse order to the now established chronology of modern art: Surrealism was more familiar than one of its principle sources, de Chirico, until the late 1920s.

De Chirico had executed his most famous work in the teens; in the twenties he was considered a patron saint by the Surrealists.[56] His paintings were introduced to New York audiences primarily at the end of the 1920s by two major exhibitions at the Valentine Gallery. Before those successful shows, virtually the only press coverage of his work appeared in the *Little Review*. Heap presented four illustrations of de Chirico's classic early works in the spring 1924 issue, with a brief analysis by Rene Crevel:

> I repeat that we long to walk into the pictures of Giorgio de Chirico; to upset us the more sumptuous rhythm reveals the indifference of a flesh which doesn't want to feel itself alive. Perfection calls death and because he is a man with a proud conscience the painter darkens the horizon with a greenish menace; one breathes the very air in these cities, which five minutes later, will be buried forever.[57]

Crevel continued by saying that de Chirico's work functioned with a new realism removed from traditional imitation, although he also saw a "surprising beauty" and "grandeur" in the paintings.[58]

The Société Anonyme International Exhibition of 1926 also featured de Chirico's painting. Dreier identified him as one of the six main trends in contemporary art:

> His most important epoch he developed in Italy during these years, when he began to paint a series of pictures of still lifes with painting which he called "interieurs Metaphysiques," each article playing the same lyrical role in the whole painting as the sky plays with the earth in a landscape. In his research he is seeking to express with the greatest force possible the images and fantasies which haunt his spirit.[59]

De Chirico's art was lost among the predominance of geometric abstraction, however, and the reviewers did not comment on his work in 1926.

The most extensive press coverage for de Chirico appeared in 1928 and 1929 when the Valentine Galleries put together two large one-person exhibitions. The impact of the first show was apparently so great that a second was planned. McBride found the early works "dry" but concluded that he "now [1928] emerges as a leader . . . [There] never was a pseudo-Greek that was quite so pseudo as his . . . strange jumble of past and present."[60] McBride's evaluation contradicted later evaluations of de Chirico's historical position which emphasize the earlier work.

Forbes Watson did not treat the imagery, preferring to analyze the formal components but he also commented on the excited reception for the works:

> Compared to the work of most of the other artists in the Parisian vogue that of De Chirico is something of a novelty in New York and it has therefore attracted a good deal of attention, when it was exhibited recently. . . . His pictures divide themselves into two groups, conceived in two distinct and separate moods. In one of his styles Chirico creates with severe flat masses of sombre color designs built of architectural and landscape elements that have a certain impressiveness. The other style is less coherent and less consistent than the first. In this group of paintings abstract and semi-abstract forms are rather wildly thrown together with the result that the artist's intentions are less clearly intelligible. A trace of self-consciousness is never absent and the obligation to Picasso is apparent throughout.[61]

Surprisingly, Watson, a critic deeply concerned about subject matter, entirely ignored the imagery in the de Chirico paintings.

The *Art News* commented that de Chirico was a new bandwagon upon which they would not climb, but also made an astute criticism:

> For your consideration here is Chirico. There are wilder men but there are few who would so offend the solemnly conservative. For our part we will most gladly hold the ladder for you but if your whistle is tuned to the 'great art' strain we cannot join you. The man is a sly rascal and an amazing artist. He has astonishing command over line and can draw more humorous legs and feet than any we have seen. And his strange figures with featureless faces, balloon-like heads and puzzle picture torsos have very pensive and very human souls. One longs to comfort them for they seem even as we, often quite upset by an inconsiderate destiny.[62]

The exhibition at Valentine Gallery the following year led to a full scale article on de Chirico by Lloyd Goodrich. He praised the strength of de Chirico's earlier works and commented on the increasing superficiality of the later paintings. Goodrich also responded to the iconography:

> Just as Picasso will deliberately magnify the proportions of a foot or hand, so will Chirico place a ruined temple inside a bedroom, or the furniture of the bedroom in the midst of a plain. It is largely this trick of grouping incongruous objects, or of placing objects in incongruous surroundings, that accounts for the nightmare quality of his work. As in a dream, these juxtapositions have a suggestive and troubling quality; they seem to imply much more than they actually state.[63]

Although Goodrich was not as evocative as Crevel, he was like Crevel, responding to the imagery rather than the style of de Chirico's powerful paintings.

McBride wrote of the impact of the work in the art world:

> Paris itself decided to put a higher valuation upon de Chirico after it heard of the New York furor. The strange wit does not seem to baffle this public. To sum it up in a few words it consists in the superposition of this new spirit upon the crumbling ruins of all that Europe formerly held sacred. There is something poignant in de Chirico's symbols of the past and the spectator is moved, unexplainably, as he is by certain gorgeous strains in poetry.[64]

The comment on the furor over de Chirico's work indicated the popularity of the paintings. McBride's analysis also reflected his perceptive understanding in its sensitive comment on the mood and meaning of de Chirico's art.

Surrealism

Only Goodrich connected de Chirico to the Surrealists. He stated in a biographical note that "Chirico is generally considered to be one of the founders of the Surrealists."[65] The American art world in the 1920s saw Surrealism only sporadically; individual artists, particularly Miró, received

attention, but the group in general was only occasionally mentioned as the newest development in Paris. The *Little Review* reproduced four Miró paintings without any explanation in the spring of 1923. The following winter, it presented the art of the just emerging leader of Surrealism, Andre Masson.

By December 1925, a little over a year after Breton adopted the term "surrealisme," two articles presented it in the New York press. The *Art News'* Paris correspondent criticized the first group exhibition:

> Nothing is more sad than a clown without wit, more depressing than a humorist without humor. Such is the impression one carries away from the exhibition of 'Surrealist' paintings where few survivors of Dadaism try in vain to bring defunct Dada to life. They are wrong to take Pegasus for a wooden horse. At the same time that their laborious lucubrations try to discover something new without succeeding, an artist without an 'ism,' a simple painter succeeds in doing it without having sought it.[66]

Such a negative appraisal of Surrealism did little to communicate the meaning of the new style.

Virgil Barker wrote on the Surrealists, and their enthusiasm for Klee and Chagall, in a "Transatlantic Column" of the *Arts*. He provided an overview of the group and its methods of operating:

> The literary wing of this group [Surrealists] have been very liberal with manifestos and programs and descriptions of their way of working. This consists essentially in removing all conscious control of the processes of art and allowing the unconscious to dictate everything. The works of both Klee and Chagall seem to be the pictorial equivalent of the literary works so produced.
>
> To more commonplace mortals, of course, this is simply the abandonment of method; in its most productive periods it works through a species of self-hypnotism. It is more than verbal fallacy to claim that the subconscious can become the superconscious, whether realistic or anything else. When one indulges in such tinkerings with one's physical and psychical apparatus, the likeliest result is a short-circuit of inspiration and a blow-out of the personality. The works that result from eruptions of the subliminal can only accidentally possess aesthetic consciousness. For a certain type of mind they may possess the power of initiation into what is not unfairly to be described as a trance; but that kind of value lies outside the sphere of art. The thing that passes for a work of art is transferred into the sphere of mysticism, black or white, and becomes simply another form of talisman sorting with glass balls and the omphalos.[67]

Barker's firm separation of mysticism and art contradicted the accepted understanding of modern art in America, particularly the theory of the Stieglitz circle. In the context of John Marin's landscape a mystical element was acceptable. In the context of European Surrealism it was dismissed as "tinkerings with...psychical apparatus."

The *Arts* received Marc Chagall's show in 1926 favorably. Goodrich correctly saw Chagall as independent of the Surrealists:

[He has a] following among the surrealistes who believe that art should come directly from the unconscious, with as little conscious control as possible. This is an excellent theory; but it is difficult to believe that Chagall's work proceeds from anything very much deeper than what the psychologists would call the foreconscious.[68]

Goodrich's differentiation was a valid one, for Chagall's sources were not from the Surrealists, but more from the Expressionists and the Russian mystical tradition.

The *Little Review* featured the Surrealists in the spring of 1926. Heap reproduced the work of Masson, Miró and Pierre Roy with a brief essay. The lead articles by Georges Ribemont-Dessaignes and Matthew Josephson were not favorable toward Surrealism. Ribemont-Dessaignes, a former Dada, wrote:

It so happened that a little piece of Dadaism thought it could perfectly well invest itself with Sex Quality and fill a respectable role within the vulva of the mob. The success of Surrealism is the wedding apparel of this bird of paradise. They don't agree any more about Surrealism than they used to about Dadaism. The same thick swamp subsists. Who is surrealist, who is not?... Like dadaism in its time, there remains the same duplicity among individuals, the same mystification which is inseparable from all deep outbursts.... A certain appearance of steely violence, but only an appearance, the call to revolt and the gears of social revolts complete the analogy.

In spite of ourselves who, maybe had given too much scope to our tameness, this example makes us shake our feathers... Eyelids of hot steel and shark lids, let's stop dreaming and go hunting? We care too much for public opinion, and we blush for looking fashionable to the snobbish eye....

The strong hands which led Surrealism will no doubt, withdraw, some day, followed by loud laughter.[69]

Ribemont-Dessaignes spoke with the peevishness of an artist who was no longer at the center of the avant-garde.

Josephson's scornful article was mainly a condemnation of his former Dada friends:

Super-realists. Chameleons, rather! Even as one begins to scold you the colors change and a new 'movement' is under way. As we billet this new artistic organism in the *Little Review*... word comes that it is no longer among the living. I insist, however, upon a moment's time to record my protest against your somnambulistic literature.

It was with much sinking of the heart that I watched my friends... [author's ellipses] After the exquisite uproar of Dada, which was incontestably a miraculous sideshow for the world, this Super-realism is the faint, ugly whine of a decrepit engine....

Again, the literary production of the super-realists is bastard. Of what value are these tedious and tepid dreams, these diffuse poems in prose, these wearisome manifestoes couched in an habitual imagery and an inverted syntax.... I find their literature contemptible and woefully easy to account for.[70]

Josephson had known the Dadaists, but had left Paris and the creative world to take up life in the stock market. Certainly, his changed perspective contributed to his rejection of the new art form. His comments did, however, point up the strong interconnections of the literary and visual aspects of the movement.

Goodrich's review of Leopold Survage's work in June of 1927 reflected a negative bias toward the imagery of Surrealism:

> M. Survage's abstractions are flavored with a dash of *surrealisme.* There is a strong element of symbolism in his work; he is evidently haunted by certain images—a bird, a fish, women at a well, the shadow of a man on a wall—and these recur constantly in his pictures. In spite of these esoteric subjective elements in his work, however, it has a feeling of balance and clarity, that is attractive.[71]

In contrast to his earlier article on de Chirico, this one demonstrated Goodrich's preference for the straightforward, and even formal, over the esoteric in art. This attitude would later develop into a favoring of Regionalism, although in 1927 he still supported formal aspects of modern art.

A lengthy discussion of Surrealism appeared in the newly established *Art Digest* in the spring of 1927. It included a long letter from the artist Hiler. The *Art Digest* editor wrote an introduction to the letter explaining that

> the latest "ism," whose name, "Surrealism" is beginning to appear in English and American journals. It seems to be a phoenix-like outgrowth of or even a reaction from Dadaism, which was a negation of everything.[72]

Hiler's letter described the founding of the movement in an anecdotal way and, most importantly, actually quoted directly from Breton's "Manifeste du Surrealisme" and his well-known definition of Surrealism as "pure psychic automatism by means of which it is proposed to express, either verbally or in writing or in any other manner whatsoever, the actual functioning of thought." The illustration in the article was a painting by Georges Malkine of a chair floating in the clouds. The example suggested the simplistic level on which the American audience experienced Surrealism as late as 1927.

Albert E. Gallatin's acquisition and display in 1929 of Miro's *Dog Barking at the Moon* led to widespread criticism of that artist's work. The famous work was, according to the *Art Digest,* the first Surrealist painting in America. McBride commented:

> Miro is a surrealist, one of the iconoclasts who defy realism and some say the chief of the movement....
>
> ...This picture is pure symbolism. There is a recognizable dog in it, but it is a Caran d'Ache dog stylized to a high degree like the new wooden toy dogs with which fashionable parents beguile their Peter Arno children. The moon too is recognizable as a moon, though it

is not quite like the moons we have been used to and then there is a mighty ladder . . . Nothing to grow alarmed about, . . . yet many modern art lovers flee when no man pursueth. . . .

[T]his was 'pure' symbolism . . . The leader can mean one thing to you and another thing to me and I think that we should be thankful that we get different things out of it and not make a quarrel over such a thing.[73]

McBride, as usual, mixed perception with a witty insinuation that the rest of the world was just a little dim-witted.

The *Art Digest* responded by headlining their article about the acquisition: "Miro's Dog Barks While McBride Bites." A large reproduction of the painting on the front page accompanied an article that quoted various critics on the painting (the typical *Art Digest* format), including McBride. The editors' description set up an atmosphere of doubt:

What is it and why did Mr. Gallatin buy it? The one who wants to know had best stand in front of it. An impossible dog looks up idiotically at a sick moon set in a sky which has the purple depth of infinity. There is a ladder reaching upward toward a tiny patch of light in that terrible and depressing sky, and one can't tell whether the rift is receding and vanishing or coming forward and spreading. And somehow one feels very, very small in front of this ladder, which may lead to futility, in the presence of an idiot dog barking at he knows not what. For, its prophets say, surrealist art is not pictorial, but psychological.[74]

Art Digest's careful description of the painting, with hints of its peculiarities, continued the open-mindedness of the 1920s toward modern art. In another year, *Art Digest* would be proselytizing for Regionalism.

Thus Surrealism was familiar to American audiences in the 1920s, if only in a limited way, both in terms of artists and in terms of the movement's principles. Strangely, it received far less attention from both dealers and critics than did geometric abstraction, although it would seem to have had more in common with the New York critics' increasing interest in subject matter. Geometric abstraction evolved more directly from Cubism, a style that was better understood. Surrealism, coming from Dada and already an eccentric development in the critics' eyes, had a less solid foundation for the critics to use in judging the work. In addition, the interest in the unconscious apparently made the American writers uneasy. American critics sought an American style in a clean hard-edged Machine Age art. This style dominated the criticism in the last third of the decade.

6

Styles of the Machine Age

Even as the critics of the 1920s were beginning to assimilate Cubism and Expressionism, and striving to interpret Dada and Surrealism, they were also confronted with the next generation of modernism, the art that utilized the structural implications of Cubism. Ranging from Futurism to Constructivism, this art reflected the new fascination with the machine that preoccupied Europe from the mid-teens to the end of the 1920s. The work relates to the Machine Age through the use of abstract forms that reflect the principles of machine construction, through an impersonal quality that suggests a machine-made object or through the use of machine related imagery.

Images of the Machine

American Futurism: Joseph Stella

Joseph Stella first painted industrial scenes as early as 1908, but his best known images are those of the late teens and early twenties. *Brooklyn Bridge* of 1919 and *New York Interpreted* of 1922 established his reputation as a major American modernist. Stella imbued his imagery with a romantic flavor by using lush colors and dramatic lighting, a quality that linked him to nineteenth-century romanticism. His own comment about the Brooklyn Bridge reflected his excitement about the entire modern environment:

> To realize this towering imperative vision in all its integral possibilities I lived days of anxiety, torture, and delight alike, trembling all over with emotion like those railings, in the midst of the bridge vibrating at the continuous passage of the trains. I appealed for help to the soaring Walt Whitman's verse and to the fiery Poe's elasticity. Upon the swarming darkness of the night, I rang all the bells of alarm with the blaze of electricity scattered in lightnings down the oblique cables, the dynamic pillars of my composition, and to render more pungent the mystery of the metallic apparition, through the green and the red glare of the signals, I evacuated here and there caves, as subterranean passages to infernal recesses.[1]

Stella's words endowed the man-made bridge with spiritual power and energy that invigorated the imagery of the steel forms. They were infused with his romanticized, positive vision, rather than an alien or threatening aura.

The same tone dominated his discussion of the five-panel series of *New York Interpreted:*

> In 1920 I gathered all my strength to assault the theme that for years had become an obsession: The Voice of the City of New York Interpreted. . . .
>
> Continually I was wandering through the immense metropolis especially at night, in search of the most salient spectacles to derive from the essentials truly representative of her physiognomy. And after a long period of obstinate waiting, while I was at the Battery, all of a sudden flashed in front of me the skyscrapers, the port, the bridge with the tubes and subways.[2]

The experience as described by Stella sounds almost like a religious experience.

Duchamp may have been an influence in Stella's celebration of New York when he wrote in 1915 that "New York itself is a work of art, a complete work of art."[3] Both Stella and Duchamp also responded to the Italian Futurists' manifesto which called for a new art that reflected a modern urban environment. Stella was, in fact, the only American artist to embrace the Futurists' principles in his art and spirit.

The critics loved Stella's energy. Hamilton Easter Field, the idealistic founder and first editor of *The Arts,* found Stella an artist about whom he could be unstintingly enthusiastic. He characterized Stella as "ultra modern," contrasting *The Brooklyn Bridge* with the work of a weak, academic painter like Jonas Lie:

> The Brooklyn Bridge . . . is to me a symbol of modern America—the most famous piece of engineering construction in America, although no longer the most important. Joseph Stella came to America as a boy and the Brooklyn Bridge came to symbolize our natural life to him. He has just painted what to me is the apotheosis of the bridge.[4]

Field compared Stella to the "massive opulence" of Rubens. To an extent, Field occupied the same position in the critical world as Stella did in the art world: he was a link between the emotional outpourings of nineteenth-century romanticism and the cooler modernity of the 1920s contemporary styles.

The Société Anonyme displayed *New York Interpreted* together with Stella's other industrial imagery in 1923. Dreier accompanied the exhibition with a pamphlet celebrating the "poet-painter" Stella and his art:

> This son of Italy has left all the softness, all the warmth, for the call of the brillancy of the flare of the electric lights—which dazzle but never warm. In his *New York Interpreted,* he has shown us how unhuman human energy can become.[5]

Dreier praised the work and the artist, even while she had reservations about the imagery. Alexander Brook, a usually reserved and conservative commentator in the *Arts,* responded with florid outpourings:

> New York is a mythological city of infusible elements of unrealities, impossibilities, the preposterous spot where perpetual motion defies denial, where an irresistible force meets an impenetrable body, a hydraheaded monster rearing its head leagues above the wonders of antiquity.[6]

Brook, like Field, did not really analyze the paintings, but rather, offered impressionistic ideas.

At the same time as the Société Anonyme exhibition, the *Little Review* published a "Stella Number" with sixteen reproductions of the paintings and a photograph of Stella and Duchamp. In her usual understated but abrupt style, Jane Heap gave a one-sentence commentary on the artist's work: "The average New Yorker who conceives his city as composed of noise, dirt and policemen will learn a great deal from this exhibition."[7]

Thomas Craven had reservations about the factory imagery, claiming that it was not sufficient to make the art successful:

> Mr. Stella believes that the American artist should stay at home, "derive his motif from his own life and surroundings and work strenuously." This is old and undeniable doctrine and to put it in practice he has occupied himself with the delineation of industrial activity. Factories, skyscrapers and gas tanks are molded by his imagination into architectural fantasies. His position in painting will depend upon his ability to give meaning and coherence to his romantic interpretation of modern life.[8]

The comment was strange for the future promoter of "American Scene" painting, but Craven was still a formalist in 1922.

Henry McBride offered the only evaluation of Stella's art that reflected reservations as well as a careful examination of the paintings. He found that *New York Interpreted* was not as good as he had hoped it would be:

> Part of the yearning, when we heard that Stella was doing a big New York picture, was that it might be a crashing success; and that it cannot truthfully be said to have been. When asked, I have generally said, I like them very much. There is an enormous amount of aspiration, an enormous amount of intellectual energy in them and generalship of execution—but also a lot that offends.
>
> The thing has a ferocious amount of parallelism. The tall towers appearing behind each other are razor edged. I get the effect that Stella's New York is all strung up on wires.[9]

McBride's analysis identified one of the aspects of Stella's *New York Interpreted* that later critics also questioned: the compositions. In the twenties, Stella was primarily accepted by critics for his subjects, compositions or colors, but most of all for the spirit of his work.

The Immaculates: Charles Sheeler

While Stella's urban imagery appealed because of his combination of romanticism and modernity, the Immaculates' cooler iconography and Cubist-influenced style inspired a different reaction. The members of the Immaculates included Charles Sheeler, Preston Dickinson, Niles Spencer, Elsie Driggs and others who showed together at the Daniel Gallery throughout most of the decade. They were identified and called Immaculates by 1926.[10]

Of the Immaculates Charles Sheeler was the most sophisticated and complex, and thus was subject to the most diverse interpretations. A survey of the criticism of Sheeler's work charts the general shift in twenties' criticism from an emphasis on modernism and formal qualities, to a pre-Regionalist focus on subject matter, particularly American subject matter.

Sheeler's imagery included skyscrapers, the elevated subway and interior architectural subjects, as well as still lifes. His style was cool and impersonal: a machine aesthetic. Yet, Sheeler was most of all a classical artist, bringing to all of his subjects a consistently idealizing, detached attitude. In his classicism Sheeler was the most avant-garde American modern, for he shared that perspective with the artists of "L'Esprit Nouveau" in Paris.[11] Sheeler's own comment on an exhibition of sixth and fifth century Greek art expressed his attitude to art concisely:

> It is of further interest to examine the evidence as it is beautifully demonstrated in the Aphrodite that as great purity of plastic expression may be achieved through the medium of objective forms as has thought to be obtainable by some of our present day artists by means of a purely abstract presentation of forms. The study of abstract problems by pure reason had its origin with the Greeks. . . . A perfect balance was maintained between the mind and nature, and the means of realizing both of these elements in a single entity was called Art. The Greek miracle was accomplished by the perfect adjustment of concrete form to abstract thought.[12]

Art critics emphasized other sources. The *Art News* connected his work to an earlier stage of modernism, perhaps thinking of the ash can artists or the watercolors of New York by John Marin. The reviewer correctly distinguished Sheeler's more skillful handling of formal qualities:

> [His] oils are reminiscent of the first flush of the Modernist movement in New York, since they are chiefly views of skyscrapers, painted in flat tones, and angular in pattern. But his color is so pure and his effect of enormous height so strong that his Modernism is of a quality to make the pictures painted in the beginning of the movement seem dull and amateurish. The color in "New York" and "Skyscraper" is remarkable for the strength, purity and fine design it makes in the various masses.[13]

One writer in the *Arts* suggested that Sheeler had a desire to express the mechanical world and connected the formal design to that:

> Charles Sheeler's is a cool, cerebral art, all steely perfection, crystalline impersonality and purity of style. . . . [The] subject is more or less the excuse, the point of departure for a scheme of abstractions. His real subject is always spaces, volumes, forms. . . . All is sure, conscious, calculated. A picture by Sheeler has the clear, sharp, cold beauty of one of our modern machines, the severe impersonality of a mechanical drawing. One suspects that he has striven to express in his manner no less than his subjects, the tone and character of our mechanical civilization. [14]

A major feature article by Forbes Watson combined formalist analysis and a shift toward Watson's particular version of pre-Regionalist nativism. Although in analyzing specific works Watson outlined the principles of composition that were the basis of the paintings, he connected the austere style of those forms to an American tradition of design:

> In the clean-cut fineness, the cool austerity, the complete distruct of superfluities which we find in some pieces of early American furniture, I seem to see the American root of Sheeler's art. [15]

Watson's article, one of his finest throughout the decade, was an early statement of an American perspective on Sheeler that would dominate analysis of his work after 1930.

Other critics began to express reservations in the mid-1920s about the coolness of Sheeler's imagery and style: Watson suggested that Sheeler was "loosening up" in his new work; a positive new direction, in his opinion. He concluded that "Sheeler can open up the throttle a long way without any fears." [16]

Sheeler did shift directions in the mid-1920s, perhaps in response to contact with the European avant-garde ideas through his friendship with Matthew Josephson. [17] But rather than continuing to "loosen up" he turned to an even tighter, cooler depiction of industrial imagery. In 1927 at the Ford Motor Company Plant in River Rouge, Michigan, he created an image of American industry with his camera that would bring him respect with the European avant-garde and would sustain his painting for many years. [18]

Analysis of other Immaculate artists usually reiterated the same terminology used for Sheeler. One of the clearest statements of the group style identified their characteristic combination of subject and style:

> Factories, sheds, bridges and smokestacks, loom large in the current Daniel showing, all rendered in the precise line, flat color and clearly defined pattern that have become trademarks of the immaculate school. [19]

Thus, critics up to the end of the decade emphasized both form and subject in the Immaculate work. Only Watson gave a strong American flavoring to the character of Sheeler's style. In the 1930s and later, the American aspect of the Immaculate subjects, rather than style, has consistently been given more emphasis, and the term "Immaculate" replaced by that of "Precisionist."[20]

"L'Esprit Nouveau" and Fernand Léger

At the same time that the Immaculate style emerged in American art, the European avant-garde idea of "L'Espirit Nouveau" also began to receive attention in America. That idea first appeared in America in an early issue of the magazine of the same name. The authors, Pierre Jeanneret (later known as le Corbusier) and Amadeo Ozenfant praised anonymous industrial designs as continuing the classic spirit of Greek temples. In January 1921 Hamilton Easter Field reviewed the magazine saying:

> It has much food for thought in it. Two tributes are paid to America, one to our 'movies,' the other to our industrial architecture. Photographs are reproduced of types of buildings that are new to me.[21]

Field was referring to the copiously reproduced grain silos. The authors admired the austere designs of American and Canadian agricultural buildings, even as American critics, absorbed with the review of modern art exhibitions in New York, had never seen them. Nonetheless, Field, always open-minded, reviewed the magazine favorably.

The art of Fernand Léger, closely affiliated in style and spirit to "L'Esprit Nouveau" was surprisingly prominent in New York in the early 1920s. Ezra Pound brought Léger's ideas to the attention of the American public as early as 1922 with an article in the *Dial:*

> Fernand Léger is industrious. Taking his work retrospectively one knows of a time he stopped painting and for some years puzzled over the problem of ideal machines, three dimensional constructions having all the properties of machines save the ability to move or do work. This is a perfectly serious aesthetic problem. Léger comes to a provisional answer in the negative, not convinced, but wondering whether the object, the real machine, won't in the end be more interesting to look at and better aesthetically.... Léger finds the easel picture a construction. Many of his designs only become effective when one imagines them forty feet by sixty. Léger would be perfectly happy doing the outside of a railway terminal, or probably doing an ad on the slab side of a skyscraper.[22]

Shortly after this letter to the *Dial,* Pound was also responsible for the publication of Léger's important essay "The Esthetic of the Machine," in the *Little Review.*[23] The essay in its praise of the beauty of the machine had an

immediate impact on Jane Heap.[24] It apparently was the catalyst for her comment in the very next issue that "something very interesting could be written about the Machine as a religious expression as great if not greater than the great cathedrals.... I have thought of doing it."[25] While Heap's comment might also have been in response to other sources,[26] her support for and interest in Léger's ideas is reflected in the increasing domination of machine-related art in the *Little Review* and its gallery.

New York saw more than Léger's theories on art. His art first appeared in November 1923 in the ballet *Skating Rink*. Léger designed the scenery and conception of the ballet. He also accompanied it to America for its New York debut. McBride meticulously described the ballet in the *New York Herald* after quoting several paragraphs from Léger's essay on "The Esthetic of the Machine":

> In his ballet Léger represents the skating rink as a vast complex in which the human beings moved as regularly and monotonously as pistons or wheels. The curtain is a melange of doll-like human beings, magnified roller skates and confused geometric forms...against which the human figures are arranged as if they were inanimate objects.[27]

McBride concluded with a description of the standing ovation that the work and the artist received, documenting thereby the positive response in New York to the new linking of art and the machine.

The Société Anonyme held a major exhibition of Léger's painting in November 1925. The catalog essay by Dreier suggested only a superficial understanding of Léger's ideas in its emphsasis on beauty and transcendental thought:

> In his picture "Man and Woman," the absorption of humanity by the machine is made clear; its beauty is brought to full light in the one entitled "Discs"—but when one turns to that magnificent decoration called "Le Déjeuner," one is convinced that the power of thought which hold his creations will rise above the machine and master it through its philosophy which conquers the life of today.[28]

Following Dreier's essay, Karl Einstein's prose poem praised Léger's energy in general terms. Even Leger's own "Notations on Plastic Values" had no references to the machine.[29]

Louis Lozowick, in reviewing the exhibition, more accurately connected Léger to the Machine Age:

> The influence of mechanical industrial civilization on art is indirect and, therefore, all the more subtle. The economy in the use of materials, the logic of their coordination, the precision of their functioning, the abstract geometric contour of their mass fill our environment, affect our vision, enter our consciousness, fashion our tastes.

The theory of an artist is usually a rationalization of his own practice. Léger's work is charged with the rhythm of the present mechanized world. Some forms employed by him are borrowed from it and used in novel combinations, others are suggested by it and transmuted beyond recognition. In the end objective verisimilitude yields to aesthetic reality.[30]

Lozowick here combined his own knowledge of the machine aesthetic with an astute analysis of the works.

The *Art News* also commented on Léger's art in the context of the machine:

[*Personnage dans un Jardin* is] one of the best examples of Léger's rendering of the modern myth of the power of the machine and its result on modern life. He utilizes his epoch and transforms it into expressions of the painting art that is almost plastic. Machinery may have reached the external as seen in the arts and bodies of his people. But their soul remains as untouched as heretofore. Therein lies the optimism of the painter. He is well-known to that exclusive group in America who enjoy the unusual.[31]

The note on the soul reflected a continuing desire for an extra-physical dimension to art and a reluctance to accept the machine itself as a spiritual entity.

McBride's response to Léger's exhibition suggested a certain ambivalence toward Machine Age art:

There is nothing depressing in the idea of machines. America, the land of machines, is not a depressing country to live in, is it? Of course not. You who drive motors with great speed, heads of families who tune their radios with extreme nicety and housewives who sweep their rooms with electric sweepers, are not to be commiserated are they? Not much. But at the same time not many among us apparently relish having the artists hold the mirror up to nature....[32]

Alone among the reviewers, he noted the anomaly that a European artist was presenting machines to America by writing wittily that "it merely means that if we have the machines, France has the artists."[33]

In the 1926 International Exhibition, Dreier elevated Léger to one of six major directions of contemporary art, that of the international group working out the problems of the "Intérieures Mécaniques."[34] Dreier here invented her own terminology which, unfortunately, she did not elaborate on in other articles.

Machine Age Abstraction: Suprematism and Constructivism

Reports to New York from Europe

One of the first American writers to discuss the avant-garde art of Suprematism and Constructivism as it was developing in Russia in the late teens and early

twenties was Oliver Saylor, a theater critic. Saylor spent six months in Russia during the winter of 1917/1918, the first months of the Bolshevik regime. As a result he communicated to America a record of the early stages of Russian modernism, including Futurism, Suprematism and the principles of Constructivism.

In an article in *Vanity Fair* of September 1919, Saylor described the history of the Russian avant-garde, including the late nineteenth-century "World of Art" movement and Futurism. He concluded with an appraisal of Malevich and Suprematism that quoted from Malevich's pamphlet, *On the Way from Cubism and Futurism to Suprematism,* and summarized Malevich's ideas:

Today, he has renounced all effort to 'represent' any scene, object or idea in colors. He uses color and masses for their own sake and finds that occupation and the explanation of his work in the galleries sufficient to take up all the time he is not serving in the ranks of the Red Guard as an ardent Bolshevik. . . .
Just what is the subconscious intent behind the work of Malyevitch, [*sic*] and his followers, I do not know. He is the target of ridicule in Russia, just as he would be in any country. But I found his strange compositions unusually jolly to look at. In our gray world that is something.[35]

The appraisal of Malevich is a notable record of an early, although predictable, response to Malevich in Bolshevik Russia.

Saylor also introduced the principles of Constructivism and identified the theater as the birthplace of the style. He described the development of Russian art from Cubism to Constructivism as it appeared in the scenery of the Kamerny Theater in Moscow:

The Kamerny. . . repudiate[s] the scenery of two dimensions, width and depth, and construct[s] the surface of its scenery in three dimensions; width, depth and height, in such a way that these dimensions would be in harmonic relation with the rhythmic and plastic movements demanded by the mise en scene of the play. The quality of height at the Kamerny, therefore, has no leading strings to reality, but is dependent on the emotional and rhythmic effect sought in each scene of the play.[36]

In this passage Saylor presented an intermediate stage in Russian theatrical style between Cubism and the fully developed machine esthetic of the Constructivists.

Another important source on European modern art was Flora Turkel, the Berlin correspondent for *Art News.* She provided an important group of articles on modern Russian and German art as it was shown in Berlin in the early 1920s. Turkel's articles on the avant-garde were usually factual, detailed and somewhat conservative. Fortunately, she did not restrict herself to art that corresponded to her own opinion of what was good art. She based one major

article on the Russian book by Constantin Umansky. The article covered both the Suprematists and Tatlin:

And the so-called "Tatlinismus," initiated by Wladimir [*sic*] Tatlin is spreading the opinion that mere painting limits the possibilities of expression, and uses in its "kontre-reliefs" many kinds of materials...

The school of "Tatlinismus" utilizes machines for the adequate expression in sculpture of the spirit of this age. The modern monument, its followers say, ought to be nothing but a machine and be used besides for a practical purpose, having within cinema shows, telegraph instruments and other mechanical contrivances. [37]

Although the title of the article referred to "bizarre extremes" (probably an editor's opinion), the discussion itself was cooly reportorial.

In November 1922 Turkel reviewed the now famous exhibition of avant-garde Russian art at the Van Dieman Gallery in Berlin. The huge exhibition, sponsored by the new Russian government, introduced the Cubo-Futurists, Suprematists and Constructivists to Germany. Turkel connected the display to political events and suggested that the Suprematist art was more interesting as documents of a struggling nation than as works of art. She valued the work of selected individuals: "A few of the pictures enable us to state that Altman, Rodchenko and Rosanova are capable artists, who surely will get over this sterile period dictated by an intellectual problem." [38] She also singled out Tatlin's pieces saying that he "represents the spirit of this age in parts of machinery construction in glass and many kinds of materials." [39]

Although Turkel was not overly enthusiastic about the Constructivists, she continued to describe them. One provocative comment on a piece by Rudolf Belling was thoughtful about the problems of abstract Constructivism:

Rudolf Belling, National Gallery. Constructivism with this artist has become productive of new forms, filled with the power of aesthetic significance. [In this portrait] the head is horizontally divided into two parts, one side expressing the mental, the other the sensual, in the personality of the represented and a flame bursting from the interior of the head symbolizes the model's temperament and ardent soul. Those of Belling's works which cling to naturalistic forms are much less attractive and do not surpass average sculptural work. [40]

Evidently, Turkel was more receptive to an art work with a degree of identifiable form, but she was also open-minded about abstraction in contemporary art.

In addition to her coverage of Russian art, Turkel was also one of the first and only writers of the early twenties to write on the Bauhaus, the design school organized by Walter Gropius that would have such an important impact in America later in the century. For Turkel the Bauhaus work was similar to that of the Constructivists. Her review of Laszlo Moholy-Nagy's abstract compositions conveyed ambivalence:

Doubtless there is aesthetic significance in the well-balanced lines, cubes and geometrical forms. . . . The question arises whether it is not a greater task to fill these forms which do not convey to the beholder any objective with life and impressiveness than it is to use the ordinary and well-known forms of reality.[41]

Her comment suggested meditative questioning of the central issue of abstract art, rather than a rejection of the work.

Turkel was more intrigued by the experimental color plays created at the Bauhaus by Ludwig Hirschfield-Mack and similar experiments at Der Sturm:

[The Bauhaus and Der Sturm] have taken up these old ideas [of color music] and are making new experiments which seem to be connected with cubistic-futuristic tendencies in painting. By means of projecting, forms of different shape and size are reflected as in cinemas, on a white plane and set in motion with variation in colors. Ludwig Hirschfield-Mack in Weimar accompanies his 'color plays' with music, while Kurt Schwertfeger in the Sturm operates also after a preconceived rhythm, but without music. Fine effect is attained in both cases, color, form and movement combining in a complex of sensation, new and striking to the spectator.[42]

Turkel considered radical abstract experimentation in film much easier to accept outright than in traditional media of painting and sculpture. In reporting on these films for the *Art News* in 1924, she displayed real foresight; only recently have they received further consideration. Taken collectively, Turkel's columns in the *Art News* are valuable and informative sources on the avant-garde contemporary art of the 1920s. Her biography, regrettably, has been lost.

The American-run and circulated periodical *Broom*[43] also provided important, if erratic, information on Constructivism. Based in Berlin from November 1922 to March 1923, exactly the months during which Constructivism emerged, *Broom* reproduced Tatlin's *Tower* or *Monument to the Third International* as early as November 1922. The reproduction was accompanied by an explanatory note by Louis Lozowick, an American artist/critic, who defined the meaning of Constructivism:

Construction and not Composition, teaches new Gospel.
Why?
Because the composition is inspired by the past, looks toward the past, and therefore belongs to the past; because composition means ornamentation, decoration, romanticism, prettiness; because composition stands apart from life, serves as illusion to exhausted mentality, acts as stimulants to enervated organism.
And construction?
Construction is inspired by what is most characteristic of our epoch: industry, machinery, science. Construction borrows the methods and makes use of the materials common to the technical processes. Hence iron, glass, concrete, circle, triangle, cube, cylinder, synthetically combined with mathematical precision and structural logic. Construction scorns prettiness, seeks strength, clarity, simplicity, acts as stimulus to a vigorous life.[44]

This passage reappeared, in whole or in part, in later writings of Lozowick as the central theme of his explanation in Constructivism. It was a central influence in the American definition of Constructivism as articulated by the best-informed critics of the 1920s.

Broom followed the discussion of Tatlin's *Tower* with a more complex consideration of "Modern Russian Art". Lozowick again provided the information on the development from the late nineteenth century to the 1920s. He identified the Suprematists as Malevich, Exter, Rodchenko, Drevin, Lissitzky and Rosanova who

> tried to carry the analytic process of Cubism to its logical conclusion. They sought to get rid of what appeared chaotic in cubism by employing a greater economy of means. They combined pure elementary colors and simple elementary forms in a manner to suggest movement and create rhythm.[45]

Lozowick then distinguished between various types of Constructivism including one that

> grants the legitimacy of artistic activity, although it would transform that in harmony with the demands of the new age. Art should root in the weightiest realities of our day. These are science and industry. The Constructivists, therefore go for instruction to science and borrow an example from industry. Like science they aim at precision, order, organization; like industry they deal with concrete materials: paper, wood, coal, iron, glass. Out of these new objects—not pictures—are created not imitative of reality but built with a structural logic to be utilized eventually, just as steam was utilized long after its discovery; new objects that can affect society just as they are rooted in it. Hence the Constructivists consider their work strictly utilitarian. Technical processes organize dead materials; constructivist art would mold the new social personality.[46]

Among the artists included in this tendency were El Lissitzky and Vladimir Tatlin. Lozowick's article, an historical and theoretical discussion of Constructivism, also reappeared later in the American press, particularly under the auspices of the Société Anonyme.[47]

Other *Broom* coverage of modern art included an essay by Enrico Prampolini, "The Aesthetics of the Machine and Mechanical Introspection." That article would also reappear throughout the 1920s in the *Little Review*. Prampolini praised the Futurists' celebration of the machine, but objected to the "Constructionists":

> The Constructionists, though they take as their starting point an extremely clear theory, announcing the constructive exaltation of the Machine, become inconsistent in the application of their doctrine, confusing exterior form with spiritual content....
> Is it not the new mythical deity which weaves the legends and histories of the contemporary human drama? The Machine in its practical and material function comes to

have today in human concepts and thoughts the significance of an ideal and spiritual inspiration.[48]

Prampolini differed significantly from the Russian Constructivists in his emphasis on the spiritual element, an aspect that made his theories appealing.

New York Exhibitions and Reviews

In addition to the coverage by writers located in Europe, Constructivism appeared in America in exhibitions primarily under the sponsorship of the Société Anonyme and the *Little Review*. Since Louis Lozowick was involved in both of these organizations, he played a central role in creating the interest in Constructivism, although both Dreier and Heap were already strongly committed to the avant-garde movements prior to his return to America in 1924. Dreier visited the exhibition of Russian art in Berlin in October 1922 and purchased Malevich's *Knifegrinder,* along with other paintings. Heap already had a fascination for the machine under the stimulus of Léger. Dreier and Heap both began to display Constructivism in the same year Lozowick returned from Berlin.

The Société Anonyme held their first full-fledged exhibition of Suprematists and Constructivists in February 1924. It included Malevich, Exter, and Tatlin. The conservative *New York Times* gave the Constructivists a long analysis. The anonymous article included an evaluation of Malevich and the Constructivists that quoted Lozowick's phraseology and commented on the contradictory interpretations of the movement:

> Neither of these definitions seems different or new, but just the eternal struggle to formulate another part of the esthetic hypothesis. Unless labelled, it would not be always possible to distinguish between the two schools. To whichever school Lipschutz [*sic*] belongs, there is great beauty to his modeled abstractions. Lissitsky's arrangement of values is sensitive and Malevitch's "The Scissor Grinder" in [*sic*] full of the sound of a turning wheel.[49]

The *Times'* willingness to consider the radical works was a considerable shift in emphasis for that newspaper. The anonymous article was probably the work of a new critic, more receptive to the most avant-garde trends than the *Times* longtime critic Elizabeth Luther Cary.[50] The brief reference to the Suprematists in the *Art News* also relied on Lozowick's terminology.[51] Other art publications did not comment on the exhibition.

During the same winter as the Société Anonyme exhibition, the *Little Review* began illustrating the work of the Constructivists, accompanied by a characteristically concise comment by Heap:

THE RUSSIAN CONSTRUCTIVISTS. Here is a group of men who have broken with painting and sculpture and have become engineers of art. They take the materials of industry: steel, wood, paper, coal, glass . . . [Heap ellipses] They study the weight, texture and psyche of each material and then treat it with a precision, organization and balance which produces "constructions" which indicate that there is a necessity for a change in the outside aspect of the world . . . [Heap ellipses] We reproduce in this issue work by Lissitsky and Gabo; in an earlier number we showed the work of Tatlin. Other men in the group are Medunetsky, Stenberg, Ioganson, Kliutzius.[52]

Her comment suggested familiarity with Lozowick's writings, although she has altered the wording.

In the spring of 1925 Heap published another major essay from the European avant-garde almost comparable in importance to Léger's "Esthetic of the Machine" article. Theo van Doesburg, a central figure in the Dutch de Stijl group, presented "The Evolution of Modern Architecture in Holland."[53] The article was accompanied by several illustrations of the new architecture of Holland, then unknown in American architectural circles except to a select group.

The emphasis on avant-garde directions other than traditional painting and sculpture continued when Heap catalyzed a New York showing of the enormous International Theatre Exposition. Organized primarily by the de Stijl architect Frederick Kiesler, the exhibition included the Dutch modernists, the Germans, the Russians and others, with examples of new stage sets based on Constructivist and de Stijl principles. The exposition included 2000 models from sixteen countries. It was displayed in Steinway Hall, rather than a gallery or museum. By bringing the new art of the stage to New York, Heap also brought the most recent ideas on avant-garde in general. The exhibition was accompanied by a comprehensive catalog with statements and illustrations from most of the artists. The catalog circulated as an issue of the *Little Review*.[54]

One intelligent response to the exhibition appeared in the *New York Times*. Kenneth MacGowan, one of the organizers and an established theater writer gave a historical background for the development of the avant-garde theater:

The futurists have painted very seldom, upon flat back-drops. They have preferred to assemble odd-shaped three-dimensional objects. It is not a very long step from their modernism to the enthusiasm for the fourth kingdom, the Mechanical, which has produced such congeries of machinery as Kiesler used most appropriately for a background to R.U.R. The next step is Constructivism. . . . Its chief prophet throughout central Europe is Kiesler.[55]

He continued with a brief discussion of the Constructivist group and concluded with an interesting analogy to the plays of Eugene O'Neill. He suggested that since O'Neill presented interior and exterior realities simultaneously, his

writing was similar to a Constructivist stage set that showed exterior and interior spaces at the same time.[56]

An unsigned article in the *New York Times* mentioned the International Theatre Exposition within the context of art in general. While the review mainly featured displays at the National Academy of Design and the Society of Independent Artists, it also commented that the Theatre Exposition showed "more of the vitality of modern art than our old friends the Independents." It connected the new stage movement to the machine:

> Within the past four or possibly five years, however, the strictly modern idea of establishing upon the stage the unity of our mechanical era has been realized in Europe and America. America has given most to the mechanism of modern life and has followed the machine further along the path it has described for humanity, but Europe has been amazingly prompt to make use of machine and mechanism in the development of a new esthetic. The principle interest of the [Kiesler] explanation to the present writer is the connection it obviously has with the modern spirit in painting and sculpture and the promise it holds out of needing for the modern stage the cooperation of the leaders in modern art.[57]

Sheldon Cheney, who was responsible for publicizing the exhibition, wrote an informed review in *Theatre Arts Magzine*. His article also characterized the exhibition as a new departure that drew on earlier art movements:

> [A] group of European artists, in league with the Expressionists, Constructivists and Dadaists of the other arts, have abandoned representation and created new and strikingly theatrical backgrounds for acted plays. One is no longer 'modern' over there unless one 'constructs,' unless one's creativeness is informed by the spirit of the machine age. Engineering, mechanics, planes, volumes, these are the materials with which the mind of the newest stage decorator composes—in a time when the talk is all 'anti-decorative,' and 'composition' is to be understood in a non-pictorial but nonetheless symphonic sense. Even the occasional provocative "Constructionist" pictures in *Theatre Arts Magazine* had not prepared us for a whole World's Exposition based on constructionist principles.[58]

At the end of the article, Cheney summarized exactly what exposure he had had to the Constructivists:

> Then there are the Constructivists as we know them from stray photographs and from the example of the Moscow Art Theatre Musical Studio productions in New York; Rabinovitch, who first introduced the idea to us in *Lysistrata;* Tairoff with geometrical forms and 'different levels like the piano on which emotions are played,' Meyerhold, 'the bio-mechanic revolutionary giant, whose scenes are made of iron, concrete, glass, in geometric figures,' and Altman, and Bragagila. And Picabia, Léger and Picasso. And many other known and unknown.[59]

His blurring together of artists of various styles under the umbrella of Constructivism was generalized, but suggested the scope of the show.

Cheney followed up the preliminary review of the exhibition with a series of three articles that explained in detail the principles of the new movement. The last provided a definition of the Constructivist setting:

> The typical Constructivist setting may be described as a skeleton structure made up of the physically necessary means for acting a play: an agglomeration of the stairs, platforms, runways etc.... stripped to their basic and structural forms, held together by plain scaffolding, and arranged to permit the running off of the play at its fullest theatrical intensity.... It is utterly unnatural, in its grouping together of many elements detached from life, and in its bareness, its lack of every casual detail of nature and of such usual elements as walls and ceilings. Every plank and post of it is tested by the rigid question of its functional use. It is the 'practicables' of the old pictorial stage plucked out of the picture, skeletonized and nailed together for safe usage.[60]

McBride reviewed the theater exposition, but had some reservations about the principles of Constructivism as presented by Meierhold. McBride believed that some changes in the theater would be effective, but that the Constructivists had gone too far:

> We have had far too many costumers who rig up their dancers so that they cannot dance and stage designers who provide settings that kill the action. But that is a far cry to anti-decoration. Use comes first, but without "decoration" there cannot be art.[61]

The Little Review Gallery displayed the work of the Constructivist sculptors Naum Gabo and Antoine Pevsner just after the theater exposition in May 1926. McBride responded skeptically:

> Provocative Jane Heap, editress of the *Little Review* which troubles New York three or four times a year, that is to say whenever it appears, with the suspicion that it is twenty years behind the times instead of being twenty years ahead, is at it again.
> She has arranged a strange art exhibition by the Russian Constructionists [*sic*] in her new gallery at 66 Fifth Avenue and those who wish to accept or contend certain avowed aspirations of the time will be obliged to go there....
> [They] play constructionally with the forms made familiar to many thousands of people in this industrial age....[They] speak the language of the times...that is the language we would speak if we were 'pure souls.'[62]

While McBride was reserved in his praise for the art, the *New Yorker* reviewer presented what a more average critic in New York thought of Constructivist sculpture in mid-1926. Murdock Pemberton, an eager but newly converted advocate of modern art, wrote of the same show at the Little Review Gallery:

> Here is something that the artless city editor goes wild about; chances for all sorts of sneering, funny stories about Bolshevik art. Anyway the show makes our head swim. You don't know

what modern is until you see the construction of old planes and forms. We thought a lot of it beautiful and quite sensible too. . . . This show makes Archipenko look like something out of the Academy by Grand Central.

Certainly, the art critics lagged behind the theater critics such as Cheney and MacGowan in their interpretation of Constructivism.

The International Theatre Exposition organized by Kiesler and Heap was more radical in form and intention than Katherine Dreier's International Exhibition of Modern Art. Dreier's show was entirely made up of the more traditional formats of painting and sculpture, and shown in a conventional art museum environment. Dreier's large exhibition included over three hundred works by artists from twenty-six countries including a large group of Eastern European countries.

More systematically organized than Heap's extravaganza, Dreier accompanied the exhibition with publications, lectures and other educational events that ordered and organized the movements of modern art. Dreier divided the artists into six awkwardly described categories led by de Chirico, Léger, Malevich, Gabo and Pevsner, Mondrian and the "International Group of Constructivists."[64] Yet, in Dreier's discussion of them the differences between them are slight, with beauty still emphasized above all other qualities. In connection with Moholy-Nagy, Dreier spoke of a Bauhaus installation of a show in Dresden:

> Another remarkable contribution are the spatial color divisions for rooms, which he designed for and through the Bauhaus. On the opposite page is a reproduction of a gallery designed by the Bauhaus and showing the constructivist paintings by Moholy-Nagy. When entering this beautiful spacious room, one is not conscious of the variety of colors on the walls until one has been there for some time and let them speak to one, so exquisite is the harmony and so delicate the relationhip.[65]

Dreier's interpretation of the new Constructivist art connected it to her own ideas on the importance of the beautiful and the spiritual in art. Dreier maintained a basic allegiance to Kandinsky, to whom she dedicated the exhibition, and the principles of Expressionism and theosophy as well. As a result, she excluded Tatlin and gave more emphasis to the abstract, theoretical artists of Constructivism. Lozowick's 1925 book on Russian art, sponsored by Dreier, corrected some of this misinterpretation.[66] Dreier's copious interpretations form a striking contrast to Heap's approach to Constructivism, which was to allow the work to speak for itself or through the comments of the artists.

The analysis of the large exhibition reflected a variety of perspectives and the transitional state of American criticism in 1926. Elizabeth Luther Cary of the *New York Times* was notably open-minded.[67] Cary had apparently seen the

Little Review's International Theatre Exposition of the previous year, for she was particularly enthusiastic about the new art's application to the theater. Her analysis of what the modern artist was trying to do was striking for its effort to be receptive:

> It may be merely that they desire as artists to make us feel with our eyes as we feel with our fingers. To make us see thickness and softness and hardness as qualities interesting in their effect on the mind. Or they may wish to arrange flat surfaces in patterns of intricate relations with lively variations in the designs made by the edges of these surfaces. Or they may have the idea of making you see movement in an art of spaces by devices of repetition and direction. Any of these efforts may be expanded and complicated indefinitely as the artist has more or less mental power to spend on his problem and to resolve it in combination with other problems.[68]

The Cary review documents how far the American critical world had developed in its acceptance of modern art.

The *Art News* also suggested that receptiveness to abstract art was the order of the day, although the reviewer was overwhelmed by the size of the show:

> Cross breeding of the Carnegie International with the Société Anonyme might be good for the eugenics of art, but if we were forced to choose, we should take our chance in finding greater permanent satisfactions with an abstraction by Juan Gris or a torso by Pevsner than with the Pittsburgh normalcies.... One commences with the familiar Americans and gradually penetrates to inner chambers where the abstract reigns supreme in glowing color, singing metal, fragile glass—and fragments of macaroni. Numbering 307 items, of which the majority are abstract, the show as a whole offers certain visual difficulties. Despite our earnest efforts, the Constructivists, the Suprematists, the exponents of the Intérieurs Mécanique and Intérieurs Metaphysiques—even the clarificationists of Holland—began after a certain time to blend into a huge kaleidoscope.[69]

Despite the writer's difficulties in distinguishing the new styles, he accepted the viability of abstraction. The terminology was borrowed from Dreier's confusing lexicon.

McBride's review in the *New York Sun* linked the machine aspect of the exhibition to Picabia. He also celebrated the workmanship of the pieces:

> [Archipenko, Gabo, Pevsner, Duchamp] and many other choice laboratorial talents have constructed definite things of beauty, not shadowy presentiments of things, but *things*. The workmanship in these arrangements of glass, metal, celluloid etc. is exquisite. That is one point I have not quite figured out. The connection of this exquisite workmanship with an age that disdains workmanship.[70]

The *New Yorker* critic Pemberton, in one of two enthusiastic articles proclaimed:

> If you have children, for God's sake, take them to the show of modern art. It will teach them that art does not have to be a cow in a meadow or a man on a cross; that in art, as in life, the horizons of life may touch infinity.[71]

He outlined a way to visit the show by careful planning of the order of the rooms to visit, claiming that "it is a whirling, thrilling, exciting sort of thing." The *Art Digest* summarized the positive reviews and illustrated Pevsner's portrait of Duchamp and a semiabstract work by Archipenko.[72]

Several other critics began displaying a **pre-Regionalist** bias against abstract European art. Forbes Watson saw abstract artists creating "thin abstraction that look like empty layouts waiting for the compositor to finish his make up."[73] Thomas Hart Benton stated that the paintings showed "no evidence of a systematic ordering of these facets toward an organization having some relevancy to the outside world."[74] This lack of understanding of the connection of the Constructivist style and the modern world is a crucial moment in the history of the criticism of modernism in the 1920s. Watson, Benton and others could not respond to the metaphysical aspects of purely abstract art. This shortcoming, along with other pressures, led them to take up the art of the American scene just a few years later.

The final chapter in the presentation of avant-garde European art in the 1920s in New York was Jane Heap's Machine Age Exposition of 1927. The exhibition was pioneering from the perspective of both its installation and its contents. The exhibition was held in the Steinway Building, which was austere in atmosphere. One critic referred to the setting as an example of "significant form:"

> This was the unpainted white plaster finish of the walls, columns, beams, girders and floor slabs of an unpartitioned office floor of a common type of building erected for commercial renting. An amusing touch was the use of ordinary tin pails inverted as reflectors in the place of lighting fixtures.[75]

The exhibition examined the theme of the Machine Age by displaying photographs of contemporary architecture, models, machinery of all sizes and shapes, and photographs of paintings and sculpture that either depicted the machine or used the Constructivist style. Despite the breadth and completeness of the display, few art critics responded to the exhibition with serious consideration. The major review by Herbert Lippmann, an architect, enthusiastically praised the importance of the show and the principles it presented.[76] The contrast to the extensive coverage received by the International Theatre Exposition is partially related to the additional prestige of that exhibition because of the role and presence of Kiesler.

The catalog included for the first time in a Heap enterprise a major essay by Jane Heap that stated her philosophy:

There is a great new race of men in America: the Engineer. He has created a new mechanical world, he is segregated from men in other activities...it is inevitable and important to the civilization of today that he make a union with the architect and the artists. This affiliation will benefit each in his own domain, it will end the immense waste in each domain and will become a new creative force.

The snobbery, awe and false pride in the art-game set up by the museums, dealers and second-rate artists, have frightened the general public out of any frank appreciation of the plastic arts.[77]

Heap, unlike Dreier, embraced the connection of science and engineering to art. She rejected the conventional, bourgeois art world and specifically took issue with the idea of beauty:

We will endeavor to show that there exists a parallel development and a balancing element in contemporary art. The men who hold first rank in the plastic arts today are the men who are organizing and transforming the realities of our age into a dynamic beauty. They do not copy or imitate the Machine, they do not worship the Machine,—they recognize it as one of the realities.

No true artist ever starts to make 'beauty'...he has no aesthetic intention he has a problem.[78]

Heap suggested that if beauty appeared in machines it was not intentionally placed there, but a function of the utility of the machine.

Another article in the catalog by Louis Lozowick refuted the complaint of Benton, in reviewing Dreier's exhibition, that the new abstract art had no connection to life. Lozowick wrote of America's "gigantic engineering feats," such as skyscrapers and grain elevators, but differentiated between the influence of the environment and the depiction of the environment:

Environment, however, is not in itself art but only raw material which becomes art when reconstructed by the artist according to the requirement of aesthetic form. The artist cannot and should not, therefore, attempt a literal soulless transcription of the American scene but rather give a penetrating creative interpretation of it which, while including everything relevant to the subject depicted, would exclude everything irrelevant to the plastic possibilities of that subject.[79]

Lozowick was unusually perceptive in his ability to encompass all manifestations of the machine as art. Dreier, in contrast saw beauty as the legitimizing spiritual quality. For Heap, the function and utility of the object were sufficient.

The rest of the Machine Age catalog included essays by Hugh Ferriss on architecture, Alexander Archipenko on "The Machine and Art," André Lurcat on modern French architecture and other articles. Heap's exhibition and catalog were a ground breaking presentation of the machine in art, the machine as art and the new architecture of modernism that would soon be identified by

the Museum of Modern Art as the "International Style."[80] The slightness of the response to the display in the traditional art press only underlined the radical character of the endeavor.

R.H. Macy's held two machine exhibitions during 1928, perhaps under the stimulus of Heap's show, or other provocations such as Lindbergh's first flight across the Atlantic in May 1927, the same month as Heap's exhibition. The first display featured "airplanes, motors, accessories and instruments." The second exhibition was a huge display of "art and industry" that included five thousand exhibits. Fifteen thousand people visited the exhibition during its brief two weeks on display at the department store.[82] Malevich's painting *The Knifegrinder*, purchased by Dreier at a 1922 exhibition in Berlin, was part of the exhibition. It had travelled from Moscow and the heart of avant-garde Russian art, to the center of American consumer society.

Macy's sponsored scholars to speak about modern art and the machine, suggesting how wide the interest in that topic had become by 1928. As in the criticism of Dreier's 1926 display, the lectures accompanying the Macy's endeavor divided between a celebration of the modern world and a search for a native style.[83]

The forces of nativism in American criticism would soon prevail and modernism as presented and discussed by Heap, Dreier and the critics of the twenties would take a second place to the issue of American scene painting. At the same time in the late 1920s, another group of individuals was providing support for the complete legitimization of modern art by creating institutions for its permanent display.

The Institutionalization of Modern Art

The Gallery of Living Art

The death of John Quinn in 1924 stimulated interest in a museum with a permanent display of modern art. A. Conger Goodyear claimed that at Quinn's death "Arthur B. Davies talked to his friends Miss Lillie Bliss and Mrs. Cornelius J. Sullivan about the organization of a museum with the Quinn collection at its nucleus. But this idea never got beyond the shadow stage."[1] Forbes Watson wrote an editorial at the time of the Quinn sale bemoaning that no museum had had the foresight to buy similar works. He suggested the need for a "museum of modern art" like the Luxembourg in Paris:

> The contemplated museum might act in time to secure such works of art for its own permanent collection, or it might act as a sort of trial museum for the centrally situated museums throughout the country. Established in New York for example, it might receive for its support funds from all the great museums, as time verified the selections that it would make if managed by a director freed from the interference of lay trustees.[2]

The story of the Quinn sale is a separate topic,[3] but Watson's editorial inspired the collector Albert E. Gallatin to found his own museum: the Gallery of Living Art. The first endeavor of the gallery was a loan show at New York University in the spring of 1927. Gallatin wished

> to give Washington Square and the outlying Greenwich Village district a centre for contemporaneous American work. He hopes in that way and place to present for the benefit of students and the neighboring public a continuous reflection of the changing phases of artistic endeavor, as exemplified by men of standing in the profession and by newcomers who seem to have a pictorial message worth saying.[4]

The artists in the display were from the ash can group and the Stieglitz circle. They were characterized by the author of the article as "modern" and "radical."

The placement of Gallatin's collection at New York University was not an accident: Albert Gallatin's great-grandfather had founded the university and

he himself was on the Board of Trustees.[5] In addition, the school had pioneered the first academic courses in the country in the "History and Principles of Art Criticism" and "Modern French Painting" during the academic year 1926-1927. Professor A. Phillip McMahon initiated the two undergraduate courses in the new Department of Fine Arts. The criticism course included a "review of the principles of the criticism of the fine arts developed by modern critics and the application of those principles to modern works of art." The "Modern French Painting" covered "neoclassicism, romanticism, realism, impressionism and the more recent schools."[6] The environment for the display of modern art at New York University could not have been more favorable. In the spring of 1927, the school reported that Gallatin's exhibition had been "receiving appreciative attention" and that Gallatin was now chairman of the Exposition Committee.[7]

In the summer of 1927 Gallatin made an important study of modern French art. He wrote to Henry McBride, with whom he had been in correspondence for some years, that for four months he had

> devoted most of my time [to] studying the Ecole de Paris. I have had three visits of about three hours each to Picasso, who has shown me an almost endless amount of work. It has been a very interesting study and I think I now have some comprehension of his work to date. I think his compositions and abstractions of 1912-15 are his most important things, together with certain paintings in the exhibition last year, I have bought a very fine painting of this period for my collection.[8]

Although Gallatin had purchased a Picasso and a Cézanne around 1921 and had been interested in older French art even earlier, the in-depth study of Picasso's work shifted the emphasis of his collection from American to European modern art. In addition to buying the paintings by Picasso, he lists work by Matisse, Braque, Chagall, Maillol, Signac, Derain, Dufy and Léger, among others. These works were bought with the idea of the museum display at New York University. Gallatin continued in the same letter to McBride:

> Right here we have a more formidable assemblage of contemporary art than is owned by any public museum in America, and I shall hope to add lots of things in the next year or two. I rather fancy an intimate museum: say three rooms about 20 × 20 with about fifty things on view, all very choice examples of the really worth-while men and no very large pictures...
> ... I saw Sherrill [Chancellor of New York University] last month and he said that New York University had *definitely* decided to set aside the space which we considered would be suitable for the gallery of contemporary art. So we shall positively open up in the autumn.[9]

The gallery opened in late November 1927. An advance press release announced its intentions, quoting from a statement by Gallatin:

The new gallery...will be international in character. I am interested in good pictures, whatever their source and —while we shall make every effort to encourage American art there will be no nationalistic propaganda. We shall set a high standard and hope to have representative pictures by every living artist who merits it. It is probable that most of our special exhibitions will be of American painters, but that can only be decided as occasion arises. [10]

Gallatin also emphasized that the gallery would be nonbureaucratic, with "no expenses other than buying works of art." In fact, Gallatin did all the clerical work personally. Henry McBride was a codirector. The amount of his influence on Gallatin is difficult to document, but the two men were very close in their attitudes toward modern art.

When the collection opened to the public, the *Art News* detailed exactly which works appeared in the opening installation. The list included many American and French artists, including such recent work as that of Léger and de Chirico. A fifth of the art came from other collections, particularly that of Ferdinand Howald.

The reviews were favorable, although Forbes Watson regretted that the gallery did not have more "daring." He complained that all of the artists had been seen "constantly" in the galleries. Watson also called attention to the unusual placement of the art in a study hall:

When college students cannot look up from their studies without seeing modern art on the walls before them, they will probably be inspired to take an interest in it that otherwise they might not take. [11]

McBride's commentary compared the gallery to the Société Anonyme and the Metropolitan Museum of Art suggesting that it was

limiting its endeavor to *causes célèbres* of the present and...leaving the past to the Metropolitan and future to Miss Katherine Dreier.... Time has a way of marching on apace and the new gallery will, I suppose, continually be treading upon Miss Dreier's heels. [12]

Elizabeth Luther Cary's review of the exhibition in the *New York Times* demonstrated the influence of Jane Heap's Machine Age exposition of the previous spring and clarified Cary's attitude to modern art by 1927:

Then, the University building and the gallery of pictures in the framework of the machine age-heating pipes—brass gongs, fire alarm boxes forming abstract compositions after the heart of Léger, if a Léger owns so pulpy and shapeless an organ as a heart...
...[Gallatin] has taken risks in choice and purchase and now takes his own risk in putting the collection at the service of the public. Even now with the youth of modernism passing and its Janus face known to most of the young world, there is a pinch of courage required for this public confession of faith. [13]

Cary's remarks document her increasing receptiveness to modern art. She had begun writing about art since before the Armory Show, and her continually developing tolerance is a reflection of her growth as a critic over several decades.

Gallatin continued to add recent art to his collection. The following year he purchased two Miró paintings and a work by Ozenfant.[14] The new Mirós and other recent acquisitions were first displayed at the Brummer Gallery in November 1929. The show included Masson, Klee, Léger, Man Ray and Stella, in addition to Gallatin's other French and American holdings. By moving outside the New York University environment Gallatin was expressing his desire to have more space for his expanding collection. Gallatin stated in the catalog the hope that the Brummer exhibition would generate interest in providing a larger installation space.[15] Both Watson and McBride reviewed the show,[16] but by the time it was open, the Gallery of Living Art had already been eclipsed by the founding of the Museum of Modern Art.

Gallatin offered an alternative to the established museum and the commercial gallery. His idea of exhibiting modern art informally, in a public environment, was unique; he frequently expressed his disdain for more traditional museums.[17] As an individual willing to act on his own, and pursue a personal dream to educate the public through his own means, he was most similar to Katherine Dreier and the Société Anonyme, although far less concerned with educating the public by means of publications. His collection continued to grow in the 1930s and he himself became a significant artist, but his dream of a permanent gallery never came to fruition. Finally, in 1943, because of New York University's desire to take the small space allotted to him for another purpose, he gave his collection to the Philadelphia Museum of Art.[18]

The Museum of Modern Art

The founding of the Museum of Modern Art in November 1929 was the beginning of a new era for modern art in America. The museum since its beginning has been historical rather than pioneering. It has institutionalized and defined, rather than suggested and explored. As a result of its wealthy founders, sophisticated publications and brilliant director, the museum permanently altered the character of the environment of modern art in New York. Critical attention became more focused on the museum than any other place; gallery shows were less important and individual initiatives less significant.

At the time of its founding, the Museum of Modern Art was rooted in the twenties. The individuals involved with that founding were formed by the art shown, and the critical issues discussed during the decade. Although they came

from the most elite social and academic strata in America, they were public spirited, independently thinking collectors and intellectuals. Their link to the Armory Show was notable. Two of the three founders, Lillie Bliss and Mary Sullivan, were active backers of the Armory Show and collectors of modern art in the teens. Davies, the organizer of the Armory Show, was a consultant to Lillie Bliss for her collection of French modern art. It was Arthur B. Davies' death that led to the final decision. In the last month of 1928, Davies' death, alone in the Italian Alps, shocked the art world. The following spring the idea for the Museum of Modern Art finally crystallized.[19]

While Lillie Bliss and Mary Sullivan were collectors of modern French art, the third member of the group, Abby Aldrich Rockefeller, was a pioneer in the collection of American art. Her collection of American folk art was one of the finest in the country; she also collected the American moderns from the ash can school to the Whitney group, such as Bernard Karfiol and Eugene Speicher, as well as the Immaculates. Her first purchases for the museum in 1929 were paintings by Bernard Karfiol and Kenneth Hayes Miller. Rockefeller's collection in the twenties seems to have stopped short of the Stieglitz group, although she did purchase work from Daniel regularly.[20]

Abby Aldrich Rockefeller first had a gallery in her home, where she turned her "children's playroom on the top floor of her home in Manhattan into a private gallery."[21] One of the few times that this "gallery" was mentioned in the press was for the memorial exhibition of the paintings of Arthur B. Davies in the spring of 1929.[22] Although, by the previous spring, she had already begun discussing the possibility of a museum with her son, the plan was made definite between Rockefeller, Bliss and Sullivan in the summer of 1929.[23] For its director they selected Alfred H. Barr, a young art historian.

While the modern interests of the three women were French and American, a reflection of the dominant trends of the New York art market, Barr's orientation provided a significant contrast. Although he was educated at Princeton and Harvard, institutions that did not yet include modern art in the curriculum by 1926, Barr developed an original and independent approach to modern art. The decisive factor in his early years had been a course on medieval art with C.R. Morey; Morey's course included all the arts: architecture, wall painting, books, minor arts and crafts. Barr had the original idea of using this approach for modern art: of synthesizing cultural expressions, rather than looking only at the traditional painting and sculpture. He used this theory to teach a course at Wellesley, and the same premise became the basis for the organization of the Museum of Modern Art as he presented it to the trustees in 1929.[24]

In addition to his innovative methodology, Barr was versed in the most recent stylistic developments in modern art: his 1926-27 course included Surrealism and Constructivism. He had learned about Le Corbusier as a

preceptor in a modern architecture course at Princeton.[25] In addition, Barr has left a record of having read *Vanity Fair, Dial* and *Arts,* as well as French and German magazines.[26] He visited the Société Anonyme exhibitions and as early as 1923 hung a Kandinsky exhibition at Vassar College.[27]

In 1927 and 1928 Barr spent a year in Europe to work on a dissertation. The topic of the project, as he described it in a letter to Forbes Watson, was an overview of the situation in the art world in the 1920s:

> My thesis is to be an analysis of the present anarchic condition of European and American (N.Y.C.) taste and a description of the various waves of enthusiasm for the medieval, oriental, pre-Hellenic, African, children, pre-Columbian, Victorian, subconscious etc., etc., which during the last century and a half have accumulated till at present, for many of us, almost any "expression" is "art." The thesis will probably have to be confined to concentration upon painting. The subject of course is commonplace, but I have not yet seen a scholarly discussion of this process of disintegration of what was once a vary narrow and self-satisfied canon of "what is art"—exclusively European and primarily Hellenistic-Renaissance in tradition.[28]

The idea of examining the non-Greek basis for art reflected Barr's rebellion against the classical education that he had received. Probably because of his underlying iconoclasm, he became fascinated with the most avant-garde activities in Germany and Russia during his trip. Barr visited the Bauhaus and spent several months in Russia, where he saw Constructivist stage design and experimental films.[29] An article he wrote about some of these artists displayed his receptiveness to their ideas, and a critical mind much larger than the mainstream.[30] Perhaps no other person in America in 1928 had the rare combination of an elite art history education and firsthand contact with the center of Russian revolutionary art.

Barr's dissertation was never written. On his return from the trip, he taught briefly at Wellesley and then assumed the position of director of the Museum of Modern Art. Just before his return from Europe, a letter from Paul Sachs seemed to predict his future course, as well as summarizing the condition in the art world in early 1928:

> There has been great progress here in America during the year of your absence. The interest in museums and modern art in museums and in all that is connected with modern art and modernized art has greatly increased.... It is a time for cooperation not irritation.[31]

As director of the Museum of Modern Art, Barr tempered his radical outlook. The new museum's first show was not "an international survey that would... encompass all the contemporary arts," as Barr proposed,[32] but a solid group of Post-Impressionists. The attendance was 47,292, the largest audience ever to attend an exhibition of modern art. In the wake of the developments of the 1920s, the course that the Museum of Modern Art took

was hardly radical; in fact, it was only one short step beyond where the Metropolitan Museum of Art had been at the beginning of the decade with their exhibition of Impressionists as modern artists.

The large attendance also reflected the sophisticated press operation that accompanied the opening of the museum. There was nothing eccentric or haphazard about the Museum of Modern Art. It brought together modern marketing techniques and the art world. The influential editor of *Vanity Fair*, Frank Crowninshield, was a member of the Board of Trustees. Crowninshield "engineered a luncheon for newspaper men" two months before the museum opened, leading to front page coverage and editorials in the major New York newspapers.[33]

The press release presented to the journalists criticized the Metropolitan Museum of Art for not acquiring "modernists." It envisioned the new museum as an American Luxembourg that held the work of living artists until ten years after their death. The American version would include

> a very fine collection of the immediate ancestors of the modern movement such as Van Gogh, Seurat, Gauguin, Toulouse-Lautrec, Henri Rousseau, artists dead some of them forty years, but whose paintings are still too controversial to be accepted freely by the Metropolitan...[and a] permanent collection of the most important living masters.... In time [it will] include drawings, prints, photography, typography, arts of design in commerce and industry, architecture, stage designing—furniture and decorative arts, *filmotex*...[34]

The rest of the press release described the condition of modern art in New York, suggesting that the gap between avant-garde and accepted art had been narrowing, but that despite the efforts of open-minded critics, dealers and collectors, the museums had not kept pace with the new art:

> The cubists and subsequent rebels have made continuously fresh assaults upon the rapidly weakening opposition. Until now few critics dared to condemn too quickly....
>
> Indeed it looks as if the world had learned its lesson. Enthusiasm, esthetic curiosity and tolerance abetted, it must be confessed, by some snobbery and speculation, have gone far in transforming the position of the modern artist, closing that breach of misunderstanding and mutual indifference which had come between him and his public, though in a manner very different from that which existed before....
>
> ...Are not our critics flexibly minded, sympathetic to innovation. Our picture dealers do they not dare to experiment especially in this field which has expanded so astonishingly in the last ten years. The great public itself, which can not afford to collect is thoroughly aroused. The rage untutored as it is for modernistic furniture is evidence of a new taste. And our museums what have they done? Have they kept pace with the progressive spirit of our collectors and critics and the general public?[35]

The release concluded that while a few initiatives had been taken, New York was particularly lax in the area of modern collecting; therefore the Museum of Modern Art had been founded.

The press release clearly displays the role of the museum in relation to the 1920s as a whole. It is an essential document for understanding the change in the attitude toward modern art in New York, from an esoteric event understood by only a small group of people to an issue and idea familiar to the public in general. The museum, from the beginning, distinguished itself from earlier endeavors to present modern art, while acknowledging the importance of those initiatives.

The ideas presented in the press release were probably a result of collaboration, although Barr certainly had a significant role in its formulation. In an article in the *Sun* of November 1929, he presented some similar ideas:

> The Armory Show merely marked the beginning in America of an epoch of controversy. At first a very few seers, most of them artists, admired the works of the moderns, but gradually the ratio shifted until now, within fifteen years, the laughter of the majority is transformed into devout admiration and fist shaking into or almost into an attitude of prayer always with the exception of a few curious anachronisms.
>
> The period of transition begun by the Armory Show has come to an end in the opening of the Museum of Modern Art. Four of the painters most abused sixteen years ago are now selected as a firm foundation. . . . Strangely enough, in spite of its emphatic modernity New York is very far behind the rest of the world in establishing such a public institution. For many years we have had to depend largely upon the generosity of dealers for our contact with modern art.[36]

Thus, the importance of the dealers and critics of the 1920s in educating the public in the subject of modern art was a widely accepted fact in the late twenties.

Forbes Watson wrote a lengthy editorial in the *Arts* in response to the press release. He claimed credit for setting the stage for the museum with his editorial advocacy of a museum of modern art since before the war:

> It is not surprising that *The Arts,* after contributing so much to the tilling of the soil, should feel joyous because such a beautiful flower has at last raised its head in a field that so many volunteers have cultivated enthusiastically. *The Arts* is naturally pleased also to have participated in the development of conditions which ensure the success of New York's new institution.[37]

Watson also noted that the museum would have difficulty pleasing people, no matter what it did.

The first exhibition at the Museum of Modern Art featured ninety-eight paintings, drawings and watercolors by Cézanne, Gauguin, Seurat and Van Gogh. Most of the criticism was a flood of articles that simply praised the museum and the exhibition. The artists had long since been accepted by all but archconservatives, and the September press conference had prepared the final less-enlightened group of critics.

Two significant points stand out in the reviews. First, the exhibition was the first showing of modern art to be so overcrowded with viewers that the paintings were almost impossible to see, a forecast of the future in the art world. McBride suggested that attending on a rainy day or before 9:00 AM would help:

> Otherwise you'll be jostled and perhaps not see some of the most important pictures at all. The crowds, in fact, are unprecedented.... After the opening the people struggling for admission were obliged to form a line that extended out into Fifth Avenue.[38]

Second, most of the articles suggested that the opening of the museum meant the acceptance of modern art. No one had any illusions about the exhibition breaking new ground, although it did provide an opportunity for the most conservative critics finally to get on the bandwagon. The drama of the display was certainly lessened by the fact that most of the works came from American private collections and the artists had all been seen and evaluated frequently.

William McCormick demonstrated that some modern art, at least, was now acceptable to the extreme conservative. McCormick wrote a syndicated art column that appeared in newspapers across the country. In the article on the Museum of Modern Art he contrasted the "good taste, modesty and courtesy of the [Museum of Modern Art's] attitude" to the "virulently bad taste with which much of [modern art's] propaganda had been conducted. And it is not the least admirable feature of the present situation that bad taste is completely eliminated." He also claimed that Cubism and Futurism were "wrecks" but that the "veterans of modernism from Cézanne down are fairly well established," an ambiguous distinction.[39]

The conservative dealer, William Macbeth, displayed a similarly circumscribed acceptance of modern art, even as he objected to the museum itself:

> Please do not misunderstand what we mean when we use the general term "Modern Art." It does not refer to the admittedly great leaders, men like Cézanne, Van Gogh, and very few others abroad, and all the Bellows, Speicher group and their logical successors at home, who have made definite contributions to the art of our time. They have given us essentials of form, interpretations of power, a new visualization of what color can do. The best of them will endure throughout all generations.
>
> It is the work of their imitators, and in turn *their* imitators, that we would definitely and emphatically repudiate, and it is because the supporters of modern art cannot or will not differentiate between the authentic and the spurious that the public has been so woefully confused.[40]

For these conservative critics, the new show was acceptable because it was within the restricted parameters they had established as "good" modern art.

Frederick W. Eddy offered another perspective, complaining that the museum was showing only dead artists:

A venture which ranks itself as a museum puts something of a slight on present production by going to the grave for leadership in modern art. [It gives]...the impression that in the opinion of the museum promoters the so-called modern movement, while originating within living memory, had its best expression in the past and the present is indifferently following on. This appraisal even if unwittingly made, will find many in agreement.

McBride wrote for many of the other critics when he commented that the Museum of Modern Art was the realization of what all the advocates of modern art had been working toward for many years. He also pointed out how unthreatening the art was:

It truly makes us rub our eyes now that we have gone such a journey to see that we have arrived at our destination.
 And the exhibition itself is so incontestably serious and so impressively alive that the astonishment will now be general that so many fences had been erected to keep this art from the public. What was the insidious danger of it twenty years ago or even ten years ago? Nothing other than that it was alive.[42]

The museum's second exhibition was "Paintings by Nineteen Living Americans." Few of the group are considered modern today; most of them came from the popular group that was centered at the Whitney Studio Club. The inclusion of Feininger stands out as a Barr choice, because Feininger was then little known. He was working at the Bauhaus where Barr probably met him during his European trip. Three artists from the Stieglitz group, Demuth, Marin and O'Keeffe, were also included. The other artists were the ash can group, Eugene Speicher and Bernard Karfiol. The undefinitive character of the exhibition demonstrates a basic anomaly in the Museum of Modern Art: even as it was able to present definitive exhibitions of European art, it was caught in the most immediate tastes and currents of the late 1920s in its choice of American artists. A more historically enduring choice for the first American exhibition of modern art at the museum would have been the Immaculates. In the catalog introduction, Barr stressed the eclectic character of the selection, mentioning that the choices had been made by the trustees and a committee.

Unlike the first exhibition, which pleased everybody, this exhibition was objected to by nearly everyone. The press fury was as ferocious as the praise up to that time had been. While that criticism lies beyond the decade of the 1920s, the extent of the discussion alone demonstrates the new focus that the Museum of Modern Art gave to the critical energy in the New York press. The museum, because of its wealth, sophistication and self-conscious sense of history, immediately dominated the modern art scene in New York. When it acted, all the critics responded to it.

Barr's comments in two articles from the early 1930s reveal his attitude toward modern art. One article, written in relation to the third exhibition at the

museum, "Painting in Paris," was an overview of contemporary French art. It included mini-retrospective groups of Picasso and Matisse, drawn from American collections. Barr selected four painters to discuss: Braque, as a Cubist and a formalist; de Chirico, as an alternative to formalism; Miró's *Dog Barking at the Moon,* as an example of "surrealism [which] seems the most important movement in painting since Cubism" and finally, Picasso, who brought together Cubism and "the new romantics."[43] Barr, even while directing the museum that was defining modern art for a whole generation, was consistently trying to present options rather than an exclusive viewpoint. This approach itself was a product of his receptiveness to the many different directions of modern art in the 1920s.

In 1934, he wrote even more emphatically of the impossibility of defining modern art in a paragraph that recalled his proposed dissertation:

> Since the war, art has become an affair of immense and confusing variety, of obscurities and contradictions, of the emergence of new principles and the renaissance of old ones....
> ... The truth is that modern art cannot be defined with any degree of finality either in time or in character and any attempt to do so implies a blind faith, insufficient knowledge or an academic lack of realism.[44]

The contradictions between Barr's reluctance to define modern art and his role as the director of the Museum of Modern Art are striking. His openness led to a significant and dynamic exhibition program, which included such echoes of the 1920s as exhibitions of theater design, machine art and modern architecture. Yet these same exhibitions, particularly in the areas of architecture, painting and sculpture, eliminated the fluid exchange of ideas and theories about modern art that marked the decade of the 1920s. They defined the styles and development of modern art with a new certainty and historical sophistication.

Thus, the Museum of Modern Art at the time of its founding had two conflicting aspects, first, the idea of an institution of modern art based on the principles of permanence, history and scholarship; and second, the subtle awareness of the diversity and complexity of modern art and criticism as developed by the young Alfred Barr during his formative years in the 1920s.

By creating an institution led by a professionally trained staff, the founders of the Museum of Modern Art effectively ended the adolescence of modernism in America. They established the legitimacy of modern art and theory. As a result, the explorations of the pioneering and altruistic writers and dealers of the 1920s were no longer necessary or possible. While in later decades a single gallery would occasionally emerge as a leading supporter of the avant-garde, such as that of Peggy Guggenheim in the 1940s, never again would the display and interpretation of modern art be entirely the responsibility of critics, dealers and collectors.

In the 1920s, modernism, rather than dying out, assumed a new maturity and complexity. As a style it included both American and German Expressionism, the Immaculates, Cubism, Dada, Surrealism and Constructivism. As a theory it developed from the narrow interpretations of a few intellectuals to a broad spectrum of definitions articulated by an ever increasing number of writers. As a historic event, it became the focus of a museum. This book has sought to document the new scope and character of modern art from 1920 to 1930 by a study of the interpretations of modernism in those years. By so doing it demonstrates that modernism, far from disappearing, became an increasingly widespread, understood and accepted phenomenon between 1920 and 1930.

Notes

Introduction

1. Barbara Rose, *American Art Since 1900* (New York: Praeger, 1967), p. 113. For a more recent recitation of this pervasive idea see Ruth Bohan, *The Société Anonyme's Brooklyn Exhibition* (Ann Arbor: UMI Research Press, 1982), p. 29 and Stuart Buettner, *American Art Theory 1940-1970* (Ann Arbor: UMI Research Press, 1981), p. 36.

2. One resource for the more well-read critics was Julius Meier-Graefe, *Modern Painting* (London: Putnam, 1908). In America two other surveys of modern art influenced many critics: Arthur J. Eddy, *Cubists and Post-Impressionism* (Chicago: A.C. McClurg and Co., 1914) and Willard Huntington Wright, *Modern Painting, Its Tendency and Meaning* (New York: John Lane Co., 1915). A survey of the books on modern art from 1900 to 1940 reveals the many different interpretations of the concept of modern during those years.

3. Robert L. Herbert, Eleanor S. Apter, and Elise K. Kenney, *The Société Anonyme and the Dreier Bequest at Yale University* (New Haven: Yale University Press, 1984), hereafter referred to as *Soc. Anon. Cat.*

4. Peninah R. Y. Petruck, *American Art Criticism 1910-1939* (New York and London: Garland, 1981). See also the recent dissertation by Betsy Fahlman, "Guy Pène du Bois: Painter, Critic, Teacher," (Ph.D. Dissertation: University of Delaware, 1981).

5. Judith Zilczer, *The Noble Buyer: John Quinn, Patron of the Avant-Garde* (Washington: Hirshhorn Museum, 1978).

6. Arlene Olson, *Art Critics and the Avant-Garde: New York, 1900-1913* (Ann Arbor: UMI Research Press, 1980); Judith Zilczer, "The Aesthetic Struggle in America: 1913-1918: Abstract Art and Theory in the Stieglitz Circle," (Ph.D. Dissertation: University of Delaware, 1975); Howard A. Risatti, "American Critical Reactions to European Modernism" (Ph.D. Dissertation: University of Illinois at Urbana-Champagne, 1975).

7. Marilyn C. Baker, "The Art Theory and Criticism of Willard Huntington Wright" (Ph.D. Dissertation: University of Wisconsin, 1975).

8. Milton Brown, *American Painting from the Armory Show to the Depression* (Princeton: Princeton University Press, 1955).

9. The issue of the beginning of modern art is much more complex than can be appropriately summarized here.

10. The seed idea for the present study came from William Agee, who in April 1977 suggested that a study of modernism in the 1920s would be an interesting topic for research. I am grateful to Linda D. Henderson, who as my dissertation advisor gave me invaluable support, and to the other members of that committee for their insightful comments during the intermediate steps of this project.

Chapter 1

1. "Exhibitions Now On: French Art Display at Museum," *American Art News,* December 13, 1919, p. 7 and H.B.W[ehle], "The French Paintings," *Bulletin of the Metropolitan Museum of Art,* January 1920, pp. 8-9.

2. A meeting of the Association of Art Museum Directors of the United States and Canada held in Worcester, Mass. in the spring of 1920 discussed "The Relation of the Art Museum to the Various 'isms' of Modern Art." The meeting is discussed in "Art Director's Convention," *Arts and Decoration,* June 25, 1920, p. 136.

3. "Modern Art in Philadelphia," *American Art News,* May 8, 1920, p. 3. The New York Press covered the exhibition because much of the work came from New York dealers, particularly Alfred Stieglitz and Marius de Zayas.

4. "Arch Cubists Recant?" *American Art News,* June 12, 1920, p. 1.

5. P[eyton] B[oswell], "Philadelphia Sees Best in New Art," *American Art News,* April 23, 1921, p. 6; "Modernists Insane Say These Medics," *American Art News,* June 4, 1921, p. 3.

6. Judith Zilczer, *The Noble Buyer, John Quinn* (Washington D.C.: Smithsonian Institution, 1978), p. 54.

7. H.B. W[ehle], "Loan Exhibition of Modern French Paintings," *Bulletin of the Metropolitan Museum of Art,* May 1921, pp. 94-96; see also "Exhibition of Impressionist and Post-Impressionist Paintings," *Bulletin of the Metropolitan Museum of Art,* June 1921, p. 118.

8. "Museum Opens Its Modernist Show," *American Art News,* May 7, 1921, p. 5. The essay reproduces most of Bryson Burroughs' catalog introduction, filling a full page of the paper. See also "'Met' Explains Modernists Show," *American Art News,* April 23, 1921, p. 5; Hamilton E. Field, "The Metropolitan French Show," *The Arts,* May 1921, pp. 2-8.

9. "Crowds Flock to See Museum Show," *American Art News,* May 14, 1921, p. 6. The article lists all the works on display.

10. "Attack on Museum is Still Anonymous," *American Art News,* September 17, 1921, p. 4.

11. Mary Roberts, "Anonymous Propaganda Disguised as Art Criticism," *The Touchstone* in *The Arts,* August-September, 1921, p. 24. The article also refers to the widespread positive critical response to the exhibition, p. 26.

12. H.B. Wehle, "The George Bellows Exhibition," *Bulletin of The Metropolitan Museum of Art,* October 1925, pp. 234-236.

13. B[ryson] B[urroughs], "Recent Accessions," *Bulletin of the Metropolitan Museum of Art,* January 1924, p. 20.

14. Bryson Burroughs, *Catalog of Paintings* (New York: Metropolitan Museum of Art, 1931).

15. Paul Strand, "American Water Colors at the Brooklyn Museum," *The Arts,* December 1921, pp. 148-152; Henry McBride, "Art News and Reviews—Watercolors Shown in Brooklyn,"

New York Herald, November 13, 1921, p. 4; Alexander Brook, "February Exhibitions: Russian Art at the Brooklyn Museum," *The Arts,* February 1923, pp. 132, 134.

16. Hamilton Easter Field, "The Kelekian Collection," *The Arts,* December 1921, pp. 131-148; "Comment on the Arts," *The Arts,* May 1921, p. 46. This article compares the Brooklyn and Metropolitan Exhibitions. See also Henry McBride, "Art News and Reviews—Brooklyn Museum First with Matisse and Cézanne Exhibition," *New York Herald,* April 3, 1921, p. 11.

17. "$254,870 Obtained for Modernist Art," *American Art News,* February 4, 1921, pp. 6-7. The article lists the price for each work. The Brooklyn Museum under Fox's leadership also sponsored in 1926 the Société Anonyme's important International Exhibition of Modern Art. For Fox's comment on the exhibition see W.H.F[ox], "Forward," *Catalog of an International Exhibition of Modern Art* (Brooklyn: Brooklyn Museum, 1926-27), unpaginated, in *Selected Publications vol. 1: Documents.*

18. Watson's comment was quoted by Henry McBride in his column "Notes and Activities in the World of Art," *New York Herald,* March 27, 1921, p. 5.

19. McBride, "Notes," p. 5.

20. J.C.G., "Cleveland is Jolted by Modernistic Art," *American Art News,* May 21, 1921, p. 5.

21. *Soc. Anonym. Cat.,* p. 2. Herbert cites the program of the Der Sturm gallery in Berlin as a model for the Société Anonyme, p. 3.

22. Ruth Bohan, *The Société Anonyme's Brooklyn Exhibition: Katherine Dreier and Modernism in America* (Ann Arbor: UMI Research Press, 1982) pp. 29-30, hereafter referred to as *Brooklyn.*

23. Bohan, *Brooklyn.* Chapter 2 provides an excellent and thorough analysis of the sources of Dreier's artistic philosophy.

24. *Soc. Anon. Cat.* gives a complete account of the partnership between Duchamp and Dreier throughout the history of the Société Anonyme, pp. 1-32.

25. Société Anonyme, *Its Why and Its Wherefore* (New York: Société Anonyme, 1920) unpaginated. Reprint, *Selected Publications, Société Anonyme (The First Museum of Modern Art, 1920-1944)* (New York: Arno Press, 1972).

26. Katherine Dreier, *Western Art and the New Era* (New York: Brentano's, 1923). For a complete list of the lectures and related events of the Société Anonyme see *Soc. Anon. Cat.* pp. 773-775.

27. *Soc. Anon. Cat.,* p. 1 suggests that Dreier laid out exhibitions with "historical layering" of "premodern, early modern and contemporary art." The flyers accompanying the exhibitions used style labels to identify the artists, personal communication from Robert Herbert, August 1984.

28. Irma B. Jaffe, *Joseph Stella* (Cambridge: Harvard University Press, 1970), p. 92.

29. John Covert started the collection of the Société Anonyme with a donation of six of his paintings in 1923. Covert is also called "founder, director and first exhibitor" although his name does not appear in the early literature. John Storrs had a one person show in February 1923. Jan Matulka was also backed by Dreier as discussed in Whitney Museum *Jan Matulka 1890-1972* (Washington D.C.: Smithsonian Institution Press, 1980), pp. 15, 19, 20, 21. For a complete study of Dreier's exceptional collection see *Soc. Anon. Cat.:* see also the earlier publication Katherine S. Dreier and Marcel Duchamp, *Collection of the Société Anonyme: Museum of Modern Art 1920* (New Haven: Yale University Press, 1950).

30. Bohan, *Brooklyn* is a complete account of the background and character of this important exhibition.

31. Dreier, *Western Art*, p. 5.

32. Dreier, *Western Art*, p. 24.

33. Dreier, *Western Art*, p. 136.

34. Dreier, *Western Art*, p. 125.

35. Dreier, *Western Art*, p. 21.

36. Jackson Bryer, "'A Trial-Track for Racers,' Margaret Anderson and the *Little Review*," (Ph.D. dissertation: University of Wisconsin, 1965) and Jackson Bryer, "Joyce, 'Ulysses' and 'The Little Review'," *South Atlantic Quarterly*, 1967 (2), pp. 148-149 and Frederick Hoffman et. al., *The Little Magazine: History and Bibliography*, (Princeton: Princeton University Press, 1946), chapter 4, gives a long discussion of the history of the *Little Review*.

37. Abby Ann Arthur Johnson, "The Personal Magazine: Margaret C. Anderson and *The Little Review*, 1914-1929," *South Atlantic Quarterly*, 1976 (3), p. 356.

38. Guillaume Apollinaire, "Aesthetic Meditations," *The Little Review*, spring 1922, pp. 7-19; *The Little Review*, autumn 1922, pp. 41-59; *The Little Review*, winter 1922, pp. 49-60. Heap included illustrations of work by virtually all of the artists discussed.

39. Fernand Léger, "The Esthetics of the Machine," *The Little Review*, spring 1923, pp. 45-49 and, autumn and winter 1923-24, pp. 55-58. The spring issue did not come out until the fall based on internal evidence in the magazine.

40. Jane Heap, et. al., *Machine Age Exposition*, (New York: The Little Review, 1927) and *International Theatre Exposition* (New York: The Little Review, 1926).

41. Jane Heap, "Lost: A Renaissance," *The Little Review*, May 1929, p. 5.

42. The most recent discussion of Jane Heap is my paper "The Role of *The Little Review*, in the Introduction of Modernism to New York in the 1920s," presented to the Seventy-Second meeting of the College Art Association, Toronto, February 1984.

43. For a complete account of Stieglitz' early career as well as the idea of his decline in the 1920s see William Homer et. al., *Avant-Garde Painting and Sculpture 1910-1925* (Wilmington: Delaware Art Museum, 1975) and William I. Homer *Alfred Stieglitz and the American Avant-Garde* (Boston: New York Graphic Society, 1977).

44. M[urdock] P[emberton], "The Art Galleries," *The New Yorker*, December 18, 1925, pp. 19-20.

45. James N. Rosenberg, *Painter's Self Portrait* (New York: Crown, 1958) p. 47.

46. Alfred Stieglitz, "Introduction," *A Collection of Works by Living Artists of the Modern Schools* (New York: The Anderson Galleries, 1922) unpaginated. A copy of this catalog with annotated prices was made available to me by courtesy of Garnett McCoy, Archives of American Art, Washington, D.C.

47. For a discussion of these exhibitions and their place in the development of Stieglitz as a photographer, see Weston Naef, *The Collection of Alfred Stieglitz* (New York: The Viking Press, 1978), pp. 222, 223; for criticism of the exhibitions see Naef's bibliography, pp. 980-997.

48. Alfred Stieglitz, "A Statement," *Exhibition of Stieglitz Photographs* (New York: Anderson Galleries, 1921), unpaginated.

49. Stieglitz, "Statement."

50. Alfred Stieglitz, "Chapter III," *The Third Exhibition of Photography by Alfred Stieglitz* (New York: The Anderson Galleries, 1924), unpaginated.

51. Wanda Corn, "Apostles of the New American Art: Waldo Frank and Paul Rosenfeld," *Arts Magazine,* February 1980, pp. 159-163. In a personal communication Corn suggested that Frank, Rosenfeld and Stieglitz "grew in an interest in American art together." June 1980.

52. Helen Appleton Read, "New York Exhibitions, Seven Americans" *The Arts,* April 1925, p. 231. The catalog for the exhibition was titled *Alfred Stieglitz Presents Seven Americans* (New York: The Anderson Galleries 1925).

53. Carl Zigrosser, *My Own Shall Come to Me* (Haarlem, 1971) p. 197.

54. Announcement for the Intimate Gallery, December 7, 1925, unpaginated. Sheldon Cheney Papers, Archives of American Art, Washington, D.C.

55. Herbert Seligmann, ed., *Alfred Stieglitz Talking, Notes on Some of His Conversations 1925-1931* (New Haven: Yale University Press, 1966). For another Stieglitz anecdote see Dreier, *Western Art,* pp. 123-124.

56. The artists that contributed to these magazines included Thomas Hart Benton, Oscar Bluemner, Charles Demuth, Arthur Dove, Marcel Duchamp, Alfeo Faggi, John Marin, Kenneth Hayes Miller, George Of, Georgia O'Keeffe, Charles Sheeler, Stanton MacDonald Wright and others.

57. Roberta Tarbell, "Gertrude V. Whitney as Patron" (Paper delivered at the Sixty-eighth Meeting of the College Art Association, New Orleans, 1980).

58. Gertrude Vanderbilt Whitney, "The End of America's Apprenticeship in the Arts," *Arts and Decoration,* November 1920, p. 68. Other Segments of the article appeared in *Arts and Decoration,* June 1920, pp. 83, 124; August 1920, pp. 150-151; September 1920, pp. 230-231; October 1920, pp. 307, 348.

59. Forbes Watson papers, microfilm D57, Archives of American Art, Washington, D.C.

60. Lloyd Goodrich, *The Whitney Studio Club and American Art* (New York: Whitney Museum of American Art, 1975), p. 3.

61. Goodrich, *Whitney Studio Club,* p. 6.

62. B.H. Friedman, *Gertrude Vanderbilt Whitney* (Garden City: Doubleday, 1978), p. 403. A longer list of artists is provided in the book.

63. Friedman, *Whitney,* p. 403.

64. Herman More and Lloyd Goodrich, "Juliana Force and American Art," *Juliana Force and American Art* (New York: Whitney Museum of American Art, 1949), pp. 15, 28.

65. Gertrude Whitney letter to Forbes Watson, Forbes Watson Papers, microfilm D57, Archives of American Art, Washington, D.C.

66. *Juliana Force,* Checklist of exhibitions, p. 64-65.

67. *Juliana Force,* p. 48.

68. "Whitney Studio Club to Close," *The Art News*, August 18, 1928, p. 14.

69. Zigrosser, *My Own*, p. 172.

70. *Juliana Force*, p. 24.

71. Forbes Watson, "The Opening Season," *The Arts*, October 1927, pp. 220-221.

72. Forbes Watson, "The Opening Season: A New Travelling Exhibition," *The Arts*, November 1924, pp. 279-282.

73. "Younger Moderns Exhibit Good Work," *The Arts News*, May 23, 1925, p. 1.

74. Guy Eglington, "Modernistic Gloom at the Whitney Club," *The Art News*, November 18, 1925, p. 4.

75. Henry McBride, "Modern Art," *The Dial*, January 1925, pp. 84, 85.

76. Stephan Bourgeois, *Exhibition of Modern Art Arranged by a Group of European and American Artists in New York* (New York: Bourgeois Gallery, 1917), unpaginated.

77. Stephan Bourgeois, *The Adolph Lewisohn Collection of Modern French Paintings and Sculptures* (New York: E. Weyhe, 1928), p. xiii.

78. Oscar Bluemner, "'In Other Words,'" *Exhibition of Modern Art Arranged by a Group of European and American Artists in New York* (New York: Bourgeois Gallery, 1918), pp. 5, 9.

79. Jennings Tofel, catalog preface quoted in Henry McBride, "Notes and Activities in the World of Art," *New York Sun and Herald*, March 7, 1920, sec. 4, p. 7.

80. Stephan Bourgeois letter to Oscar Bleumner, December 15, 1928, microfilm N737, Archives of American Art, Washington, D.C.

81. Bourgeois, *Lewisohn*, p. xii.

82. Stephan Bourgeois, *Annual Exhibition of American Painters and Sculptors* (New York: Bourgeois Gallery, 1923), unpaginated.

83. S[tephan] B[ourgeois], "Preface," *Exhibition of Sculpture and Drawings by Gaston Lachaise* (New York: Bourgeois Gallery, 1920), unpaginated.

84. Bourgeois, *Lewisohn*, pp. 1, 176.

85. Bourgeois played a pioneering role in the introduction of oriental art to New York as an artistic expression that fit with his mystical philosophy. See [S]tephan [B]ourgeois, "Preface," *Exhibition of Chinese Painting* (New York: Bourgeois Gallery 1921), unpaginated.

86. Louis Bouché, autobiography, Archives of American Art, Washington, D.C.

87. Charles Daniel, typescript of his reminiscences, microfilm 1343, Archives of American Art, Washington, D.C., p. 51.

88. Emily Farnharn, *Charles Demuth Behind a Laughing Mask* (Norman: University of Oklahoma Press, 1971), p. 110.

89. Elizabeth McCausland, "The Daniel Gallery and Modern American Art," *Magazine of Art*. November 1961, p. 281.

90. Dickran Tashjian, *William Carlos Williams and the American Scene, 1920-1940* (New York: Whitney Museum of American Art in association with the University of California Press, Berkeley, 1978), pp. 14, 15.

91. Man Ray, *Self Portrait*, (Boston: Little, Brown and Co., 1963), pp. 48, 49, 56.

92. McCausland, "Daniel Gallery," p. 283.

93. Man Ray, *Self Portrait*, p. 76. He goes on to call Daniel "merely the money man."

94. Seligmann, *Alfred Stieglitz Talking*, p. 30.

95. McCausland, "Daniel Gallery," pp. 284-285.

96. Daniel, typescript of reminiscences, p. 7.

97. Marcia Tucker, *American Paintings in the Ferdinand Howald Collection* (Columbus: The Columbus Gallery of Fine Art, 1969). Howald also collected European modern art.

98. Henry McBride, "Born American and Others: The Daniel Gallery Use[s] the Melting Pot to Acquire American Art," *New York Sun*, October 26, 1929, p. 10.

99. Royal Cortissoz, "American Art," *New York Herald Tribune*, December 2, 1923, p. 7. Another favorable reference by Cortissoz is "Random Impressions in Current Exhibitions," *New York Herald Tribune*, February 17, 1924, p. 7.

100. Daniel, typescript of reminiscences, p. 70.

101. Murdock Pemberton, "A Memoir of Three Decades," *The Arts*, October 1955, pp. 29-30.

102. Murdock Pemberton, "In Which the Beau Geste Opens the Season Among Those Who Deal in Moderns," *The New Yorker*, October 23, 1926, p. 74.

103. Marius de Zayas (with Paul Haviland), *A Study of the Modern Evolution of Plastic Expression* (New York: 291, 1913).

104. Eva Epp Raun, "Marius de Zayas: The New York Years," (M.A. Thesis: University of Delaware, 1973), p. 31.

105. Eva Epp Raun, "Appendix: Modern and de Zayas Gallery Exhibition Schedules," *Arts Magazine*, April 1980, p. 125 in Francis M. Naumann, ed., "How, When, and Why Modern Art Came to New York," *Arts Magazine*, April 1980, pp. 96-125.

106. Marius De Zayas, "Negro Art," *The Arts*, March 1923, pp. 199-205.

107. In March 1923 de Zayas sold his collection of art; *The Collection of Marius de Zayas of New York City* (New York: Anderson Galleries, 1923).

108. Carl Zigrosser, *A World of Art and Museums* (Philadelphia: Art Alliance Press, 1975), pp. 28, 76.

109. Zigrosser, *World*, p. 39.

110. Zigrosser, *World*, p. 40.

111. "Review of Current Exhibitions: Alfred Maurer," *The Art News*, January 16, 1926, p. 7; "Seven in Whitney Studio Club Show: Paintings by Maurer," *The Art News*, January 1923, p. 5.

112. Clipping from *Publisher's Weekly*, October 27, 1923, in Weyhe Gallery scrapbook, unpublished; another bookstore that played an important role in the modern art world was the Sunwise Turn Bookstore. It was a gathering place and held informal exhibitions. Harold Loeb was a backer.

113. Rosenberg, *Painter's Self Portrait*, p. 56.

114. Maxwell Geismer, ed., *Unfinished Business, James N. Rosenberg Papers* (Mamaroneck: Vincent Marasia, 1967), p. ii. The same preface mentions Rosenberg's later role in urging the Metropolitan Museum of Art to purchase American art in 1949.

115. Geismer, ed., *Unfinished,* pp. 197-198 lists the artists shown in the first season, activities of second season on pp. 200-201.

116. Geismer, ed., *Unfinished,* p. 146.

117. Bouché, autobiography, Archives of American Art, Washinton, D.C. All the information on Belmaison comes from this source unless otherwise indicated. Bouché and his friends were also involved later in the decade in the Downtown Gallery.

118. Louis Bouché, *French Exhibition Paintings by the Younger Group* (New York: Belmaison Gallery, 1923).

119. "Current Shows in New York Galleries: Modern Paintings—Arnoux Drawings," *The Art News,* March 18, 1922, p. 2.

120. Henry McBride, "Modern Art," *The Dial,* January 1922, p. 110.

121. Forbes Watson, "Stodgy Routine Unknown to Belmaison..." *The World,* October 21, 1923.

122. Peter Selz, *German Expressionist Painting* (Berkeley: University of California Press, 1957), p. 249.

123. John Willett, *Art and Politics in the Weimar Period* (New York: Pantheon, 1978), pp. 29, 232.

124. Dore Ashton, "Art World Has Been His Life," *New York Times,* February 3, 1957, p. 10.

125. J.B. Neumann, typescript, Archives of American Art, Washington, D.C., uncatalogued.

126. J.B. Neumann, *Artlover,* 2:9 [late 1920s?], unpaginated.

127. Murdoc[k] Pemberton, untitled essay, *Artlover,* summer 1936, p. 84.

128. J.B. Neumann letter to Max Beckmann, February 27, 1930, Archives of American Art, Washington, D.C., uncatalogued.

129. Pemberton, *Artlover,* pp. 83-84.

130. The information on Brummer is gleaned from his catalogs and exhibitions. No study has been made of Brummer. For his catalogs see microfilm BR9, Archives of American Art, Washington, D.C.

131. "Rehn Gallery," *Archives of American Art Journal,* July–October, 1966, p. 35.

132. "More Sanity in Art Says Howard Young," *The Art News,* October 18, 1924, p. 4.

133. "Buyers are Western, Say Messrs Milch," *The Art News,* October 18, 1924, p. 4.

134. "Our Art More in Demand Says Rehn," *The Art News,* October 11, 1924, p. 3.

135. "Dudensing Favors Art of Today," *The Art News,* October 25, 1924, p. 6.

136. "Publish Buyers of Modern Art Works," *The Art News,* October 11, 1925, p. 5; "We Like Our Art Says Mr. Montross," *The Art News,* October 11, 1925, p. 5. See also on this page the article, "Modern Art Brings Cheer to Humanity," with the views of C.W. Kraushaar.

137. "Modern Art to Live, Avers Mr. Daniel," *The Art News,* October 18, 1924, p. 5.

138. "These Are the Bold Modernists at the National Academy," *The Art Digest,* April 15, 1927, pp. 1-3. Some of the "moderns" included were illustrated in *The Art Digest.* They included Maurice Sterne, Ernest Fiene, Boardman Robinson, Joseph Stella and Charles Burchfield. See also Forbes Watson, "Hospitality's Dividends," *The Arts,* April 1927, p. 167.

139. Henry McBride "Modern Art," *The Dial,* December 1927, pp. 532-534.

140. "Picasso First, But Americans Win 6 of 9 Carnegie Honors," *The Art Digest* Mid-October, 1930, p. 5. The "Portrait of Mme Picasso" that won the first prize is not too different in style from the conservative American modern artists like Bernard Karfiol.

Chapter 2

1. Clive Bell, *Art* (London: Chatto and Windus Ltd., 1913) citation from (New York: B.P. Putnam and Sons, 1958), p. 7. Bell comments here on the debt that he owed to Fry in the formulation of his ideas. For further insights into the interrelationship of Fry and Bell see Frances Spalding, *Roger Fry—Art and Life* (Berkeley: University of California Press, 1980), p. 164.

2. See for example Clive Bell, "Modern Art and How to Look at It," *Vanity Fair,* April 1924, pp. 56, 58 and "The Place of Art in Art Criticism," *The New Republic,* September 15, 1920, pp. 73-74.

3. Guy Eglington, "Art and Other Things" *International Studio,* August 1925, p. 377.

4. Roger Fry, *Vision and Design* (New York: Brentano's, 1921), pp. 11-25 and Roger Fry, "London Statues," *The Dial,* December 1925, pp. 469-473.

5. For example see Arthur Dow's "Modernism in Art," *American Magazine of Art,* January 1917, pp. 113-116. Field supported Fry by featuring two lengthy reviews of *Vision and Design:* see Alan Burroughs, review of *Vision and Design, The Arts,* May 1921, pp. 57-58 and Hamilton Easter Field, review of *Vision and Design, The Arts,* August-September 1921, pp. 51-54.

6. For a more complete documentation of the importance of Fry and Bell in the 1920s see my article "Formalism and American Art Criticism in the 1920s," *The Journal of the Theory and Criticism of the Arts,* forthcoming, 1984-85.

7. A more complete discussion of Watson's criticism is in Peninah Petruck, *American Art Criticism 1910-1939* (New York: Garland, 1981), pp. 134-176. McBride is also discussed, pp. 91-134.

8. Forbes Watson, untitled newspaper clipping, *The World,* Feb. 1, 1925, microfilm D49, Archives of American Art, Washington, D.C.

9. Forbes Watson, "Charles Sheeler," *The Arts,* March 1923, p. 341.

10. Forbes Watson, "Pablo Picasso Knocks Loudly at the Doors..." *The World,* November 25, 1923.

11. Henry McBride, *Matisse* (New York: Knopf, 1930), pp. 14-15.

12. Henry McBride, "Walkowitz and the Parks," *International Studio,* November 1924, p. 156.

13. Henry McBride, "Modern Art," *The Dial,* June 1926, p. 527.

14. Henry McBride, "Modern Art," *The Dial,* April 1927, p. 353.

15. Henry McBride, *Matisse*, p. 9.

16. Walter Pach, "An Artist's Criticism," *The Freeman*, October 25, 1922, p. 165.

17. Walter Pach, "The Point of View of the Moderns," *International Studio*, April 1914, pp. 861-863.

18. Walter Pach, *The Masters of Modern Art* (New York: B.W. Huebsch, 1924), pp. 94, 98-99.

19. Guy Eglington, "Art and Other Things," *International Studio*, January 1925, p. 341. Another review critical of Pach's evolutionary determinism was by Robert Allerton Parker in *The Arts*, January 1925, pp. 51-52.

20. "Eglinton [*sic*] drowned," *The Art Digest*, July 1928, p. 4. The article mentions that Eglington had been in a German detention camp during World War I where "he had nothing to do but read and think, and ponder upon the meaning of things."

21. Guy Eglington, "The Theory of Seurat," *International Studio*, July 1925, p. 290.

22. The most obvious statement of Eglington's evolutionary determinism is "The American Painter," *The American Mercury*, February 1924, pp. 218-220.

23. One entry has already been quoted in commenting on Clive Bell's terminology. The full dictionary other than that installment appeared in Eglington's column in *International Studio*, March 1925, pp. 495-498; April 1925, pp. 68-70; May 1925, pp. 148-151; July 1925, pp. 306-309; August 1925, pp. 375-37; Deoch Fulton provided one chapter in his column "Cabbages and Kings," June 1925, pp. 229-230.

24. Thomas Craven, "Mr. Roger Fry and Artistic Vision," *The Dial*, July 1921, pp. 101-106: see also "Psychology and Common Sense," *The Dial*, March 1924, p. 240.

25. Craven's biographical data appear in his book *Modern Art* (Garden City: Halcyon House, 1940) following the unpaginated plates.

26. Thomas Craven, "Charles Sheeler," *Shadowland*, March 1923, p. 71.

27. Thomas Craven, "John Marin," *Shadowland*, October 1921, p. 77.

28. Thomas Craven, "Thomas Hart Benton," *Shadowland*, September 1921, p. 66.

29. Thomas Craven, *Men of Art* (New York: Simon and Schuster, 1940), p. 516.

30. John Dewey, *Art as Experience* (New York: G.P. Putnam's, 1958), p. 87.

31. Dewey, *Art as Experience*, p. 87.

32. The best analysis on the origins of the term "expressionism" and its early meaning in the history of modernism is Donald Gordon, "On the Origin of the Word 'Expressionism,'" *Journal of the Warburg and Courtauld Institutes*, 1966, pp. 368-385. One other American writer on modern art who utilized expressionism, particularly drawing on Kandinsky, was Arthur Jerome Eddy, *Cubists and Post Impressionism* (Chicago: A.C. McClurg, 1914).

33. Cheney comments on these aspects in *The Open-Air Theatre* (New York: Kennerley, 1918), pp. 30-38. According to his son John Cheney, his father participated in at least one drama, personal communication, June 1980.

34. Gordon Craig, *On the Art of the Theatre* (London: Heinemann, 1911).

35. Sheldon Cheney, *The New Movement in the Theatre* (New York: Forum, 1914), pp. 302-303.

36. Cheney's earlier contacts with the art world included seeing the Armory Show of 1913 in Boston, and the Panama Pacific Exposition in San Francisco in 1916, for which he wrote a guide. Sheldon Cheney, *An Art-Lover's Guide to the Exposition* (Berkeley: At the Sign of the Oak, 1915), pp. 76, 86. The guide reflects that by 1916 Cheney was mainly familiar and comfortable with the ash can artists.

37. In those years Bourgeois was showing the work of Georgia O'Keeffe, John Marin, Joseph Stella, Albert Gleizes and others. Cheney recalled later that he knew Alfred Stieglitz as well, although not the date of their first meeting, personal communication, June 1979.

38. Société Anonyme, *Selected Publications,* vol. 1, "Report 1920-21," p. 28.

39. Cheney and Dreier were apparently more than casual acquaintances. Katherine Dreier letter to Sheldon Cheney January 5, 1923, comments "Where are you and what are you doing these days? Do get in touch with me. I enjoyed meeting your mother so much." Dreier's importance to Cheney was also reflected in his repeated references to the Société Anonyme in my interview with him, Berkeley, California, November 1979.

40. Sheldon Cheney, "Expressionism in Art: Art's Latest Revolution," *Shadowland,* October 1921, pp. 59-61.

41. Sheldon Cheney, *A Primer of Modern Art* (New York: Boni and Liveright, 1924), p. 41.

42. Cheney, *Primer,* p. 196.

43. For example in the *Primer,* chapter 11 "Expressionism" includes Cézanne, Matisse, Derain as well as such artists as Franz Marc. Kandinsky is treated in a separate chapter, "The Swing Toward Abstraction" (chap. 9).

44. Walter Pach, *Masters of Modern Art.*

45. Sheldon Cheney, *The New World Architecture* (New York: Longman Green and Co., 1930).

46. Sheldon Cheney, *Expressionism in Art* (New York: Liveright, 1934). Cheney's early awareness of Hofmann's important theories came through his friendship with Glenn Wessels in Berkeley. Wessels was Hofmann's sponsor and translator.

47. The *Primer* went through numerous editions and remained in print until 1966, influencing generations of beginning students of modern art. Clement Greenberg recently acknowledged that Sheldon Cheney's book on modern art was more familiar to him than those of Fry and Bell in the early years of his career, personal communication, July 1, 1984, San Francisco, California.

48. Paul Strand, "Aesthetic Criteria," *The Freeman,* January 12, 1921, p. 426.

49. One early summary of Dewey's writings appears in a collection of essays, John Dewey et. al., *Art and Education* (Merion: The Barnes Foundation Press, 1929). For Lewis Mumford's comments on art and the environment see *Sticks and Stones, A Study in American Architecture and Civilization* (New York: Horace Liveright, 1924), chapter 7 and *Aesthetics, A Dialogue* (Amenia: Troutbeck Press, 1925).

Chapter 3

1. John Marin, "Here It Is," *Mss,* no. 2, 1922, p. 3.

2. Paul Strand, "American Water Colors at the Brooklyn Museum," *The Arts,* December 1921, p. 151.

3. Paul Rosenfeld, "American Painting," *The Dial,* December 1921, p. 663.

4. Rosenfeld, *Port of New York* (New York: Harcourt, Brace, 1924), pp. 155-156.

5. Rosenfeld, *Port,* p. 158.

6. Marsden Hartley, *Adventures in the Arts* (New York: Boni and Liveright Inc., 1921. Reprint, New York: Hacker Art Books, 1972), pp. 98-99.

7. Henry McBride, "Modern Art," *The Dial,* March 1922, p. 329.

8. Henry McBride, "More Miracles by M. [*sic*] Marin," *New York Sun,* November 12, 1927.

9. Thomas Craven, "John Marin," *Shadowland,* October 1921, p. 77.

10. Craven, "John Marin," pp. 75-76.

11. Alexander Brook, "The Exhibitions: John Marin," *The Arts,* April 1923, p. 272.

12. Virgil Barker, "The Water Colors of John Marin," *The Arts,* February 1924, pp. 67, 69.

13. Forbes Watson, "Water Colors by John Marin," *The World,* February 24, 1924, unpaginated, microfilm D49, Archives of American Art, Washington, D.C.

14. Guy Eglington "John Marin, Colorist and Painter of Sea Moods," *Arts and Decoration,* August 1924, p. 13.

15. Eglington, "John Marin," p. 14.

16. "Exhibitions in New York: John Marin," *The Art News,* December 12, 1925, p. 5.

17. Louis Kalonyme, "John Marin: Promethean," *Creative Arts,* October 1928, pp. xl, xli.

18. For a thorough discussion of Marin's development see Sheldon Reich, *John Marin: A Stylistic Analysis and Catalogue Raisonne* (Tuscon: University of Arizona Press, 1970).

19. Rosenfeld, *Port,* pp. 204, 205; a recent dissertation on O'Keeffe is Katherine Hoffman, "A Study of the Art of Georgia O'Keeffe," (Ph.D. dissertation: Institute of Fine Arts, 1976).

20. "Georgia O'Keeffe 'Individualist,'" *American Art News,* February 3, 1923, p. 5.

21. "Exhibitions in New York: Georgia O'Keeffe," *The Art News,* February 13, 1926, p. 7.

22. Gail Levin, "Wassily Kandinsky and the American Avant-Garde 1912-1950," Ph.D. Dissertation: Rutgers University, 1976, p. 54.

23. Barbara Haskell, *Arthur Dove* (Boston: New York Graphic Society, 1974), p. 135.

24. Rosenfeld, *Port,* p. 169.

25. H.C., "Stieglitz Group in Anniversary Show," *The Art News,* March 14, 1925, p. 5. The titles of paintings in reviews are frequently different from their current names, making exact identification difficult. Dove did several paintings of storms around this time, as illustrated in Haskell, *Dove,* nos. 45, 48.

26. "Exhibitions in New York: Arthur Dove Intimate Gallery," *The Art News,* December 24, 1927, p. 9; the *Hand Sewing Machine* is illustrated in Haskell, *Dove,* no. 51.

27. Henry McBride, "Sale of the Arthur B. Davies Collection . . .," *New York Sun,* April 13, 1929, p. 9.

28. Emily Farnham, *Charles Demuth, Behind a Laughing Mask,* (Norman: University of Oklahoma, 1971), p. 110. The motivation for the shift to Stieglitz was, ironically, apparently financial, Farnham, *Charles Demuth,* p. 17.

29. Demuth was a close friend of Georgia O'Keeffe's, who also disliked art talk.

30. Rosenfeld, "American Painting," p. 662.

31. Forbes Watson, "American Note in Demuth's Art: Watercolors of Rare Distinction Displayed at Daniel's," *The World,* December 2, 1923, p. 8.

32. Henry McBride, "Charles Demuth's Cerebral Art," *New York Sun,* April 10, 1926, p. 6.

33. Royal Cortissoz, "American Art," *New York Herald Tribune,* December 2, 1923, p. 7.

34. Barbara Haskell, *Marsden Hartley* (New York: Whitney Museum of American Art, 1980), p. 52.

35. Marsden Hartley, "Dissertation on Modern Painting," *The Nation,* February 9, 1921, p. 229.

36. Dickran Tashjian, *Skyscraper Primitives: Dada and the American Avant-Garde* (Middletown: Wesleyan University, 1975), pp. 24-27. See also another consideration of this issue in Rick Stewart, "Charles Sheeler, William Carlos Williams and Precisionism: A Redefinition," *Arts Magazine,* November 1983, pp. 100-115.

37. Marsden Hartley, "Art—and the Personal Life," *Creative Art,* June 1928, p. xxxi.

38. Rosenfeld, *Port,* pp. 92, 93, 97.

39. Herbert J. Seligmann, "The Elegance of Marsden Hartley—Craftsman," *International Studio,* October 1921, p. li, lii.

40. Raymond Wyer, "Germany and Art," *International Studio,* December 1918, p. xlii.

41. "Post Bellum Art in Germany," *American Art News,* March 26, 1921, p. 1.

42. "Revolution Reflected in the 'New' Art of Germany," *Current Opinion,* October 1919, pp. 254-256.

43. Oscar Bie, "Mid European Expressionism, the New Creed and its Prophets," *Arts and Decoration,* June 25, 1920, pp. 88-89.

44. Bie, "Mid European Expressionism," p. 112.

45. C. Kay Scott, "Art: The Expressionist Movement," *The Freeman,* September 28, 1920, p. 63.

46. Scott, "Expressionist," p. 64.

47. F[lora] T[urkel], "Russia Favors New But Guards Old Art," *American Art News,* June 17, 1922, p. 1.

48. F[lora] T[urkel], "Berlin," *American Art News,* November 4, 1922, p. 7.

49. Kenneth MacGowan, "Expressionism in the German Theatre," *Vanity Fair,* November 1922, pp. 53, 116; compare this article to Sheldon Cheney, "'Expressionism' in German Theatres and Our Own," *New York Times Book Review,* April 30, 1922, pp. 5, 26.

50. MacGowan, "Expressionism," p. 116.

51. "The Cabinet of Dr. Caligari," *Vanity Fair,* June 1921, p. 32.

52. Herman George Scheffauer, "The Vivifying of Space," *The Freeman,* December 1, 1920, p. 249.

53. Herman George Scheffauer, "The 'Absolute Poem'" *The Freeman,* September 18, 1921, p. 61.

54. Lloyd Goodrich, review of *The New Vision in the German Arts, The Arts,* July 1924, p. 60.

55. Ernest Bode, "Expressionism Without Tears," *Vanity Fair,* March 1923, p. 59.

56. "Paintings at Société Anonyme," *The Art News,* November 4, 1920, p. 2.

57. Hamilton Easter Field, "Current Art Exhibitions," *The Arts,* December 4, 1920, pp. 34-35.

58. "Kandinsky's Latest Paintings," *The Art News,* March 31, 1923, p. 2.

59. Elizabeth Luther Cary, "Art Exhibitions of the Week—Foreign Notes: Wassily Kandinsky," *New York Times,* April 1, 1923, sec. VIII, p. 7.

60. Dreier, *Western Art,* p. 103.

61. William Valentiner diary entry around 1921, microfilm D31, Archives of American Art, Washington, D.C. See also Margaret Sterne, *The Passionate Eye: The Life of William B. Valentiner* (Detroit: Wayne State University, 1980).

62. "Valentiner Sees German Renaissance, Expects Expressionistic Movement to Bring About a Rebirth of the Human Soul—Talks of its Leaders," *The Art News,* November 11, 1922, p. 1.

63. Max Deri, "Principles of Modern German Art," *International Studio,* July 1923, p. 317.

64. Julius Meier-Graefe, "German Art After the War," *The Dial,* July 1923, pp. 2, 6, 8.

65. F.E. Washburn Freund, "Modern Art in Germany," *International Studio,* October 1923, pp. 41-46.

66. William Valentiner, "Introduction," *A Collection of Modern German Art* (New York: Anderson Galleries, 1923), unpaginated.

67. Valentiner, "Introduction," unpaginated.

68. "The Season Opens," *The Arts,* November 1923, p. 215. Forbes Watson did not even review the exhibition.

69. "Modern Germany Speaks of Its Art: A Kind of Terrible Ernestness Even in Landscapes—At Times, An Intentional Brutality," *The Art News,* October 13, 1923, p. 1.

70. Royal Cortissoz, "Notes and Activities in the Field of Art," *Scribner's Monthly Magazine,* January 1924, p. 124.

71. Henry McBride, "German Water Colors and Prints Shown," *New York Herald,* December 2, 1923, p. 8.

72. "American Buyers Like German Art," *The Art News,* October 27, 1923, p. 4.

73. Henry McBride, "A New Group of Modernists," *New York Sun,* February 21, 1925.

74. "Germany's Own Estimate of 'the Blue Four'," *The Art Digest,* mid-December 1929, p. 10.

75. C. Adolph Glassgold, "Max Beckmann," *The Arts,* May 1927, pp. 244, 247.

76. Forbes Watson, "The Carnegie International," *The Arts,* November 1927, p. 267. The exhibition was also seen in Brooklyn and San Francisco.

77. Rom Landau, "Modern Movements in German Art," *The Arts,* July 1928, pp. 24-30.

Chapter 4

1. Christian Brinton, "Evolution not Revolution in Art," *The International Studio,* April 1913, pp. xxvii-xxxv, Reprint, *The Armory Show, International Exhibition of Modern Art 1913,* vol. 3 (New York: Arno Press, 1972); J. Nelson Laurvik, *Is It Art? Post Impressionism, Futurism, Cubism* (New York: The International Press, 1913), Reprint, *The Armory Show,* vol. 3; Peter Moak, "Cubism and the New World: The Influence of Cubism on American Painting, 1910-1920" (Ph.D. Dissertation: University of Pennsylvania, 1970) provides an overview of the stylistic impact of Cubism on American art.

2. A Picabia statement is reprinted in "Cubism by a Cubist," *Armory Show,* vol. 2; for commentary citing Picabia's ideas see Christian Brinton, "The Modern Spirit in Contemporary Painting," *Impressions of the Art at the Panama-Pacific Exposition* (New York: John Lane, 1916) pp. 22, 23; Arthur J. Eddy, *Cubists and Post-Impressionism* (Chicago: A.C. McClurg and Co., 1914).

3. For a complete discussion on Picabia see William A. Camfield, *Francis Picabia, His Life and Times* (Princeton: Princeton University Press, 1979).

4. Walter Pach, *Queer Thing, Painting* (New York: Harcourt Brace, 1938), Chapter 23, suggests his sources in Meier-Graefe, Kant and Fry. More information on Pach will emerge when his papers become available.

5. Pach, *Queer Thing,* p. 144.

6. Edward Fry, *Cubism* (New York: McGraw Hill, 1966), p. 110.

7. Walter Pach, *Masters of Modern Art* (New York: B.W. Huebsch, 1924), p. 83.

8. Christopher Gray, *Cubist Aesthetic Theories.* (Baltimore: John Hopkins Press, 1953) is the best source on the Symbolist aspect of Cubist theory.

9. Fry, *Cubism,* p. 105.

10. Walter Pach, "The Point of View of the 'Moderns'," *The Century,* April 1914, p. 862, reprint, *The Armory Show,* vol. 3.

11. Pach, *Masters,* p. 88.

12. Pach, *Masters,* p. 90.

13. Elie Faure, *History of Art,* trans. Walter Pach (New York: Dover Publications, reprint from Harper & Brothers 1921-1923), p. xxx; Faure stated his thesis most completely in *The Spirit of the Forms* (New York: Harper & Bros., 1930). Elie Faure was a Paris surgeon who wrote and lectured on art as a hobby. Pach stated he was thrilled by Elie Faure in *Queer Thing,* pp. 262, 263. He translated Faure's books and articles for many years.

14. Pach, *Masters,* p. 160.

15. Pach, *Masters,* p. 83.

16. Albert Gleizes, "The Impersonality of American Art," *Playboy* (fall 1919), p. 26; "Cubism," *The Living Age,* November 6, 1920, pp. 357-360 (review of *Du Cubisme et des moyens de le comprendre*).

17. "Is Cubism Pure Art?—A Debate," Walter Pach, "Picasso's Achievement," *The Forum*, June 1925, pp. 769-775; Alfred Vance Churchill, "Picasso's 'Failure'," pp. 776-783.

18. Daniel Catton Rich, "The Conscience of a Critic," *Arts Magazine*, November 1962, pp. 48-57.

19. Guillaume Apollinaire, "Aesthetic Meditations," *The Little Review*, spring 1922, pp. 7-10; fall 1922, pp. 41-59; winter 1922, pp. 49-60. It was circulated to the members of the Société Anonyme; Board of Directors letter to Sheldon Cheney, July 1, 1922, Société Anonyme Papers, Yale University.

20. Henry McBride, "Art News and Reviews as the New Season is Getting Underway: Apollinaire's Cubistic Authority," *New York Herald*, October 15, 1922, p. 6.

21. Henry McBride, "Art News and Reviews—Noted Picture By Duchamp on Exhibition," *New York Herald*, March 9, 1924, p. 13.

22. Henry McBride, "News and Views of Art, Including the Clearing House for Works of Cubists," *The New York Sun and Herald*, May 16, 1920, p. 8.

23. Henry McBride, "Views and Reviews of the Week in the Art World: Work of Charles Sheeler Attracts Attention," *New York Sun and Herald*, February 22, 1920, p. 7.

24. Henry McBride, "Joseph Stella's Startling Art: Niles Spencer's Successful Work" *New York Sun*, April 11, 1925, p. 9.

25. Henry McBride, review of *Adventures in the Arts*, *The Dial*, December 1921, p. 706.

26. Henry McBride, "Views of Bourdelle Sculpture: Fernand Léger's Modernistic Art," *New York Sun*, November 21, 1925, p. 14.

27. Henry McBride, "Notes and Activities in the World of Art," *New York Sun and Herald*, October 24, 1920.

28. Gertrude Stein, "Genuine Creative Ability," *Creative Arts*, February 1930, sup. 41. Henry McBride invited this article.

29. Dreier, *Western Art*, pp. 81, 82.

30. Dreier, *Western Art*, pp. 83, 84.

31. Cheney, *Primer*, p. 169.

32. Cheney, *Primer*, pp. 111, 112.

33. Frank Rutter, *Evolution in Modern Art* (London: George G. Harrap & Co. 1926), pp. 96, 98.

34. Virgil Barker, review of *Evolution in Modern Art: A Study of Modern Painting 1870-1925*, *The Arts*, January 1927, p. 55.

35. R.H. Wilenski, *The Modern Movement in Art* (London: Faber and Faber Ltd., 1928), p. 137.

36. Virgil Barker, review of *The Modern Movement in Art*, *The Arts*, April 1928, p. 267.

37. Jay Hambidge and Gore Hambidge, "The Ancestry of Cubism," *The Century*, April 1914, p. 871.

38. Hambidge, "Ancestry," p. 871.

39. "Artist Giles Paints Cubism with Words, *New York Times*, March 17, 1921, p. 18.

40. Andrew Dasburg, "Cubism—Its Rise and Influence," *The Arts,* November 1923, p. 280.

41. Dasburg, "Cubism," p. 280, 282.

42. Dasburg, "Cubism," p. 282.

43. Guy Eglington, "Art and Other Things," *Arts and Decoration,* March 1925, p. 497.

44. "Recent Work of the Moderns," *The Art News,* February 16, 1924, p. 5.

45. "Passing and Permanent," *The Art News,* November 7, 1925, p. 8.

46. "Modernism Up to Date," *The Art News,* December 5, 1925, p. 8.

47. "Reinhardt Shows French Art," *The Art News,* November 5, 1927, p. 1.

48. "Forbes Watson in the 'N.Y. Evening Post'," *Camera Work,* April-July 1913 (published November 1913), p. 49.

49. Forbes Watson, Editorial, *The Arts,* March 1925, pp. 125-126.

50. Forbes Watson, Editorial, *The Arts,* September 1925, pp. 121-123.

51. Diego Rivera, "From a Mexican Painter's Notebook," *The Arts,* January 1925, p. 22. Rivera was influenced by Elie Faure in his rejection of Cubism, verbal communication with Ramon Favela, June 1981.

52. Clive Bell, "Matisse and Picasso," *Arts and Decoration,* November 1920, p. 42.

53. Clive Bell, "The Rise and Decline of Cubism," *Vanity Fair,* February 1923, p. 53.

54. Thomas Craven, "The Progress of Painting: Individual Tendencies," *The Dial,* 1923, p. 584.

55. Thomas Craven, "The Independent Exhibition," *The New Republic,* March 14, 1923, p. 70.

56. Albert Barnes probably influenced Thomas Craven in his rejection of Cubism. Barnes had written a requiem for Cubism in 1916, "Cubism: Requiescat in Pace," *Arts and Decoration,* January 1916, pp. 121-124. Craven was in contact with Barnes in 1922; see my masters thesis, Susan Platt Carmalt, "Thomas Hart Benton as Aesthetic Theoretician" (M.A. Thesis: Brown University, 1973), p. 35.

57. Julius Meier-Graefe, "What Has Happened to Cubism," *Vanity Fair,* June 1928, pp. 78, 124; see also the lengthy article by George Saiko, "The Meaning of Cubism," *Creative Arts,* September 1930, pp. 206-212; other examinations of Cubism are Ladislas Medygas, "Cubism's Effect on French Art," *International Studio,* February 1924, pp. 410-414 and H.A.L. "Note on Gris and Cubism," *Broom,* August 1923, pp. 32, 34.

58. "Archipenko, Russian Sculptor-Painter," *American Art News,* February 12, 1921, p. 5.

59. Flora Turkel, "Archipenko Coming with New Art Plan," *The Art News,* May 12, 1923, p. 1.

60. "Archipenko Coming to Live in America: Famous Modernist Found Berlin Disturbing and Longed for New York's Wonders and Beauties," *The Art News,* October 20, 1923, p. 3.

61. Alexander Archipenko, "Nature the Point of Departure," *The Arts,* January 1924, pp. 32-36.

62. "Archipenko at Kingore's," *The Art News,* January 26, 1924, p. 3.

63. "Marc Chagall and Alexander Archipenko," *The Art News,* January 16, 1926, p. 7.

64. Christian Brinton, *The Archipenko Exhibition* (1924), in *Selected Publications,* vol. 3.

65. Henry McBride, "Modern Art," *The Dial*, February 1923, p. 218. McBride suggests that "the recent scare headlines that 'Cubism is Finished,' were exaggerated, since M. Villon continues being cubistic and continues being interesting."

66. Walter Pach, "Villon" in *Selected Publications*, vol. 2, pp. 4, 5.

67. "Exhibitions in New York: Jacques Villon," *The Art News*, March 31, 1928, p. 11.

68. Alexander Brook, "The Exhibitions: Albert Gleizes," *The Arts*, April 1923, p. 276.

69. Henry McBride, "The Skating Rink by Fernand Léger," *New York Herald*, November 18, 1923, p. 8 is one example of a review of Léger's theater work.

70. Lloyd Goodrich, "New York Exhibitions: Fernand Léger," *The Arts*, December 1925, p. 349. The reference to "Norman blood" reflects incipient environmentalism.

71. Louis Lozowick, "Art: Léger," *The Nation*, December 16, 1925, p. 712.

72. Waldemar George, "Fernand Léger," *The Arts*, May 1929, pp. 303-313.

73. Henry McBride, "Whitney Studio Club Opens an Exhibition," *New York Herald*, May 8, 1921, p. 11.

74. Forbes Watson, "The Exhibitions: Glenn Coleman," *The Arts*, May 1928, pp. 318, 320.

75. "Exhibitions in New York: Glenn Coleman, Stuart Davis," *The Art News*, April 28, 1928, p. 11.

76. Henry McBride, "The Palette Knife," *Creative Arts*, November 30, 1929, pp. 77, 78.

77. "Airy Handspring is Done by Picasso," *American Art News*, June 25, 1921, p. 5. The subtitle read "New Style of Arch-Extremist not in any way Related to Cubistic Designs that Set Pace for Imitations."

78. Henry McBride, "Modern Art," *The Dial*, February 1922, p. 221.

79. "Picasso's Recent Work," *The Art News*, May 12, 1923, p. 2.

80. "Picasso Speaks," *The Arts*, May 1923, pp. 314-329.

81. "Picasso is Painting in a Classic Style," *The Art News*, November 24, 1923, p. 2.

82. Forbes Watson, "Pablo Picasso Knocks Loudly at the Doors of our Museums," *The World*, November 25, 1923.

83. Forbes Watson, "A Note on Picasso," *The Arts*, December 1923, p. 332. In contrast to Watson, see the primary account of Picasso by his friend, Jean Cocteau, "Picasso, A Fantastic Modern Genius," *Arts and Decoration*, November 1924, pp. 44, 72-74; another personal commentary on Picasso was Max Jacob "The Early Days of Pablo Picasso," *Vanity Fair*, May 1923, pp. 62, 104.

84. Herbert Seligmann, "Picasso on Fifth," *The Nation*, December 19, 1923, p. 714.

85. Henry McBride, "Modern Art," *The Dial*, January 1924, p. 102.

86. Elizabeth Luther Cary, "Modern French Prints," *International Studio*, November 1924, p. 133.

87. Guy Eglington, "Art and Other Things," *International Studio*, August 1924, p. 375.

88. Katherine Dreier, "Picasso," *Modern Art* (New York: Société Anonyme, 1926), p. 82 in *Selected Publications*, vol. I.

89. Lloyd Goodrich, "In the Galleries," *The Arts,* March 1930, p. 412.

Chapter 5

1. There is a scholarly debate about Dada. One opinion is epitomized by a recent article by Francis Naumann, "The New York Dada Movement: Better Late than Never," *Arts Magazine,* February 1980, pp. 143-149; Naumann uses a narrow definition of Dada, that confines it to activities so labelled, and limits it to a very small group of works and artists. A second opinion, as seen in Dickran Tashjian, *Skyscraper Primitives: Dada and the American Avant-Garde* (Middletown: Wesleyan University, 1975) holds a much broader definition that covers a wide range of activities both within and without the visual arts as relating to Dada. One intermediate view is presented by William Camfield, *Francis Picabia, His Life and Times* (Princeton: Princeton University Press, 1979), chapter 6.

2. "Current News of the Art and Exhibitions," *The Art News,* January 16, 1916, p. 7. See also in the same year a review of Jean Crotti's work in "Exhibitions Now On: More Modernists at Montross," *The Art News,* April 8, 1916, p. 5. Man Ray showed in the same year and in 1919 as described by him in *Self Portrait* (Boston: Little Brown, 1963), pp. 71, 76.

3. Tashjian, *Skyscraper Primitives,* p. 242. Note 20 evaluates how Dada the publications actually were.

4. Arturo Schwarz, *New York Dada* (Milan: Prestel-Verlag, 1973) p. 90.

5. Margaret Anderson, *My Thirty Years' War* (New York: Covici Friede, 1930), pp. 177-178.

6. McBride, "News and Views of Art: Including the Clearing House for Works of Cubists," *New York Sun and Herald,* May 16, 1920, p. 8.

7. Man Ray, *Self Portrait,* pp. 92, 96, 97. He mentions that Dreier bought the piece. Man Ray made many duplications of it.

8. McBride, "Clearing House," p. 8.

9. Hamilton Easter Field, "Current Art Exhibitions," *The Arts,* December 4, 1920, p. 34. The review was for a later exhibition, but the piece is cited by Man Ray as in the first exhibition as well.

10. "A Post-Impressionist Scandal," *The Art News,* April 17, 1920, p. 1.

11. Francis Naumann reproduces the article in his "New York Dada," p. 148 and discusses it in detail.

12. A translation and reproduction of the manifesto appears in Robert Motherwell, ed., *The Dada Painters and Poets* (New York: Wittenborn, Schultz, Inc., 1951), pp. 183, 190. He omits some passages. The Dada Manifesto is in *The Little Review,* January-March 1921, pp. 63-64.

13. *The Little Review* was defended in the trial by John Quinn, but they lost; see Jackson Bryer, "Joyce, Ulysses and the *Little Review*," South Atlantic Quarterly, 1967(2) pp. 148-164.

14. Jane Heap commented in an article on the "futility of trying a creative work in a court of law." "Art and the Law," *The Little Review,* September-December 1920, pp. 5-6.

15. John Rodker, "Dada and Else Von Freytag Von Loringhoven," *The Little Review,* July/August, 1920, pp. 33-36. The article also quotes from Picabia. Another article on the literary Dadas is Louis Lozowick, "The Russian Dadaists," *The Little Review,* September-December 1920, pp. 72-73.

16. "Nothing is Here, Dada is Its Name," *American Art News*, April 2, 1921, p. 1.

17. "Nothing," p. 7.

18. Marsden Hartley, *Adventures in Arts* (New York: Hacker Art Books, 1972), pp. 248, 251, 254.

19. Katherine Dreier, *Western Art and the New Era* (New York: Brentano's, 1923), p. 118.

20. Motherwell, *Dada*, reproduces *New York Dada*, pp. 214-218.

21. Henry McBride, "New Dada Review Appears in New York," *New York Herald*, April 24, 1921, p. 11.

22. Perhaps McBride's preoccupation with typesetting may have led to Duchamp's typographical parody of McBride's criticism, Henry McBride, *Some French Moderns Says McBride* (New York: Société Anonyme, 1922).

23. Henry Tyrell, "Dada: The Cheerless Art of Idiocy," *The World Magazine*, June 12, 1921, cited in Naumann, "Dada" p. 147.

24. "Dadaists have Real Varnishing Days," *American Art News*, May 14, 1924, p. 5.

25. See for example, "Dadaism vs. Tactilism," *American Art News*, February 12, 1921, p. 1.

26. See for example, "New Picabia Row Sets Paris Agog," *The Art News*, February 4, 1922, p. 2.

27. Sheldon Cheney, "Why Dada?," *The Century Magazine*, May 1922, p. 27.

28. Cheney, "Why Dada?" p. 28. This idea comes across even more strongly in the manuscript for the article in the Sheldon Cheney Archives, Bancroft Library, University of California, Berkeley. See p. 67 especially.

29. Jane Heap, "Dada," *The Little Review*, spring 1922, p. 46.

30. Jane Heap, "The Art Season," *The Little Review*, spring 1922, p. 58. An article on Picabia the following winter captured more of the flavor of the work, André Breton, "Francis Picabia," *The Little Review*, Winter 1922, pp. 41-44.

31. See G. Ribemont-Dessaignes, "Dada Painting or the Oil-Eye," *The Little Review*, winter 1923-24, pp. 11-12 and several articles by Tristan Tzara including "La Virginité Avantageuse et la Recompense du Monsieur." *The Little Review*, spring 1924, pp. 5-6.

32. Edmund Wilson, Jr., "The Aesthetic Upheaval in France," *Vanity Fair*, February 1922, p. 49; Matthew Josephson, *Life Among the Surrealists* (New York: Holt, Rinehart and Winston, 1962), p. 249, mentions Wilson's important role on the magazine.

33. Wilson, "Aesthetic," p. 100.

34. Tristan Tzara, "Some Memoirs of Dadaism," *Vanity Fair*, July 1922, p. 70; reprinted with omissions in Edmund Wilson, *Axel's Castle, a Study in the Imaginative Literature, 1870-1930* (New York: Scribner's, 1931), pp. 304-312.

35. Tristan Tzara, "What We Are Doing in Europe," *Vanity Fair*, September 1922, pp. 68, 100.

36. Tristan Tzara, "Germany—A Serial Film," *Vanity Fair*, April 1923, pp. 59, 60, 104, 105 and "The Dada Masks of Hiler," *Vanity Fair*, pp. 46, 88.

37. Tzara, "Germany," p. 108.

38. Henry McBride, "Modern Art," *The Dial*, November 1922, p. 587.

39. Henry McBride, "Modern Art," *The Dial,* January 1923, pp. 113-115.

40. Henry McBride, "Modern Art," *The Dial,* December 1923; reprinted in Daniel Catton Rich, ed., *The Flow of Art Essays and Criticisms of Henry McBride* (New York: Atheneum Publishers, 1975), pp. 179-181.

41. Matthew Josephson, *Life Among the Surrealists* (New York: Holt, Rinehart and Winston, 1962), chapters 6-9.

42. Edmund Wilson, "An Imaginary Conversation," *The New Republic,* April 9, 1924, p. 180; Josephson, *Life,* pp. 255-260.

43. Wilson, "Imaginary Conversation," p. 182.

44. Waldo Frank, *In The American Jungle,* (New York: Farrar and Rinehart, 1937), reprinted from *1924,* pp. 130, 131.

45. Frank, *In the American Jungle,* pp. 132-133.

46. Tashjian, *Skyscraper,* p. 142.

47. Josephson, *Life,* p. 290; Tashjian, *Skyscraper,* p. 141.

48. Katherine Dreier, *Western Art,* p. 93; The situation with Dove is still a debate for contemporary scholars; see Barbara Haskell, *Arthur Dove,* p. 54.

49. Lloyd Goodrich, "New York Exhibitions: Arthur Dove," *The Arts,* February 1926, p. 100.

50. "Charles Demuth, Intimate Gallery," *The Art News,* April 10, 1926, p. 7.

51. Lloyd Goodrich, "New York Exhibitions," *The Arts,* May 1926, pp. 281-287.

52. Forbes Watson, "Charles Demuth," *The Arts,* January 1923, p. 78. Joseph Stella also had links to Dada, but was not related to it in the criticism.

53. "An Exhibition of Arrangements of the American Landscape Forms," *The Art News,* December 11, 1920, p. 4.

54. Forbes Watson, "Nottingham Dadas at Whitney Club," *The World,* January 27, 1924, microfilm D49, Archives of American Art, Washington D.C. The Inje-Inje are another obscure manifestation of American Dada.

55. "Dada is Dead," *The Living Age,* April 15, 1927, p. 736.

56. Josephson, *Life,* p. 215.

57. Rene Crevel, "Acknowledgement to Georgio (*sic*) de Chirico," *The Little Review,* spring 1924, p. 8.

58. Crevel, "de Chirico," p. 8.

59. Dreier, *Modern Art* in *Selected Publications,* vol. 1, p. 61; see Introduction *Catalog of An International Exhibition* in *Selected Publications,* vol. 1, unpaginated.

60. Henry McBride, "Giorgio De Chirico's Art," *The Sun,* January 28, 1928, p. 16.

61. Forbes Watson, untitled reviews, *The Arts,* March 1928, p. 150.

62. "Exhibitions in New York," *The Art News,* January 28, 1928, p. 11.

63. Lloyd Goodrich, "Giorgio de Chirico," *The Arts,* January 1929, p. 9.

64. Henry McBride, "Attractions in the Galleries," *New York Sun,* January 5, 1929, p. 12.

65. Goodrich, "de Chirico," p. 72.

66. H.S.C., "Paris," *The Art News,* December 5, 1925, p. 9.

67. Virgil Barker, "Transatlantic Column III," *The Arts,* December 1925, pp. 317-318.

68. Lloyd Goodrich, "New York Exhibitions," *The Arts,* February 1926, p. 97.

69. G. Ribemont-Dessaignes, "In Praise of Violence," *The Little Review,* spring 1926, pp. 40-41.

70. Matthew Josephson, "A Letter to My Friends," *The Little Review,* spring 1926, pp. 17-18. Josephson comments that the Surrealist issue of *The Little Review* was a response to *Aesthete, 1925, Life,* p. 291.

71. Lloyd Goodrich, "Exhibitions in New York," *The Arts,* June 1927, p. 328.

72. "The Newest 'Ism' is 'Surrealism,'" *The Art Digest,* May 1, 1927, p. 1.

73. Henry McBride, "Interesting Show of Contemporary British Art now at Agnew Galleries: Barking at Moon at Brummer's," *New York Sun,* December 7, 1929.

74. "Miro's Dog Barks While McBride Bites," *The Art Digest,* Mid-December, 1929, p. 10.

Chapter 6

1. Irma Jaffe, *Joseph Stella,* (Cambridge: Harvard University Press, 1970), p. 57.

2. Jaffe, *Joseph Stella,* p. 68.

3. Marcel Duchamp, "A Complete Reversal of Opinions by Marcel Duchamp—Iconoclast," *Arts and Decoration,* September 1915, p. 428.

4. Hamilton Easter Field, "Joseph Stella," *The Arts,* October 1921, p. 24.

5. Katherine Dreier, *Stella,* in Société Anonyme, *Selected Publications,* vol. 2, unpaginated.

6. Alexander Brook, "Joseph Stella," *The Arts,* February 1923, p. 129.

7. J[ane] H[eap], "Stella Exhibition," *The Little Review,* autumn 1922, p. 2.

8. Thomas Craven, "Joseph Stella," *The Shadowland,* January 1923, p. 78.

9. Henry McBride, "Modern Art," *The Dial,* April 1923, in *The Flow of Art,* ed. by Daniel Rich (New York: Atheneum, 1975) pp. 172-173.

10. The term "Immaculates" was used in the 1920s in reviews that saw the group as a reaction to the "slaughterhouse" art of George Bellows and William M. Chase. "Exhibitions in New York: Charles Sheeler." *The Art News,* January 23, 1926, p. 7.

11. In a lecture at Williams College, March 1984, I analyzed the close affinities of Charles Sheeler and the "L' Esprit Nouveau." The unpublished lecture is titled "Charles Sheeler and L'Esprit Nouveau: A New Insight."

12. Charles Sheeler, "Notes on an Exhibition of Greek Art," *The Arts,* March 1925, p. 153. Only one critic in the 1920s made a reference to Sheeler's classicism: Robert Allerton Parker, "The Classical Vision of Charles Sheeler," *International Studio,* May 1926, pp. 68-72.

13. "Paintings and Drawings by Sheeler," *American Art News,* April 1, 1922, p. 6.

14. Dudley Poore, "Current Exhibitions," *The Arts,* February 1925, p. 115.

15. Forbes Watson, "Charles Sheeler," *The Arts,* March 1923, p. 338.

16. "Charles Sheeler: New Art Circle," *The Art News,* January 1926, p. 7.

17. Susan Yeh, "Charles Sheeler: Industry, Fashion and the Vanguard," *Arts Magazine,* February 1980, p. 158.

18. The criticism of these works belongs to a study of the 1930s.

19. "Immaculate Group Seen at Daniels," *The Art News,* November 3, 1928, p. 9.

20. Milton Friedman, *The Precisionist View in American Art* (Milwaukee: Walker Art Gallery, 1960) is one of the most balanced analyses of the Precisionists. A recent example of the overemphasis on subject is Karen Tsujimoto *Images of America Precisionist Painting and Modern Photography* (San Francisco: San Francisco Museum of Modern Art, 1982.) See also my review "Precisionism: America's Immaculates" *Images and Issues,* March, April 1983, pp. 22-23.

21. Hamilton Easter Field, "Comment on the Arts," *The Arts,* January 1921, p. 32. For a review of the ideas of Purism, see Jacques Mauny, review of *La Peinture Moderne, The Arts,* May 1926, pp. 294, 295.

22. Ezra Pound, "Paris Letter," *The Dial,* January 1923, p. 88. The letter is dated December 1922.

23. Fernand Léger, "The Esthetics of the Machine," *The Little Review,* spring 1923, pp. 45-49 and autumn and winter 1923-1924, pp. 55-58. The spring issue did not come out until fall. Pound's role in the publication of the essay is mentioned in J[ane] H[eap], "Comments," *The Little Review,* spring 1923, p. 25. She also disclaimed influence from a "foreign editor" in the next issue, suggesting a falling-out with Pound, "Comment," *The Little Review,* autumn and winter 1923-1924, p. 25.

24. While difficult to document, the idea of a Little Review Gallery displaying machines and art apparently was the result of Heap's interest in Léger's ideas.

25. J[ane] H[eap], "Comments," *The Little Review,* autumn and winter 1924-1925, p. 22.

26. Katherine Dreier, *Western Art,* p. 136 commented that modern machines were "the vital expression of today, as vital as the great Gothic Cathedrals of Europe were an expression of their times."

27. Henry McBride, "The Skating Rink by Fernand Léger," *New York Herald,* November 18, 1923, p. 8.

28. Katherine Dreier, "Introduction," *Fernand Léger* in *Selected Publications,* vol. 2, p. 3.

29. Fernand Léger, "Notations on Plastic Values," in *Selected Publications,* vol. 2, pp. 10-11.

30. Lozowick, "Art: Fernand Léger," *The Nation,* December 16, 1925, p. 712.

31. "From the exhibition by Fernand Léger," *The Art News,* November 14, 1925, p. 2.

32. Henry McBride, "Views of Bourdelle Sculpture: Fernand Léger's Modernistic Art," *New York Sun,* November 21, 1925, p. 14.

33. McBride, "Léger," p. 14.

34. Dreier, "Introduction," *Catalog of an International Exhibition* in *Selected Publications,* Vol. 1.

35. Oliver Saylor, "Futurists and others in Famished Moscow," *Vanity Fair*, September 1919, p. 112. The circumstances of the contact with Malevich are described in Oliver Saylor, *The Russian Theatre* (New York: Brentano's 1922), p. 203.

36. Saylor, *Russian Theatre*, p. 142.

37. F[lora] T[urkel], "Russia Has Bizarre Extremes in its Art," *American Art News*, November 19, 1921, p. 4. Another early article that looked at the avant-garde Russian literary tradition was Ivan Nardony, "The Russian Revolution and Her Artists," *Arts and Decoration*, May 25, 1920, pp. 12, 13, 52. A "theme for a one-act opera" is reproduced, a drawing by Gontcharova.

38. F[lora] T[urkel], "Berlin Sees Bizarre Russian Art Show," *American Art News*, November 4, 1922, p. 1.

39. F[lora] T[urkel], "Berlin," p. 1.

40. F[lora] T[urkel], "Berlin," *The Art News*, May 31, 1924, p. 15.

41. F[lora] T[urkel], "Berlin," *The Art News*, March 15, 1924, p. 9.

42. F[lora] T[urkel], "Mobile Painting Both Old and New," *The Art News*, June 21, 1924, p. 4.

43. The periodical reached an American audience of about 3000 during these years. For a discussion of this and other "little" magazines of the 1920s see Frederick J. Hoffmann et. al., *The Little Magazine* (Princeton: Princeton University Press, 1946) pp. 102-105 which provides the complex publishing history. See also Josephson, *Life*, pp. 167-212, 240.

44. Louis Lozowick, "Tatlin's Monument to the Third International," *Broom*, October 1922, p. 232. For a discussion of Louis Lozowick see Barbara Beth Zabel, "Louis Lozowick and Technological Optimism of the 1920s" (Ph.D. Dissertation: University of Virginia, 1978.)

45. Louis Lozowick, "A Note on Modern Russian Art," *Broom*, February 1923, p. 202.

46. Ibid.

47. Louis Lozowick, *Modern Russian Art* in *Selected Publications*, Vol. 1, no. 5.

48. Enrico Prampolini, "The Aesthetic of the Machine and Mechanical Introspection," *Broom*, October 1922, p. 235.

49. "Art Exhibition of the Week: Suprematists," *New York Times*, February 24, 1924, p. 10.

50. For a study of the career of Elizabeth Luther Cary see Arlene Olson, *Art Critics and the Avant-Garde: New York 1900-1913*, (Ann Arbor: UMI Research Press, 1980).

51. "Art Exhibits in Local Galleries: The Russian Suprematists," *The Art News*, March 1, 1924, p. 8.

52. [Jane Heap], "Comments," *The Little Review*, spring 1924, p. 57. The illustrations included Lissitzky, Gabo, Peri and Altman. Tatlin's tower was illustrated in winter 1922, p. 48.

53. Theo Van Doesburg, "Evolution of Modern Architecture in Holland," *The Little Review*, spring 1925, pp. 47-51 and "Literature of the Advance-Guard in Holland," pp. 56-59. The I.K. Bonset poems are on pp. 52-53.

54. *International Theatre Exposition* (The Little Review: New York, 1926).

55. Kenneth MacGowan, "Stagecraft Shows its Newest Heresies," *New York Times*, February 14, 1926, p. 9.

56. MacGowan, "Stagecraft," p. 23.

57. "Academy of Design Reaches a New Age: Begins Second Century with Traditional Well-Mannered, Show, Stage Represses Decoration but Indicates Further Cooperation Between Painters and Directors—A New Show," *New York Times Magazine*, March 21, 1926, p. 16. *New York Times* had numerous references to the machine age such as "Smock Heralds Garb for the Machine Age," *New York Times Magazine*, February 14, 1920, p. 25.

58. Sheldon Cheney, "The International Theatre Exhibition," *Theatre Arts Magazine*, March 1926, p. 203.

59. Cheney, "International Theatre Exhibition," p. 206.

60. Sheldon Cheney, "Constructivism," *Theatre Arts Monthly*, November 1927, p. 857. Other articles in the series include "The Theatre in the Machine Age," August 1926, pp. 504-513; "The Architectural Stage," July 1927, pp. 478-489; "The Space Stage," September 1927, pp. 762-772.

61. Henry McBride, "Adventurous European Designers Propose Some Amazing Changes in Theatrical Settings," *New York Sun*, March 6, 1926, unpaginated; the issue of machine age art connects to all the media including architecture.

62. Henry McBride, "Walter Gay's Eighteenth Century Interiors...Art of Two Constructionists," *New York Sun*, May 1, 1926, p. 9.

63. M[urdoch] P[emberton], "The Art Galleries," *New Yorker*, May 8, 1926, p. 51.

64. Katherine Dreier, "Introduction," *Catalog of an International Exhibition*, in *Selected Publications*, vol. 1, unpaginated.

65. Katherine Dreier, *Modern Art* in *Selected Publications*, vol 1, p. 56. The book was separate from the above cited catalog.

66. Louis Lozowick, *Modern Russian Art*, in *Selected Publications*, vol. 1, p. 30.

67. My perspective on the criticism of the Société Anonyme International Exhibition provides a different perspective from that of Bohan, *Brooklyn*, p. 108, where she suggests that the New York critics were "less sympathetic than those of smaller towns. Bohan analyzed the articles by writers such as Thomas Hart Benton, Lewis Mumford and Forbes Watson, who were by 1926, already focusing on Preregionalist ideas. Thus, logically, they were unsympathetic to abstract art.

68. Elizabeth Luther Cary, "'Experimental Art' at Brooklyn Museum," *New York Times*, November 21, 1926, p. 11.

69. "Société Anonyme's Exciting Show," *The Art News*, November 27, 1920, p. 1.

70. Henry McBride, "Brooklyn Museum Indulges in Most Modern of Art Displays, Mirroring the Time, Machine—Made Art Presented with Disturbing Frankness," *New York Sun*, November 27, 1926, p. 5.

71. Murdock Pemberton, "The Art Galleries," *The New Yorker*, December 11, 1926, pp. 98, 99, 100.

72. "Brooklyn, City of Homes, Has Another Revel in Abstract Art," *The Art Digest*, December 1926, p. 9.

73. Forbes Watson, "International Exhibit is One-Sided," *The World*, December 12, 1926, unpaginated.

74. Thomas Hart Benton, "New York Exhibitions," *The Arts,* January 1927, pp. 47-49.

75. Herbert Lippmann, "The Machine Age Exposition," *The Arts,* June 1927, p. 324.

76. Lippmann, "Machine Age Exposition," pp. 324-326.

77. Jane Heap, "Machine Age Exposition," *Machine Age Exposition* (New York: *The Little Review,* 1927), p. 36, reprinted from *The Little Review,* spring 1925, pp. 22-24, with alterations.

78. Heap, "Machine Age," p. 36.

79. Louis Lozowick, "The Americanization of Art," *Machine Age Exposition,* p. 18.

80. Henry Russell Hitchcock and Philip Johnson, *The International Style* (New York: W.W. Norton and Co., Inc. 1932). An exhibition devoted to the "Machine Age in America 1920-1941" is scheduled to open at the Brooklyn Museum in Fall 1985, curated by Dianne Pilgrim and Richard Guy Wilson.

81. "Macy's Opens Air Show," *New York Times,* March 30, 1928, p. 2.

82. "World Art Exhibit Opened by Macy's," *New York Times,* May 15, 1928, p. 8.

83. Elizabeth Luther Cary, "International Exposition of Art in Industry Opens," *New York Times,* May 18, 1928, p. 18.

Chapter 7

1. A. Conger Goodyear, *The Museum of Modern Art, The First Ten Years,* (New York, 1943).

2. Forbes Watson, Editorial, *The Arts,* January 1926, p. 4.

3. Judith Zilczer, "The Dispersal of the John Quinn Collection," *Connoisseur,* September 1978, pp. 22-27; see also her catalog *The Noble Buyer: John Quinn, Patron of the Avant Garde* (Washington, D.C.: Hirshhorn Museum, 1978).

4. "New York University to Hold Loan Show," *The Art News,* March 19, 1927, p. 1.

5. Susan Larsen, "The American Abstract Artists Group: A History and Evaluation of Its Impact upon American Art," (Ph.D. Dissertation: Northwestern University, 1974), p. 11; Chapter 2 of her dissertation has a long section devoted to the Gallery of Living Art.

6. *Announcement of Courses 1926-1927* (New York: New York University, Department of Fine Arts), pp. 23, 25; see also "Modern Art and the University," *The Art News,* October 23, 1926, p. 8.

7. Minutes of the New York University Board of Trustees, June 15, 1926, New York University Archives.

8. Albert E. Gallatin letter to Henry McBride July 25, 1927, Henry McBride Papers, microfilm NMCB10, Archives of American Art, Washington, D.C.

9. Gallatin to McBride, July 25, 1927.

10. "Modern Art for New York University," *The Art News,* November 5, 1927, p. 1.

11. Forbes Watson, "Recent Exhibitions," *The Arts,* January 1928, p. 37.

12. Henry McBride, "Modern Art," *The Dial,* February 1928, p. 173.

13. Elizabeth Luther Cary, "Gallery of Living Art and American Print Makers," *New York Times,* December 18, 1927, p. 12.

14. "Living Art Buys Eighteen Pictures," *The Art News,* November 4, 1928, p. 1.

15. Albert E. Gallatin, "Introduction," *Loan Exhibition Held by New York University Gallery of Living Art Contemporary Paintings at the Brummer Gallery Inc.* exh. cat. (New York: The Brummer Gallery, 1929).

16. Henry McBride, "The Palette Knife," *Creative Arts,* January 1930, sup. 10 and Forbes Watson, "Exhibitions," *The Arts,* December 1929, p. 261.

17. Larsen, "American Abstract Artists," p. 37; Larsen also provides an account of the Gallery of Living Art in the 1930s.

18. Albert E. Gallatin letter to Geoffrey Hellman, January 28, 1943, A.E. Gallatin Papers, Archives of American Art, Washington, D.C.

19. Goodyear, *The First Ten Years,* p. 14.

20. Charles Daniel, "Reminiscences," Archives of American Art, Smithsonian Institution, Washington, D.C.

21. Myer Kutz, *Rockefeller Power* (New York: Simon and Schuster, 1974), p. 130.

22. Henry McBride, "Arthur B. Davies in Varied Moods," *New York Sun,* April 27, 1929, p. 7.

23. Russell Lynes, *Good Old Modern* (New York: Atheneum, 1973), p. 5; Kutz, *Rockefeller,* p. 130.

24. Goodyear, *The First Ten Years,* Appendix A "The Director's 1929 Plan," pp. 137-138.

25. Sybil Kantor, "Alfred H. Barr, Jr.: His Training and Early Writings" (Paper presented at the Sixty-Ninth Annual Meeting of the College Art Association, San Francisco, February 28, 1981).

26. William S. Lieberman, ed. "Introduction," *Art of the Twenties,* (New York: Museum of Modern Art, 1980), pp. 7-8.

27. Lynes, *Good Old Modern,* p. 20.

28. Alfred H. Barr letter to Forbes Watson, November 23, 1927, Forbes Watson Papers, microfilm D49, Archives of American Art, Washington, D.C.

29. Alfred H. Barr, "Russian Diary 1927-28," *October,* Winter 1978, pp. 7-50.

30. Alfred H. Barr, "The 'Lef' and Soviet Art," *Transition,* fall 1928, pp. 267-270.

31. Lynes, *Good Old Modern,* p. 19.

32. William Lieberman, ed. "Introduction," *Art of the Twenties,* p. 6.

33. Goodyear, *The First Ten Years,* p. 17.

34. Press Release, August 1929, Archives of Museum of Modern Art, New York.

35. Press Release, August 1929, Archives of Museum of Modern Art, New York.

36. Alfred H. Barr, "Plans of Museum of Modern Art," *New York Sun,* November 19, 1929, unpaginated.

37. Forbes Watson, "To Our New Museum," *The Arts,* September 1929, p. 46.

38. Henry McBride, "The Palette Knife," *Creative Arts,* December 1929, p. ix.

39. William B. McCormick, "Modernism Faces Permanency Test," *New York American,* November 5, 1929, p. 5.

40. William Macbeth, *Art Notes* (New York: Macbeth Gallery, 1930), pp. 1605, 1606.

41. Frederick W. Eddy, "Modernism in Art," *The Sunday World,* November 10, 1929, unpaginated.

42. Henry McBride, "New Museum of Modern Art, now Open to the Public, Begins to Make History," *New York Sun,* November 9, 1929, p. 8.

43. Alfred H. Barr, "Modern Art," *Wellesley College Literary Review,* February 1930, pp. 5-9.

44. Alfred H. Barr, "Modern and 'Modern'," *The Bulletin of the Museum of Modern Art,* May 1934, pp. 2, 4.

Bibliography

Manuscripts and Papers

(Note: the following collections are available on microfilm at the Archives of American art, Washington, D.C.)

Louis Bouché
Oscar Bluemner
Sheldon Cheney
Charles Daniel
Mitchell Kennerley
Henry McBride
J.B. Neumann
Forbes Watson
Brooklyn Museum Catalog Archive
Metropolitan Museum of Art Catalog Archive

Archives in other locations

Museum of Modern Art, New York, New York (clippings scrapbooks)
New York University, New York, New York
Alfred Stieglitz Papers. Collection of American Literature, Beinecke Rare Book and Manuscript Library, Yale University, New Haven, Conn.

Periodicals

(Note: weekly or monthly columns are not individually listed in the bibliography, but a critic regularly affiliated with a publication is indicated in brackets.)

American Art News (The Art News) [Flora Turkel, Guy Eglington, Deoch Fulton]
The American Mercury
The Art Digest [Peyton Boswell]
The Arts [Hamilton Easter Field, Forbes Watson, Virgil Barker, Lloyd Goodrich, Alexander Brook]
Arts and Decoration [Guy Pène du Bois]
Broom
Creative Arts [Henry McBride, Murdock Pemberton]

The Dial [Henry McBride, Thomas Craven]
The Freeman [Walter Pach]
International Studio [Guy Eglington]
The Little Review [Jane Heap]
The Living Age
Mss. [Alfred Stieglitz, ed.]
The Nation
The New Republic
The New Yorker [Murdock Pemberton]
Scribner's Monthly Magazine [Royal Cortissoz]
Shadowland [Thomas Craven, Walter Pach, Sheldon Cheney]
Theatre Arts Monthly [Sheldon Cheney]
Vanity Fair [Frank Crowninshield, Edmund Wilson, eds.]

Newspapers

(Note: Newspapers were examined only in relation to particular critics or exhibitions.)

New York Times [Elizabeth Luther Cary]
New York Herald [Henry McBride]
New York Sun [Henry McBride]
New York Sun and Herald [Henry McBride]
The World [Forbes Watson]

Articles and Books Published in the 1920s

"Academy of Design Reaches a New Age, Begins Second Century with Traditional Well-Mannered, Show-Stage Repress Decoration, but Indicates Further Cooperation Between Painters and Director." *New York Times,* March 21, 1926, p. 16.
"Airy Handspring is Done by Picasso." *American Art News,* June 25, 1921, p. 5.
"American Buyers Like German Art." *The Art News,* 27 October, 27, 1923, p. 4.
"Arch Cubists Recant?" *American Art News,* June 12, 1920, p. 1.
"Archipenko at Kingore's." *The Art News,* January 26, 1924, p. 3.
"Archipenko Coming to Live in America: Famous Modernist Found Berlin Disturbing and Longed for New York's Wonders and Beauties," *The Art News,* October 20, 1923, p. 3.
"Archipenko, Russian Sculptor—Painter." *American Art News,* Feburary 12, 1921, p. 5.
"Art Director's Convention." *Arts and Decoration,* June 25, 1920, p. 136.
"Art Exhibition of the Week: Suprematists." *New York Times,* February 24, 1924, p. 10.
"Artist Giles Paints Cubism with Words." *New York Times,* March 17, 1921, p. 18.
"Attack on Museum is Still Anonymous." *American Art News,* September 17, 1921, p. 4.
"Brooklyn, City of Homes, Has Another Revel in Abstract Art," *The Art Digest.* December 1926, p. 9.
"Charles Demuth, Intimate Gallery." *The Art News,* April 10, 1926, p. 7.
The Collection of Marius deZayas of New York City. New York: Anderson Galleries, 1923.
"Crowds Flock to See Museum Show." *American Art News,* May 14, 1921, p. 6.
"Cubism." *The Living Age,* November 6, 1920, pp. 357-360.
"Dada is Dead." *The Living Age,* April 15, 1927, p. 736.
"Dadaism vs. Tactilism." *American Art News,* February 12, 1921, p. 1.
"Dadaists Have Real Vanishing Days." *American Art News,* May 14, 1924, p. 5.
"Dudensing Favors Art of Today." *The Art News,* October 25, 1924, p. 6.

"Eglinton [*sic*] Drowned." *The Art Digest,* July 1928, p. 4.

"Exhibition of Impressionist and Post-Impressionist Paintings." *Bulletin of the Metropolitan Museum of Art,* June 1921, p. 118.

"Exhibitions in New York: Georgia O'Keeffe." *The Art News,* February 13, 1926, p. 7.

"Exhibitions in New York: Glenn Coleman, Stuart Davis." *The Art News,* April 28, 1928, p. 11.

"Exhibitions in New York: Jacques Villon." *The Art News,* March 31, 1928, p. 11.

"From the Exhibition by Fernand Léger." *The Art News,* November 14, 1925, p. 2.

"Georgia O'Keeffe 'Industrialist.'" *American Art News,* February 3, 1923, p. 5.

"Germany's Own Estimate of the Blue Four." *The Art Digest,* Mid-December 1929, p. 10.

"Immaculate Group Seen at Daniels." *The Art News,* November 3, 1928, p. 9.

"Is Cubism Pure Art? A Debate." *The Forum,* June 1925, pp. 769-83.

"Kandinsky's Latest Paintings." *The Art News,* March 31, 1923, p. 2.

"Macy's Opens Air Show." *New York Times,* March 30, 1928, p. 2.

"Marc Chagall and Alexander Archipenko." *The Art News,* January 16, 1926, p. 7.

"'Met' Explains Modernist's Show." *American Art News,* April 23, 1921, p. 5.

"Miro's Dog Barks While McBride Bites." *The Art Digest,* Mid-December 1929, p. 10.

"Modern Art for New York Controversy." *The Art News,* November 5, 1927, p. 1.

"Modern Art in Philadelphia." *American Art News,* May 8, 1920, p. 3.

"Modern Art to Live Avers Mr. Daniel." *The Art News,* October 18, 1924, p. 5.

"Modern Arts a Form of Dementia Praecox." *Current Opinion,* July 1921, pp. 81-82.

"Modern Germany Speaks of its Art: Kind of Terrible Earnestness Even in Landscapes—at Times, an Intentional Brutality." *The Art News,* October 13, 1923, p. 11.

"Modernism up to Date." *The Art News,* December 5, 1925, p. 8.

"Modernist Insane Say These Medics." *American Art News,* June 4, 1921, p. 3.

"More Security in Art Says Howard Young." *The Art News,* October 18, 1924, p. 4.

"Museum Opens its Modernist Show." *American Art News,* May 7, 1921, p. 5.

"New Picabia Row Sets Paris Agog." *The Art News,* February 4, 1922, p. 2.

"The Newest 'Ism' is 'Surrealism.'" *The Art Digest,* May 1, 1927, p. 1.

"Nothing is Here, Dada is It's Name." *American Art News,* April 2, 1921, p. 1.

"Our Art in Demand Says Rehn." *The Art News,* October 11, 1924, p. 3.

"Paintings and Drawings by Sheeler." *American Art News,* April 1, 1922, p. 6.

"Passing and Permanent." *The Art News,* November 7, 1925, p. 8.

"Picasso First, but Americans Win 6 of 9 Carnegie Honors." *The Art Digest,* Mid-October 1930, p. 5.

"Picasso is Painting in a Classic Style." *The Art News,* November 24, 1923, p. 2.

"Picasso Speaks." *The Arts,* May 1923, pp. 314-329.

"Picasso's Recent Work." *The Art News,* May 12, 1923, p. 2.

"Post Bellum Art in Germany." *American Art News,* March 26, 1921, p. 1.

"A Post-Impressionist Scandal." *The Art News,* April 17, 1920, p. 1.

"Reinhart Shows French Art." *The Art News,* November 5, 1927.

Museum Directors of the United States and Canada. Worchester, spring 1920.

"Revolution Reflected in the 'New' Art of Germany." *Current Opinion,* October, 1919, pp. 254-256.

"Société Anonyme's Exciting Show." *The Art News,* November 27, 1926, p. 1.

"These Are the Bold Modernists at the National Academy." *The Art Digest,* April 15, 1927, pp. 1-3.

"Valentiner Sees German Renaissance, Expects Expressionistic Movement to Bring About a Rebirth of The Human Soul—Talks of Its Leaders." *The Art News,* November 11, 1922, p. 1.

"Whitney Studio Club to Close." *The Art News,* August 18, 1928, p. 14.

"World Art Exhibit Opened by Macy's." *New York Times,* May 15, 1928, p. 8.

Anderson, Margaret. *My Thirty Years' War.* New York: Covici Friede, 1930.

Apollinaire, Guillaume. "Aesthetic Meditations." *The Little Review,* spring 1922, pp. 7-19; autumn 1922, pp. 41-59; winter 1922, pp. 49-60.

Archipenko, Alexander. "Nature: the Point of Departure." *The Arts,* January 1924, pp. 32-36.

Barker, Virgil. "Aesthetics and Scholarship." *The Arts,* January 1928, pp. 61-68.

Barnes, Albert C. *The Art in Painting.* New York: Harcourt Brace and Co., 1925.

———. "Cubism: Requiescat in Pace." *Art and Decoration,* January 1916, pp. 121-124.

———. "Some Rewards of Appreciation." *Arts,* January 1923, pp. 27-28.

Barr, Alfred H. "The 'Lef' and Soviet Art." *Transition,* fall 1928, pp. 267-270.

———. "Modern Art." *Wellesley College Literary Review,* February 1930, pp. 5-9.

———. "Modern and 'Modern.'" *The Bulletin of the Museum of Modern Art,* May 1934, pp. 2-4.

———. "Plans of Museum of Modern Art." *New York Sun,* November 19, 1929.

Bell, Clive. *Art.* London: Chatto and Windus, Ltd., 1913. Reprint. New York: G.P. Putnam and Sons, 1958.

———. *Civilization: An Essay.* New York: Harcourt, Brace and Co., 1928.

———. "The Creed of an Aesthete." *The New Republic,* January 25, 1922, pp. 241-242.

———. "The Critics' Guide." *The New Republic,* October 26, 1921, pp. 259-261.

———. "Matisse and Picasso." *Arts and Decoration,* November 1920, p. 42.

———. "Modern Art and How to Look at it." *Vanity Fair,* April 1924, p. 56, 88.

———. "The Place of Art in Art Criticism." *The New Republic,* September 15, 1920, pp. 73-74.

———. "Rise and Decline of Cubism." *Vanity Fair,* February 1923, p. 53.

———. *Since Cézanne.* New York: Harcourt Brace, 1922.

Benton, Thomas Hart. "New York Exhibitions." *The Arts,* January 1927, pp. 47-49.

Bie, Oscar. "Mid European Expressionism, the New Creed and Its Prophets." *Art and Decoration,* June 25, 1920, pp. 88, 89, 112.

Bode, Ernest. "Expressionism Without Tears." *Vanity Fair,* March 1923, p. 59, 100.

Boswell, Peyton. "Philadelphia Sees Best in New Art." *American Art News,* April 23, 1921, p. 1.

Bouché, Louis. *French Exhibition Paintings by the Younger Groups.* New York: Belmaison Galleries, 1923.

Bourgeois, Stephen. *The Adolph Lewisohn Collection of Modern French Paintings and Sculpture.* New York: Weyhe, 1928.

———. *Annual Exhibition of American Painters and Sculptors.* New York: Bourgeois Gallery, 1923.

———. *Exhibition of Modern Art Arranged by a Group of European and American Artists in New York.* New York: Bourgeois Gallery, 1917.

———. "Preface." In *Exhibition of Sculpture and Paintings by Gaston Lachaise.* New York: Bourgeois Gallery, 1920.

Breton, André. "Francis Picabia." *The Little Review,* winter 1922, pp. 41-44.

Brinton, Christian. *Modern Art at the Sesquicentennial.* New York: Société Anonyme, 1926.

———. "The Modern Spirit in Contemporary Painting." *Impressions of the Art at the Panama-Pacific Exposition.* New York: John Lane, 1916, pp. 22-23.

———. "Modernism in Museums." *Arts and Decoration,* 1921, p. 146.

Brook, Alexander. "The Exhibitions: Albert Gleizes." *The Arts,* April 1923, p. 276.

———. "February Exhibitions: Russian Art at the Brooklyn Museum." *The Arts,* February 1923, pp. 132, 134.

———. "Joseph Stella." *The Arts,* February 1923, pp. 127, 130.

Bibliography 177

Burroughs, Alan. "Review of *Vision and Design.*" *The Arts,* May 1921, pp. 57-58.

Cary, Elizabeth Luther. "An Exhibition of the Week—Foreign Notes: Wassily Kandinsky." *New York Times,* April 1, 1923, sec. 7, p. 7.

_____. "'Experimental Art' at Brooklyn Museum." *New York Times,* November 21, 1926, p. 11.

_____. "Gallery of Living Art and American Print Makers." *New York Times,* December 18, 1927, p. 12.

_____. "International Exposition of Art in Industry Opens." *New York Times,* May 18, 1928, p. 18.

Cheney, Sheldon. *An Art-lover's Guide to the Exposition.* Berkeley: At the Sign of the Oak, 1915.

_____. "The Architectural Stage." *Theatre Arts Monthly,* July 1927, pp. 478-489.

_____. "Constructivism." *Theatre Arts Monthly,* November 1927, p. 857

_____. *Expressionism in Art.* New York: Liveright, 1934.

_____. "Expressionism in Art: Art's Latest Revolution." *Shadowland,* October, 1921, pp. 51, 59-61.

_____. "'Expressionism' in German Theatre and Our Own." *New York Times Book Review,* April 30, 1922, pp. 5, 26.

_____. "The International Theatre Exhibition." *Theatre Arts Magazine,* March 1926, pp. 203-206.

_____. *The New Movement in the Theatre.* New York: Forum, 1914.

_____. *The New World Architecture.* New York: Longman Green & Co., 1930.

_____. *A Primer of Modern Art.* New York: Boni and Liveright, 1924.

_____. "The Theatre in the Machine Age."*Theatre Arts Monthly,* August 1926, pp. 504-513.

_____. "Why Dada?" *The Century Magazine,* May 1922, pp. 22-29.

Ciolwolski, H. "Stieglitz Group in Anniversary Show." *The Art News,* March 14, 1925, p. 5.

Cocteau, Jean. "Picasso, a Fantastic Modern Genius." *Arts and Decoration,* November 1924, pp. 44, 72-74.

Cortissoz, Royal. "American Art." *New York Herald Tribune,* December 2, 1923, p. 7.

_____. "Notes and Activities in the Field of Art." *Scribner's Monthly Magazine,* January 1924, pp. 123-130.

Craig, Gordon. *On the Art of the Theatre.* London: Heinemann, 1911.

Craven, Thomas. "Art and Relativity." *The Dial,* May 1921, pp. 535-539.

_____. "Charles Demuth." *Shadowland,* December 1922, pp. 11, 78.

_____. "Charles Sheeler." *Shadowland,* March 1923, pp. 11, 71.

_____. "The Independent Exhibition." *The New Republic,* March 14, 1923, p. 70.

_____. "John Marin." *Shadowland,* October 1921, pp. 11, 75, 76, 77.

_____. "Joseph Stella." *Shadowland,* January 1923, pp. 11, 78.

_____. *Men of Art.* New York: Simon and Schuster, 1940.

_____. *Modern Art.* Garden City: Halcyon House, 1940.

_____. "Mr. Roger Fry and Artistic Vision." *The Dial,* July 1921, pp. 101-106.

_____. "Preston Dickinson." *Shadowland,* November 1921, pp. 11, 68.

_____. "Psychology and Common Sense." *The Dial,* March 1924, pp. 236-242.

_____. "Thomas Hart Benton." *Shadowland,* September 1921, pp. 11, 66.

Crevel, René. "Acknowledgement to Georgio [*sic*] de Chirico." *The Little Review.* spring 1924, pp. 7, 8.

Dasburg, Andrew. "Cubism—Its Rise and Influence." *The Arts,* November 1923, pp. 278-284.

Deri, Max. "Principles of Modern German Art." *International Studio,* July 1923, pp. 315-317.

Dewey, John. *Art as Experience.* New York: G.P. Putnam's, 1958.

de Zayas, Marius. "Negro Art." *The Arts,* March 1923, pp. 199-205.

Dow, Arthur Wesley. "Modernism in Art." *American Magazine of Art,* January 1917, pp. 113-116.

Dreier, Katherine S. *Western Art and the New Era.* New York: Brentano's, 1923.

Dreier, Katherine S. and Marcel Duchamp. *Collection of the Société Anonyme: Museum of Modern Art, 1920.* New Haven: Yale University Press, 1950.

Duchamp, Marcel. "A Complete Reversal of Opinions by Marcel Duchamp—Iconoclast." *Arts and Decoration,* September 1915, pp. 427, 428, 442.

Eddy, Arthur J. *Cubists and Post-Impressionism.* Chicago: A.C. McClurg and Co., 1914.

Eddy, Frederick. "Modernism in Art." *Sunday World,* November 10, 1929.

Eglington, Guy. "The American Painter." *The American Mercury,* February 1924, pp. 218-220.

———. "Art and Other Things: A Complete Dictionary of Modern Art Terms." *International Studio,* March 1925, pp. 495-498; April 1925, pp. 68-70; May 1925, pp. 148-151; June 1925, pp. 229-320 [by Deoch Fulton]; July 1925, pp. 306-309; August 1925, pp. 375-377.

———. "John Marin, Colorist and Painter of Sea Moods." *Arts and Decoration,* August 1924, pp. 13, 14, 65.

———. "Modernistic Gloom at the Whitney Club." *The Art News,* November 18, 1925, p. 4.

———. "The Theory of Seurat." *International Studio,* July 1925, pp. 289-291.

Ely, Catherine Beach. "The Modern Tendency in Henri, Sloan, Bellows." *Art in America,* April 1922, pp. 132-143.

Faure, Elie. *History of Art.* Translated by Walter Pach. New York: Harper and Bros., 1921-1923.

Field, Hamilton E. "The Kelekian Collection." *The Arts,* December 1921, pp. 131-148.

———. "Joseph Stella." *The Arts,* October 1921, pp. 24, 26.

———. "The Metropolitan French Show." *The Arts,* May 1921, pp. 2-8.

———. "Review of *Vision and Design.*" *The Arts,* August-September 1921, pp. 51-54.

Frank, Waldo. *America and Alfred Stieglitz.* New York: Literary Guild, 1934.

Freund, F.E. Washburn. "Modern Art in Germany." *International Studio,* October 1923, pp. 41-46.

Fry, Roger. "Bolshevik Art." *Arts and Decoration,* October 1920, p. 338.

———. "London Statues." *The Dial,* December 1925, pp. 468-473.

———. "The Religion of Culture." *The Dial,* October 1925, pp. 305-309.

———. *Vision and Design.* London: Chaltot Corndees, 1921.

Fulton, Deoch. "Guy Eglington." *Creative Art,* July 1928, pp. ix, xi.

T.C.G. "Cleveland is Jolted by Modernistic Art." *American Art News,* May 21, 1921, p. 5.

Gallatin, Albert E. *Loan Exhibition Held by New York University Gallery of Living Art Contemporary Paintings of the Brummer Gallery, Inc.* New York: The Brummer Gallery, 1929.

George, Waldemar. "Fernand Léger." *The Arts,* May 1929, pp. 303-313.

Glassgold, C. Adolph. "Max Beckmann." *The Arts,* May 1927, pp. 244, 247.

Gleizes, Albert. "The Impersonality of American Art." *Playboy,* Fall 1919, p. 26.

Goodrich, Lloyd. "Giorgio de Chirico." *The Arts,* January 1929, pp. 5-10.

———. "New York Exhibitions: Arthur Dove." *The Arts,* February 1926, p. 100.

———. "New York Exhibitions: Fernand Léger." *The Arts,* December 1925, p. 349.

Hagen, Oscar. *Art Epochs and their Leaders: A Survey of the Genesis of Modern Art.* New York: Scribner's Sons, 1927.

Hartley, Marsden. *Adventures in the Arts.* New York: Boni and Liveright, 1921. Reprint. New York: Hacker Art Books, 1972.

———. "Art and the Personal Life." *Creative Art,* June 1928, pp. xxxi-xxxiv.

Heap, Jane. "Art and the Law." *The Little Review*, September-December 1920, pp. 5-6.

_____. "The Art Season." *The Little Review*, spring, 1922, p. 58.

_____. "Lost: A Renaissance." *The Little Review*, May 1929, p. 5.

Heap, Jane et. al. *Machine Age Exposition*. New York: The Little Review, 1927.

Hambidge, Jay. *Dynamic Symmetry in Composition*. Cambridge: The Author, 1923.

Hambidge, Jay and Gore Hambidge. "The Ancestry of Cubism." *The Century*, April 1914, pp. 869-875.

Henri, Robert. *The Art Spirit*. Compiled by Margery Ryerson. Introduced by Forbes Watson. New York: Lippincott, 1923.

Jacob, Max. "The Early Days of Pablo Picasso." *Vanity Fair*, May 1923, pp. 62, 104.

Josephson, Matthew. "A Letter to My Friends." *The Little Review*, spring 1926, pp. 17-18.

Kalonyme, Louis. "John Marin: Promethean." *Creative Arts*, October 1928, pp. xl, xli.

Kiesler, Frederick, Jane Heap et al. *International Theatre Exposition*. New York: The Little Review, 1926.

Landau, Rom. "Modern Movements in German Art." *The Arts*, July 1928, pp. 24-30.

Laurvick, J. Nelson. "Evolution of American Painting." *Century*, September 1915, pp. 772-786.

_____. *Is It Art?* New York: International Press, 1913.

Léger, Fernand. "The Esthetics of the Machine." *The Little Review*, spring 1923, pp. 45-49, autumn-winter 1923-24, pp. 55-58.

Lippmann, Herbert. "Machine Age Exposition." *The Arts*, June 1927, pp. 324-326.

Lozowick, Louis. "Art: Fernand Léger." *The Nation*, December 16, 1925, p. 712.

_____. "A Note on Modern Russian Art." *Broom*, February 1923, p. 202.

_____. "The Russian Dadaists." *The Little Review*, September-December 1920, pp. 72-73.

_____. "Tatlin's Monument to the Third International." *Broom*, October 1922, p. 232.

Maccoll, W.D. "Some Reflections of the Functions and Limitations of Art Criticism—Especially in Relation to Modern Art." *Camera Work*, spring, 1910, pp. 17-21.

MacGowan, Kenneth. "Expressionism in the German Theatre." *Vanity Fair*, November 1922, pp. 53, 116.

_____. "Stagecraft Shows Its Newest Heresies." *New York Times*, February 14, 1926, pp. 9, 23.

McCormick, William. "Modernism Fails Permanency Test." *New York American*, November 5, 1929, p. 5.

McBride, Henry. "Adventurous European Designers Propose Some Amazing Changes in Theatrical Settings." *New York Sun*, March 6, 1926.

_____. "Art News and Reviews as the New Season is Getting Underway: Apollinaire's Cubistic Authority." *New York Herald*, October 15, 1922, p. 6.

_____. "Art News and Reviews—Brooklyn Museum First with Matisse and Cézanne Exhibition." *New York Herald*, April 3, 1921, p. 11.

_____. "Art News and Reviews—Noted Picture by Duchamp on Exhibition." *New York Herald*, March 9, 1924, p. 13.

_____. "Art News and Reviews—Watercolors Shown in Brooklyn." *New York Herald*, November 13, 1921, p. 4.

_____. "Born American and Others: The Daniel Gallery Use[s] the Melting Pot to Acquire American Art." *New York Sun*, October 26, 1929, p. 10.

_____. "Brooklyn Museum Indulges in Most Modern of Art Displays, Mirroring the Time Machine Made Art Presented with Distrubing Frankness." *New York Sun*, November 27, 1926, p. 5.

_____. "Charles Demuth's Cerebral Art." *New York Sun*, April 10, 1926, p. 6.

_____. "Giorgio De Chirico's Art." *New York Sun*, January 28, 1928, p. 16.

————. "German Water Colors and Prints Shown." *New York Herald,* December 2, 1923, p. 8.

————. "Interesting Show of Contemporary British Art New at Agnew Galleries: Barking at Moon at Brummer's." *New York Sun,* December 9, 1929.

————. "Joseph Stella's Startling Art: Niles Spencer's Successful Work." *New York Sun,* April 11, 1925, p. 9.

————. *Matisse.* New York: Knopf, 1930.

————. "New Dada Review Appears in New York." *New York Herald,* April 24, 1921, p. 11.

————. "New Museum of Modern Art, Now Open to the Public Begins to Make History." *New York Sun,* November 9, 1929, p. 8.

————. "News and Views of Art, Including the Clearing House for Works of Cubists." *New York Sun and New York Herald.* May 16, 1920, p. 8.

————. "Sale of the Arthur B. Davies Collection..." *New York Sun,* April 13, 1929, p. 9.

————. "The Skating Rink by Fernand Léger." *New York Herald,* November 18, 1923, p. 8.

————. *Some French Moderns Says McBride.* Selected by Marcel Duchamp. New York: Société Anonyme, Melomme Publications, 1922.

————. "Views and Reviews of the Week in the Art World: Work of Charles Sheeler Attracts Attention." *New York Sun* and *New York Herald,* February 22, 1920, p. 7.

————. "Views of Bourdelle Sculpture: Fernand Léger's Modernistic Art." *New York Sun,* November 21, 1925, p. 14.

————. "Walkowitz and the Parks." *International Studio,* November 1924, pp. 156-159.

————. "Walter Gay's Eighteenth Century Interiors... Art of Two Constructionists." *New York Sun,* May 1, 1926, p. 9.

Mather, Frank. *Modern Painting.* Garden City: Henry Holt & Co., 1927.

Mather, Frank Jewett. "Art: The New Painting and the Musical Fallacy." *The Nation,* November 12, 1914, pp. 588-590. (review of Wassily Kandinsky. *The Art of Spiritual Harmony.*)

Marin, John. "Here It Is." *Mss,* No. 2, 1922, p. 3.

————. "John Marin by Himself." *Creative Arts,* October 1928, pp. xxxv, xxxviii, xxxix.

Medygas, Ladislas. "Cubism's Effect on French Art." *International Studio,* February 1924, pp. 410-414.

Meier-Graefe, Julius. "The Art of Selling Art." *Vanity Fair,* January 1930, pp. 34, 80.

————. "A Few Conclusions on American Art." *Vanity Fair,* November 1928, pp. 134-136.

————. "German Art After the War." *The Dial,* July 1923, p. 1-12.

Meltzer, Charles Henry. "Post-Cubist Art in Paris." *Arts and Decoration,* February 1922, pp. 274-275, 324.

More, Herman and Lloyd Goodrich. *Juliana Force and American Art.* New York: Whitney Museum of American Art, 1949.

Mumford, Louis. *Aesthetics: A Dialogue.* Amenia: Troutbeck Press, 1925.

————. *Sticks and Stones, A Study in American Architecture and Civilization.* New York: Horace Liveright, 1924.

Pach, Walter. "An Artist's Criticism." *The Freeman,* October 25, 1922, p. 165.

————. "Methods of Criticism." *The Freeman,* January 19, 1921, pp. 450-451.

————. "The Point of View of the Moderns." *International Studio,* April 1914, pp. 861-863.

————. *Queer Thing Painting.* New York: Harcourt Brace, 1938.

Pemberton, Murdock, "The Art Galleries." *The New Yorker,* December 18, 1925, pp. 19-20.

————. "Long Trousers." *Creative Arts,* October 1928, pp. xlix-liii.

Parker, Robert Allerton. "The Classical Vision of Charles Sheeler." *International Studio,* May 1926, pp. 68-72.

Picasso, Pablo. "Picasso Speaks: A Statement by the Artist." *The Arts,* May 1923, pp. 314-328.

Pound, Ezra. "Paris Letter." *The Dial*, January 1923, pp. 85-90.

Prampolini, Enrico. "The Aesthetic of the Machine and Mechanical Introspection." *Broom*, October, 1922, p. 235-236 (reprinted in *The Little Review*, autumn and winter 1924-1925, pp. 49-51 and *The Machine Age Exposition*. New York: The Little Review, 1927, pp. 9-10).

Ribemont-Dessaignes, G. "Dada Painting or The Oil Eye." *The Little Review*, winter 1923-24, pp. 11-12.

———. "In Praise of Violence." *The Little Review*, spring 1925, pp. 40-41.

Rodker, John. "Dada and Else Von Freytag von Loringhoven." *The Little Review*, July-August 1920, pp. 33-36.

Rosenfeld, Paul. "American Painting." *The Dial*, December 1921, p. 663.

———. *By Way of Art: Criticism of Music, Literature, Painting, Sculpture and the Dance*. New York: Coward McCann, 1928.

———. *Port of New York*. New York: Harcourt Brace, 1924.

———. "Stieglitz." *The Dial*, May 1921, pp. 397-409.

Rutter, Frank. *Evolution in Modern Art: A Study of Modern Painting 1870-1925*. New York: Dial, 1926.

Saiko, George. "The Meaning of Cubism." *Creative Arts*, September 1930, pp. 206-212.

Saylor, Oliver. "Futurists and Others in Famished Moscow." *Vanity Fair*, September 1919, pp. 54, 112.

———. *The Russian Theatre*. New York: Brentano's, 1922.

———. *The Russian Theatre Under the Revolution*. Boston: Little, Brown, & Co., 1920.

Scott, C. Kay. "Art: The Expressionist Movement." *The Freeman*, September 28, 1920, pp. 63, 65.

Scheffauer, Herman George. *The New Vision in the German Arts*. New York: Huebsch, 1924.

———. "The Vivifying of Space I." *The Freeman*, December 1, 1920, pp. 248-250.

———. "The Vivifying of Space II." *The Freeman*, December 1, 1920, pp. 275-276.

Sheeler, Charles. "Notes on an Exhibition of Greek Art." *The Arts*, March 1925, p. 153.

Seligmann, Herbert, ed. *Alfred Steglitz Talking: Notes on Some of His Conversations, 1925-1931*. New Haven: Yale University Press, 1966.

Seligmann, Herbert. "American Water Colours in Brooklyn." *International Studio*, December 1921, pp. clviii-clx.

———. "The Elegance of Marsden Hartley: Craftsman." *International Studio*, October 1921, p. li, liii.

———. "Picasso on Fifth." *The Nation*, December 19, 1923, p. 714.

Société Anonyme. *Selected Publications Société Anonyme (The First Museum of Modern Art: 1920-1944)*. 3 vols. New York: Arno Press, 1972.

Stieglitz, Alfred et al. *Alfred Stieglitz Presents Seven Americans*. New York: The Anderson Galleries, 1925.

———. *A Collection of Works by Living Artists of the Modern Schools*. New York: The Anderson Galleries, 1922.

———. "A Statement." *Exhibition of Stieglitz Photographs*. New York: Anderson Galleries, 1921.

Stein, Gertrude. "Genuine Creative Ability." *Creative Arts*, February 1930, sup. 41.

Strand, Paul. "Aesthetic Criteria." *The Freeman*, January 12, 1921, p. 426, 427.

———. "American Watercolors at the Brooklyn Museum." *The Arts*, December 1921, pp. 148-152.

Turkel, Flora. "Archipenko Coming With New Art Plan." *The Art News*, May 12, 1923, p. 1.

———. "Berlin." *American Art News*, November 4, 1922, p. 7.

———. "Berlin Sees Bizarre Russian Art Show." *American Art News*, November 4, 1922, p. 1.

————. "Russia Has Bizarre Extremes in its Art." *American Art News,* November 19, 1921, p. 4.

————. "Russia Favors New But Guards Old Art." *American Art News,* June 17, 1921, p. 1.

Tyrell, Henry. "Dada: The Cheerless Art of Idiocy." *The World Magazine,* June 12, 1921.

Tzara, Tristan. "Germany—A Serial Film." *Vanity Fair,* April 1923, pp. 59, 60, 104, 105.

————. "Some Memories of Dadaism." *Vanity Fair,* July 1922, p. 70.

————. "What are We Doing in Europe?" *Vanity Fair,* September 1922, pp. 68, 100.

Valentiner, William. "Introduction." In *A Collection of Modern German Art.* New York: Anderson Galleries, 1923.

Van Doesburg, Theo. "Evolution of Modern Architecture in Holland." *The Little Review,* spring 1925, pp. 47-51.

————. "Literature of the Avant-Guard in Holland." *The Little Review,* spring 1925, pp. 56-59.

Walkley, A.B. "Art as a Liberator: A.B. Walkley Explains the Expressionist's Theory of Art." *Arts and Decoration,* September 1927, pp. 380-382.

Watson, Forbes. "American Note in Demuth's Art: Watercolors of Rare Distinction Displayed at Daniel's." *World,* December 2, 1923, p. 8.

————. "Charles Sheeler." *The Arts,* March 1923, pp. 335-344.

————. "A Note on Picasso." *The Arts,* December 1923, p. 332.

————. "Nottingham Dadas at Whitney Club," *The World,* January 27, 1924.

————. "Pablo Picasso Knocks Loudly at the Doors of our Museums." *World,* November 25, 1923.

————. "To Our New Museum." *The Arts,* September 1929, p. 46.

Wehle, H.B. "Loan Exhibition of Modern French Paintings." *Bulletin of the Metropolitan Museum of Art,* May 1921, pp. 94-96.

Whitney, Gertrude. "The End of America's Apprenticeship in the Arts." *Arts and Decoration,* November 1920, pp. 68-69; June 1920, pp. 83-124; August 1920, pp. 150-151.

Wilenski, R.H. *The Modern Movement in Art.* London: Faber & Faber, 1927.

Williams, Helena. "Joseph Stella's Art in Retrospect." *International Studio.* July 1926, pp. 76-80.

Wilson, Edmund. *Axel's Castle: A Study in the Imaginative Literature 1870-1930.* New York: Scribner's, 1931.

————. "The Aesthetic Upheaval in France." *Vanity Fair,* February 1922, pp. 49, 100.

————. "An Imaginary Conversation." *The New Republic,* April 9, 1924, pp. 179-182.

Wright, Willard Huntington. "The Aesthetic Struggle in America." *The Forum,* February 1916.

————. *The Creative Will: Studies in the Philosophy and the Syntax of Aesthetics.* New York: John Rave, 1916.

————. *The Future of Painting.* New York: B.W. Huebsch, 1923.

————. *Modern Painting, Its Tendency and Meaning.* New York: John Lane, 1915.

Wyer, Raymond. "Germany and Art." *International Studio,* December 1918, p. xlii.

Zorach, William. "The New Tendencies in Art." *The Arts,* October 1921, pp. 10-13.

Articles and Books Published Since the 1920s.

Adams, Clinton (introd). *Cubism, Its Impact on the USA 1910-1930.* University of New Mexico, 1967.

Agee, William. *Modern American Painting 1910-1940: Toward a New Perspective.* Houston: The Museum of Fine Arts, 1977.

————. *Synchronism and Color Principles in American Painting 1910-1930.* New York: Knoedler, 1965.

_____. "New York Dada 1910-30." *Arts News Annual,* XXXIV (1968) pp. 105-113.

Allen, Frederick Lewis. *Only Yesterday: An Informal History of the 1920s.* New York: Harper's, 1931.

Barr, Alfred H. "Russian Diary, 1927-28." *October,* winter 1978, pp. 7-50.

Baur, John. *Revolution and Tradition in Modern American Art.* New York: Preager, 1967.

Benham, Reyner. *Theory and Design in the First Machine Age.* New York: Preager, 1960.

Blesh, Rudi. *Modern Art USA.* New York: Alfred Knopf, 1966.

Bohan, Ruth L. *The Société Anonyme's Brooklyn Exhibition: Katherine Dreier and Modernism in America.* Ann Arbor: UMI Research Press, 1982.

Bowlt, John. *Berlin/Hanover: The 1920s.* Dallas: Dallas Museum of Fine Arts, 1977.

Brown, Milton. *American Painting from the Armory Show to the Depression.* Princeton: Princeton University Press, 1955.

Bryer, Jackson. "Joyce's 'Ulysses' and the 'Little Review'." *South Atlantic Quarterly,* 1967 (2), pp. 148-164.

_____. "A Trial Track for Racers: Margaret Anderson and the 'Little Review.'" Ph.D. Dissertation: University of Wisconsin at Madison, 1965.

Buettner, Stewart. *American Art Theory, 1945-1970.* Ann Arbor: UMI Research Press, 1981.

Bywater, William B. *Clive Bell's Eye.* Detroit: Wayne State University, 1975.

Camfield, William, A. *Francis Picabia, His Life and Times.* Princeton: Princeton University Press, 1979.

Carmalt, Susan Platt. "Thomas Hart Benton as Aesthetic Theoretician." M.A. Thesis: Brown University, 1973.

Carter, Paul. *The Twenties in America.* New York: Thomas Y. Crowell, 1968.

Corn, Wanda. "Apostles of the New American Art: Waldo Frank and Paul Rosenfeld." *Arts Magazine.* February 1980, pp. 159-163.

Cowley, Malcolm. *Exile's Return: A Narrative of Ideas.* New York: Norton & Co., 1937.

Davidson, Abraham. "Demuth's Poster Portraits." *Artforum,* November 1978, vol. XVII, no. 3, pp. 54-57.

_____. *Early American Modernist Painting 1910-1935.* New York: Harper, 1981.

Dijkstra, Bram. *Cubism, Stieglitz and the Early Poetry of William Carlos Williams.* Princeton: Princeton University Press, 1969.

Farnham, Emily. *Charles Demuth Behind a Laughing Mask.* Norman: University of Oklahoma Press, 1971.

Frank, Waldo. *In the American Jungle.* New York: Farrar and Rinehart, 1937.

Friedman, B.H. *Gertrude Vanderbilt Whitney.* Garden City: Doubleday, 1978.

Friedman, Martin. *Charles Sheeler.* New York: Watson-Guptill, 1975.

_____. *The Precisionist View in American Art.* Minneapolis: Walker Art Center, 1960.

Geismer, Maxwell, ed. *Unfinished Business: James N. Rosenberg Papers.* Mamaroneck: Vincent Marasia, 1967.

Goodrich, Lloyd. *The Whitney Studio Club and American Art.* New York: Whitney Museum of American Art, 1975.

Goodrich, Lloyd and Herman More. *Juliana Force and American Art.* New York: Whitney Museum of American Art, 1949.

Goodyear, A. Conger. *The Museum of Modern Art, The First Ten Years.* New York, 1943.

Gordon, Donald. "On the Origin of the Word 'Expressionism.'" *Journal of the Warburg and Courtauld Institutes,* 1966, pp. 368-385.

Haskell, Barbara. *Arthur Dove.* Boston: New York Graphic Society, 1974.

_____. *Marsden Hartley.* New York: Whitney Museum of American Art, 1980.

Held, R.L. *Endless Innovations: Frederick Kiesler's Theory and Scenic Design.* Ann Arbor: UMI Research Press, 1982.

Herbert, Robert L., Eleanor S. Apter and Elise K. Kenney. *The Société Anonyme and the Dreier Bequest at Yale University.* New Haven: Yale University Press, 1984.

Hoffman, Frederick et al. *The Little Magazine: A History and a Bibliography.* Princeton: Princeton University Press, 1946.

———. *The 20's American Writing in the Post-War Decade.* New York: Macmillan, 1949.

Hoffman, Katherine. "A Study of the Art of Georgia O'Keeffe." Ph.D. Dissertation: Institute of Fine Arts, 1976.

Homer, William I. *Alfred Stieglitz and the American Avant-Garde.* Boston: New York Graphic Society, 1977.

Homer, William I., ed. *Avant-Garde: Painting and Sculpture in America 1910-25.* Wilmington: Delaware Art Museum, 1975.

Jaffe, Irma. *Joseph Stella.* Cambridge: Harvard University Press, 1970.

Johnson, Abby Ann Arthur. "The Personal Magazine: Margaret C. Anderson and *The Little Review, 1914-1929." South Atlantic Quarterly,* 1976, pp. 351-363.

Josephson, Matthew. *Life Among the Surrealists.* New York: Holt, Rinehart and Winston, 1962.

Kutz, Myer. *Rockefeller Power.* New York: Simon and Schuster, 1974.

Larkin, Oliver. *Art and Life in America.* New York: Holt, Rinehart & Winston, 1960.

Larsen, Susan. "The American Abstract Artists Group: A History and Evaluation of Its Impact upon American Art." Ph.D. Dissertation: Northwestern University, 1974.

Levin, Gail. "Wassily Kandinsky and the American Avant-Garde 1912-1950." Ph.D. Dissertation: Rutgers University, 1976.

Lieberman, William S., ed. *Art of the Twenties.* New York: Museum of Modern Art, 1980.

Lynes, Russell. *Good Old Modern.* New York: Atheneum, 1973.

McCausland, Elizabeth. "The Daniel Gallery and Modern American Art." *Magazine of Art,* November 1961, pp. 280-284.

Mellow, James. *Charmed Company: Gertrude Stein & Co.* New York: Preager, 1974.

Motherwell, Robert, ed. *The Dada Painters and Poets.* New York: Wittenborn, Schultz, Inc., 1951.

Naef, Weston. *The Collection of Alfred Stieglitz.* New York: The Viking Press, 1978.

Naumann, Francis. *Beatrice Wood and Friends: From Dada to Deco.* New York: Rosa Esman Gallery, 1978.

———. "How, When and Why Modern Art Came to New York." *Arts Magazine,* April 1980, pp. 96-125.

———. "Walter Conrad Arensberg, Poet, Patron, and Participant in the New York Avant-Garde." *Bulletin of the Philadelphia Museum of Art,* spring, 1980.

Olson, Arlene. *Art Critics and the Avant-Garde: New York 1900-1913.* Ann Arbor: UMI Research Press, 1980.

Platt, Susan Noyes. "Formalism and American Art Criticism in the 1920s." *The Journal of the Theory and Criticism of the Arts,* 1:3 (forthcoming 1985).

———. "Precisionism: America's Immaculates" *Images and Issues,* March-April 1983, pp. 22-23.

———. "The Role of *The Little Review* in the Introduction of Modernism to New York in the 1920s." Paper presented to the Seventy-Second College Art Association Meeting, Toronto, February, 1984.

Pemberton, Murdock. "A Memoir of Three Decades." *Arts,* October 1955, pp. 20-30.

Petruck, Peninah. *American Art Criticism, 1910-1939.* New York: Garland, 1981.

Reich, Sheldon. *John Marin: A Stylistic Analysis and Catalog Raisonné.* Tucson: University of Arizona Press, 1970.

Risatti, Howard A. "American Critical Reactions to European Modernism." Ph.D. Dissertation: University of Illinois at Urbana-Champaigne, 1975.

Raun, Eva Epp. "Marius de Zayas: The New York Years." M.A. Thesis: University of Delaware, 1973.

Ray, Man. *Self Portrait.* Boston: Little, Brown Co., 1963.

Rhyne, Brice. "John Quinn: The New York Stein" *Artforum,* October 1978, pp. 56-63.

Rich, Daniel Cotton. "The Conscience of a Critic: Henry McBride 1867-1962." *Arts Magazine,* November 1962, pp. 48-52.

Rich, Daniel Cotton, ed. *The Flow of Art: Essays and Criticism of Henry McBride.* New York: Atheneum, 1975.

Ritchie, Andrew Carnduff. *Abstract Paintings and Sculpture in America.* New York: Museum of Modern Art, 1951.

Rose, Barbara. *American Art Since 1900: A Critical Survey.* New York: Praeger, 1968.

_____. *Readings in American Art Since 1900: A Documentary Survey.* New York: Praeger, 1968.

Rosenberg, James. *Painter's Self Portrait.* New York: Crown, 1958.

Schwarz, Arturo. *New York Dada.* Milan: Prestel-Verlag, 1973.

Société Anonyme. *Selected Publications Société Anonyme (the First Museum of Modern Art: 1920-1944).* 3 vols. New York: Arno Press, 1972.

Spalding, Frances. *Roger Fry, Art and Life.* Berkeley: University of California Press, 1970.

Sterne, Margaret. *The Passionate Eye: The Life and Times of William R. Valentiner.* Detroit: Wayne State University, 1980.

Stewart, Rick. "Charles Sheeler, William Carlos Williams and Precisionism: A Redefinition." *Arts Magazine,* November 1983, pp. 100-115.

_____. "The European Art Invasion and the Arensberg Circle 1914-1919." *Arts Magazine,* May 1977, pp. 108-112.

Tarbell, Roberta. "Gertrude V. Whitney as Patron." Paper delivered at College Art Association, New Orleans, 1980.

Tarbell, Roberta et al. *Vanguard American Sculpture 1913-1939.* New Brunswick: Rutgers University, 1979.

Tashjian, Dickran. *Skyscraper Primitive: Dada and the American Avant-Garde.* Middleton: Wesleyan University, 1975.

_____. *William Carlos Williams and the American Scene 1920-1940.* New York: Whitney Museum of American Art, 1978.

Towner, Wesley. *The Elegant Auctioneers.* New York: Hill and Wang, 1970.

Tsujimoto, Karen. *Images of America Precisionist Painting and Modern Photography.* San Francisco: San Francisco Museum of Modern Art, 1982.

Tucker, Marcia. *American Paintings in the Ferdinand Howald Collection.* Columbus: The Columbus Gallery of Fine Arts, 1969.

Weisstein, Ulrich, ed. *Expressionism as an International Literary Phenomenon.* Paris: Didier, 1973.

Whitney Museum. *Jan Matulka, 1890-1972.* Washington, D.C.: Smithsonian Institution Press, 1980.

Willett, John. *Art and Politics in the Weimar Period.* New York: Pantheon, 1978.

Wilson, Edmund. *The American Earthquake: A Documentary of the Twenties and Thirties.* Garden City: Doubleday, 1958.

Index